D1452307

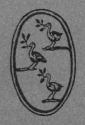

QUACK, QUACK, QUACK:

THE SELLERS OF NOSTRUMS IN
Prints, Posters, Ephemera & Books

An exhibition on the
frequently Excessive & flamboyant Seller
of Nostrums as shown in
prints, posters, caricatures, books, pamphlets, advertisements & other Graphic arts
OVER THE LAST FIVE CENTURIES

WILLIAM H. HELFAND

A WINTERHOUSE EDITION

Published by
The Grolier Club

NEW YORK 2002

William H. Helfand
A Winterhouse Edition
New York: The Grolier Club 2002

Published to accompany an exhibition at
The Grolier Club
18 September – 23 November, 2002

Designed by Winterhouse Studio
Printed by The Studley Press
Copyright © 2002 by William H. Helfand

ISBN 0-910672-40-7

Printed & bound in the United States of America

CONTENTS.

Preface.

My interest in quacks and their methods emerged early after I began a career in the pharmaceutical industry, some fifty years ago. Despite professional training in technological subjects, I found that for me a more promising path to future success was in marketing and advertising, where persuasive arguments seemed to count more than objective facts. I was then engaged in the marketing of what were termed "ethical" pharmaceuticals, which were, at the time, medicines advertised solely to health professionals. Ethical products began to be promoted in this way in the late nineteenth century, for prior to that time no such distinction could be made between pharmaceutical products available to the general public and those available only to health professionals. Nor are such distinctions made any longer as many prescription-only products are now routinely advertised in the popular media. In trying to discover the background of those men and women who had similar occupations to mine in the past, I discovered that many of my predecessors were commonly characterized as charlatans and quacks.

This was not discouraging, for these medicine sellers had a great deal to offer one of their modern progeny, and I set out to learn as much as I could from them. I have separately described how my early print collecting focused on medical themes, and even though I did not begin to concentrate specifically on sellers of medicines plying their profession at country fairs and in urban settings, this sub-group quickly became one of the most significant. As time went on, I supplemented these images with books, broadsides, pamphlets, posters and other ephemera on the varieties of systems employed to convince the curious to purchase the cure for whatever ailed them. A selection of these objects forms the various sections of this exhibition.

The genesis of this exhibition came in 1993 during the months I worked with Haskell Norman as his East Coast representative in organizing the landmark exhibition *One Hundred Books Famous in Medicine*, an exhibition that took place at the Grolier Club in 1994. Over one four-day period we visited six medical libraries, in order to choose those examples of the books to be included in the exhibition, giving prime consideration to authors' copies, dedication copies, or others that were special in some personal way. These were the writings by the great authors: Galen, Vesalius, William Harvey, Edward Jenner, James Watson and Francis Crick. These were the men and women who "got it right" and whose writings describe the breakthroughs and contributions they made to advance medical science.

But where were the losers? At the time Harvey was determining the route for the circulation of the blood, others thought otherwise, but none of those who opposed the writers of the books in this earlier exhibition are remembered in the same way. When Jenner was developing his method for presenting smallpox (no. 53 in the catalogue of the earlier exhibition), a study which showed the value of preventative inoculation, there were many dissenting, and generally unheralded, voices. James Gillray's provocative 1802 engraving of *The Cow-Pock—or—The Wonderful Effects of the New Inoculation* was but one example. For marketers of proprietary medicines, there are few biographies of vendors of now long-forgotten panaceas, few if any archival holdings of papers and memorabilia recording their activities and certainly no medallic histories to commemorate their working towards an erroneous and specious end. Their books and pamphlets do not set auction records. Historians of science and medicine do care about these rivals, however, for ignoring their conflicting methodology or rival therapeutic claims leads to an unbalanced portrayal of events and would mistake discoveries for the whole of medical history. As history is more often than not written by or about the successful, supporters of rival possibilities tend to be passed over.

While quacks and proprietary medicine sellers could not sustain any success without huge advertising expenditures, their remedies did offer alternatives to the therapy, often heroic, championed by practicing physicians. They battled accepted therapeutics as best they could, offering competitive systems or products as options to the establishment's point of view. On the positive side, these were often less expensive and frequently less drastic in their design; given the self-limiting character of much of sickness, and human gullibility, they often sufficed. Further, these unsung adversaries are responsible for the development of several novel advertising and promotion methods for their medicines that have counterparts in contemporary marketing. They deserve to be remembered in a different way than the authors of the hundred important books, and this exhibition is an attempt to show that they have not been totally forgotten.

It is not possible to list all the print dealers, book dealers, and ephemera dealers who have played a part in building this collection, but two do deserve special mention. The late Walter Schatzki was one who opened my eyes to the importance of ephemera as a witness to past events. Lydia Watkins, whom I met in the last days of the Walter T. Spencer firm and from whom I acquired many British caricatures, was another. I also owe a profound debt to

a number of friends and colleagues. In writing this catalogue, I was fortunate in receiving critical reviews by several historians of medicine and pharmacy including David Cowen, Ricky Jay, Pierre Julien, Edward Morman, Charles Rosenberg, Glenn Sonnedecker, and the scholar of American quackery, James Harvey Young. I profited too from the meticulous editing of Carol Rothkopf and Morgen Cheshire, and received steady encouragement from John Ittmann at the Philadelphia Museum of Art and James Green at the Library Company of Philadelphia as well as from several print collecting experts at the Grolier Club: Bert Friedus, Riva Castleman, Rona Schneider and Mark Tomasko. The exhibition could not have taken place without the professional hands of Nancy Houghton, Mary Young, Megan Smith and Eric Holzenberg. The catalogue could not have reached its handsome form without the talents of Jessica Helfand, William Drenttel, Kevin Smith and Rob Giampietro. To each of these colleagues and critics I owe a great deal of thanks. And I owe even more to my late wife, Audrey, who always showed steadfast encouragement in this abiding interest of mine.

William H. Helfand
JULY 2002

Introduction.

On Quackery.

A quack is someone else. The sentence "I am a quack" is one that has rarely, if ever, been spoken or written. One accuses others of practicing quackery when their methods are not considered proper, are not sufficiently scientific, or possibly might be considered deceitful or dishonest. It is thus effortlessly applied to rivals whose competitive systems might encroach on activities of the accuser.

Quackery has a long history. This exhibition treats its prevalence over the last four hundred years and gives examples of the methods used by its practitioners as well as those who became their eventual successors and have routinely been accused of being quacks, the marketers of proprietary medicines. Its title is taken from a remark by Benjamin Franklin, noted in the margins of his copy of a report issued in Paris in 1784 and now in the collections of the Library Company of Philadelphia.

In that year, concerned over the growing popularity of the animal magnetism of Franz Anton Mesmer and its challenge to political authority and to established scientific organizations, the French government appointed a Royal Commission to investigate mesmerism. A prestigious committee was selected; it included the physician J. I. Guillotin, several of his colleagues on the Faculty of Medicine, and five members of the Academy of Sciences, including J. S. Bailly, Antoine Lavoisier and Benjamin Franklin, then the ambassador of the United States in France. The Commission spent a considerable amount of time investigating Mesmer's claims, even conducting its own experiments, but ultimately concluded that Mesmer's magnetic fluid did not exist and that his theories were false. The Faculty of Medicine issued its own endorsement of the Commission's findings; the first page of its *Extrait des Registeres* included a woodcut image of the Faculty's arms, in the center of which were three ducks, each with a sprig of leaves in its mouth. Franklin wrote in the margin that "It is remarkable that the Arms of the Faculty above should be three ducks, with herbs in their mouths to prevent their pronouncing the motto, Quack, Quack, Quack." In this Franklin showed his understanding of the desire of all orthodox physicians to try to marginalize and to look down their noses at those competitors who did not have the requisite training to become members of the medical establishment. And, when Franklin's copy of the report came back from the binders with his penciled phrase partially cropped, obviously a phrase he thought much of, he proceeded to write it in again, this time in ink. 🕊

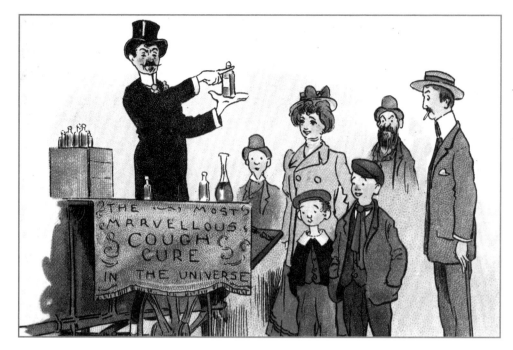

Detail from *Street Scenes:
The Quack Doctor and Some
Mugs*, c. 1909
GEORGE DAVEY (English)
Color relief print postcard;
3 9/16 x 5½ in. [9.1 x 14 cm]
Printed in Germany

The Quack.

Quack is a pejorative term, disparagingly, albeit sometimes defensively,
applied by a member of the establishment, the orthodox, regular, professional,
credentialed and accepted class to describe the unorthodox, unlicensed,
disapproved member of a fringe or irregular group. It is a term of condem-
nation employed when one wants to belittle another. Above all, the term has
become associated with the sellers of medicines and the marketers of medical
systems, those with the "true" method of curing specific ills or, in an earlier
day, *all* the ills of mankind. As noted above, no one has ever referred to
himself or herself as a quack, but it is always a loaded word applied to others.
Thus physicians, surgeons, apothecaries and other health professionals have
invariably held their own views on who was and who was not a quack.[1]

But quacks, too, entered the fray from the earliest times, hurling the word "Quack" at their rival medicine sellers. Even reputable physicians were not above accusing their associates, rationalizing that any unduly successful fellow practitioner might be naturally suspected of quackery if he succeeded more than his colleagues. It is not too difficult a tactic to point the finger at someone else in the competitive marketplace. Indeed, in eighteenth-century England and in nineteenth-century United States the use of the epithet was overdone by physicians attacking each other, and thus the term lost some of its sting when applied to the quack who was plainly a charlatan.[2]

While the origins of the term are obscure, the term "quack" probably came from the Dutch *Quacksalber,* a charlatan, mountebank, empiric or itinerant seller of medicine. It may also have been derived from the sounds made by a duck, the term being applied to the hawker of nostrums whose excessive zeal in describing the merits of his or her cure may well have sounded similar to the squawking of a duck. *The Oxford English Dictionary* traces the term to the seventeenth century, as "an ignorant pretender to medical skill, one who boasts to have a knowledge of wonderful remedies, an empiric or imposter in medicine." The chatter of the quack, in most cases more like torrents of words, would have been familiar to both town and rural populations even in ancient periods, for quacks have long been well known in every society. Over the past four hundred years they have been representative figures in folktales, stories and especially in prints, drawings and political caricatures, where anyone with whom the artist disagreed was a quack.

Up to at least the last third of the nineteenth century when medical science and understanding began to make significant strides, a patient's progress might show similar results under treatment from either regular physicians or fringe practitioners; the healing power of nature recognized no sects. While the

fringe was primarily constituted of men and women who sold medicines, there were others in it as well. Bonesetters, astrologers, wisewomen, cunning folk, and in Catholic countries, pretended saints were members of this large and heterogeneous group. Some historians fix the date when a random patient might benefit from a random physician in treating a random illness even later than the mid-nineteenth century, but in prior periods one could not hope for superior results from either group, regular or irregular.[3] Indeed, many of the basic therapeutic approaches used by the unorthodox were similar to key agents in the pharmacopoeias, relying on opium, mercury, antimony, quinine, various laxatives and only a few other medicines for their effects. Despite this, however, attacks on quacks were routine, at times becoming major efforts by established physicians and their spokesmen to rid society of those inflicting harm. It would be tempting to separate the fringe practitioner into two groups—those who sincerely believed that their nostrums and their methods were efficacious and those who knew from the outset that they were vendors of worthless rubbish— but such motivations are impossible to uncover, and one cannot look into the minds of men and women after such a long period of time and in the absence of convincing records. Moreover, in marked contrast to certain of their establishment rivals, individual quack practitioners did not leave records and archives. In truth, it is more realistic to view the rivalry between the regulars and the irregulars before medical science began its relatively recent advance as straightforward free-market competition. In a pluralistic world, patients, especially those who could afford to do so, visited both the regulars and irregulars often for the same acute or chronic condition. There is evidence that Cardinal Richelieu, Louis XIV and Louis XV were attended by both quacks and regular physicians for their terminal illnesses; James Boswell also patronized both for repeated attacks of gonorrhea.[4]

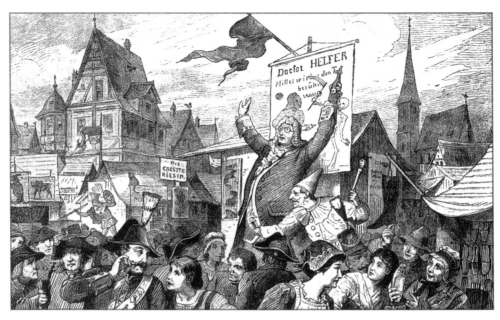

Detail from
Doctor Helfer, c. 1885
ANONYMOUS (German).
Steel engraving;
5¹¹⁄₁₆ x 5¼ in. [14.4 x 13.3 cm]

Identifying Quacks.

If motivation could not be a defining characteristic, there were still certain attributes which separated quacks from regulars. For one thing, quacks were generally itinerants before the nineteenth century, going from town to town to sell their nostrums, seldom staying long in any one location and thus not being available should problems occur with their recommendations. Many had circuits on which they traveled repeatedly. Vestiges of the migratory nature of their ancient profession continued even into the twentieth century with medicine show troupes traveling throughout the United States and Canada, and several medicine show pitchmen identically named Sequah, accompanied by groups of Indians, traveling through Europe.[5] Because of the quacks' lack of stability, they could not even attempt an understanding of a patient's clinical history and thus could not hope to build strong relationships

with their clients. In this, physicians, apothecaries and pharmacists had a considerable economic advantage, for their repeated attendance on patients whom they personally knew meant that their fees could mount steadily, and that by remaining in one place a growing reputation could bring new clients as well. The itinerant medicine seller had neither personal relations nor a neighborhood infrastructure, which could bring continued business. At the same time, however, constant travel had a definite advantage. Fringe practitioners could rarely earn enough from sales in a limited area and thus moving around enabled these medicine sellers not only to expand their marketing region but also to avoid the intense competition in many towns and cities. But others were disadvantaged by the reputation of quacks. Itinerant tooth pullers, bonesetters and surgeons also followed established routes, and their varying levels of skill in carrying out their trades could not prevent many of them from being routinely identified as quacks along with sellers of medicines.

Quacks also advertised, which certainly brought an added advantage. They made widespread use of testimonials, words of praise from contented users. They relied on some type of authority to gain credibility, claiming, for example, to be the seventh son of a seventh son or to be the Famous High German Doctor. Such attributes, they claimed, gave them special healing powers. They made an elaborate show of their credentials, pasting evidence on walls behind their temporary stages or informing their audience in great detail of the royal patients and important celebrities they had cured. In the beginning their patter alone communicated the merits of their wares, but later written and printed handbills and larger broadsides and posters helped sell their products. Later still, newspapers and magazines spread their claims even more broadly. They published books and pamphlets too, often in multiple

editions. *A Guide to Health*, a book published by Samuel Solomon as a vehicle to promote his Cordial Balm of Gilead, was claimed by its author to have gone through sixty-six editions in the eighteenth and early nineteenth centuries, and while there may not have been this exact number, there certainly were a good many, both because the book was popular and the press runs small.[6] Solomon's hyperbole too was a characteristic of the quack, for he tended to claim excessive virtues for his nostrum that at times defied reason. For many panaceas there was not a disease that could not be cured nor a patient whose condition could not be improved by taking just a few doses. Such excesses continued; in the late 1880s, for example, printed advertisements for Dr. Thomas's Eclectric Oil repeatedly and extravagantly claimed that it would positively cure earache in two minutes, toothache in five minutes, and deafness in two days. A trade card for a New York City dentist claims he has "administered gas and extracted thirteen teeth and roots in less than three-quarters of a minute—the same being replaced at once with artificial teeth," adding that "to appreciate the skill of such operating, one must see it performed."[7]

Quacks generally did promise too much. They could heal anything, their remedies certain and infallible, even when all else failed. They would promise painless cures with non-invasive and non-injurious methods and such cures might even be offered for tumors or stones in the kidney or bladder. Patients would be told that they had an incurable disease that only the secret or magic ingredient in the nostrum could cure; nature being the best healer, such advice was often valid and effective. They employed odd techniques—studying the urine in a flask to diagnose a patient's illness or examining astrological charts to determine proper dosing. They would offer terms—no cure, no money—for example. Many were superb salesmen,

using their linguistic skills to sell products of often doubtful merit, stirring the emotions of their audiences with the techniques of successful evangelists. Not surprisingly, there is evidence that men and women have worked both as preachers and as medicine sellers, and one eighteenth-century print, *A Laudable Partnership or Souls and Bodies Cured Without Loss of Time* (p. 85) illustrates the occupational dovetailing.[8]

In contrast to their competitors, the regulars, quacks invariably had little education and certainly little or no medical training. Most were not qualified to practice, had rarely been enrolled in medical colleges or a university, had not undergone proper apprenticeship, had no bona fide medical degrees, diplomas or certificates, nor were they licensed.[9] But as is typical in the competitive marketplace where there are few absolutes, there were exceptions. Certain of those who developed manipulative skills, the bonesetters, tooth pullers and surgeons did serve apprenticeships. A small number of better known charlatans did have authentic medical degrees, the leading example being John Taylor who called himself Chevalier Taylor and traveled throughout Europe couching for cataract, steadfastly proclaiming his unsurpassed skill. Although not all his operations were successful, he developed several innovations in ophthalmology and treated well-known patients including the composers Bach and Handel. Lack of credentials did not stop itinerant medicine sellers from calling themselves doctors, however, and they used this title with impunity; many quacks, including William Brodum, Samuel Solomon and Ebenezer Silby bought their M.D.s from the Scottish universities Saint Andrews or Aberdeen.[10] And the word "doctor" was employed in the brand names of a number of popular nostrums on both sides of the Atlantic.

Itinerant medicine peddlers provided entertainment and showmanship, attracting crowds to listen to their promotional messages. Quacks often were

flamboyantly dressed, energetically holding forth from a stage or platform or from the front of an elaborately designed coach or chariot to appeal to potential purchasers. The stage and chariot served to set up a private space for them to sell their wares, but without them lower-grade charlatans either used a small stand or merely threw their coats on the ground. Others employed clowns, musicians, magicians, dancers and acrobats. Such entertainment perhaps began with the earliest quacks. Girolamo Ferranti, a seventeenth-century itinerant, probably the creator of Orvietan, a major nostrum that purportedly prevented poisoning, employed the alluring Vittoria who, cleanly and neatly dressed as a young boy, "attracted large numbers of people running to her, with the somersaults she does, her divine dancing and singing"; such individuals were soon tempted to purchase Ferranti's panacea.[11] The music and the noise had an additional effect in that it helped to override the cries of pain usually encountered in the work of toothpullers. In their combined aspects of both the healing and the performing arts, these itinerant showmen provided an amalgamation that had later manifestations in the nineteenth-century American medicine show and in twentieth-century television programs. In recent times the itinerant nature as well as the flamboyant behavior of the medicine seller has largely subsided, but showmanship and creative advertising programs for proprietary medicines continue as essential factors in the sale of successful products. ❦

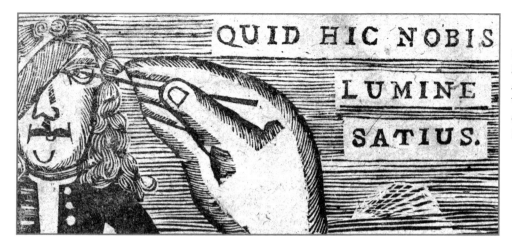

Detail from *Quid hic nobis lumine satius*, c. 1670
ANONYMOUS (Engish?)
Woodcut trade card for oculist; Sheet 3⅛ x 5⅝ in.
[7.9 x 14.3 cm]

Common Traits.

Despite the fact that there were certain qualities by which one could identify a quack, there were many other characteristics shared by both regulars and irregulars. Differences were often in style rather than kind and boundaries were often difficult to trace. The farther back in time one goes the greater the blurring of distinctions between members of the two groups. Thus there are no reliable methods to distinguish between honest empirics and immoral quacks; all one can do is judge each according to his or her merits. Both regulars and irregulars tried to develop trade symbols—wigs, canes, carriages, bottles containing colorful liquids—to set themselves apart. The elaborate packaging of patented and proprietary preparations was matched by the splendid bottles and jars of the apothecaries' shops.[12] Even reputable physicians advertised to some extent, announcing changes of address, new hours of consultation or other events, and used published statements to call attention to their activities. Both groups also developed strategies to spread information about their exploits by word of mouth.

Although the quack's stock in trade was the secret nostrum, certain well-known proprietary medicines such as Dr. James's Fever Powders, Dr. Radcliffe's Royal Tincture and Dr. Hooper's Female Pills, three well-known British products, were developed and marketed by establishment physicians. The late seventeenth-century physiologist Nehemiah Grew (1641–1712) patented Epsom salts, and the founder of the Royal Society, Sir Hans Sloane (1660–1753) marketed a salve for the eyes. In 1832, Dr. John Sappington, a graduate of the University of Pennsylvania, successfully marketed his own Anti-Fever Pills, perhaps the earliest proprietary medicine to contain quinine.[13] Physicians, as well as those without formal medical training, developed and promoted radically new medical ideas. Franz Anton Mesmer's (1734–1815) animal magnetism and Samuel Hahnemann's (1755–1843) homeopathy were two significant examples formulated by licensed physicians. While those in the fringe group boldly published pamphlets as advertisements for their specialties, certain orthodox physicians were not above publishing seemingly detailed treatises on medical questions with elaborate title pages that were little more than advertisements for themselves. Such works also frequently gave the address of the author, a thinly disguised means of informing prospective buyers of the place where the specialty might conveniently be purchased. William Sermon, a seventeenth-century British physician, published two pamphlets which were in large part devices to keep his name before the public.[14]

Both quacks and regulars relied on the same few effective agents in their prescriptions; the differences between both groups essentially lay in slight variations of their routine use of the same ingredients. Both used mercury in the treatment of venereal disease and antimony as a febrifuge, even though the medicine sellers denied that their products contained

such powerful agents. Both made heavy use of opium and its derivatives as analgesics. Opium was the chief ingredient in many nostrums including Dover's Powders, Starkey's Pills and Matthews' Pills and morphine was the active principle in Mrs. Winslow's Soothing Syrup, recommended by its manufacturers for teething children. Laxatives, universally employed by both groups, included rhubarb, jalap, gamboge, aloes and related vegetable drugs listed in official compendiums; these were always popular ingredients in proprietary medicines because the user had early evidence of their effectiveness. Beyond these few steadfast constituents of the *materia medica*, the majority of what was prescribed by both groups, at least until the late nineteenth century, had little more than a placebo effect. Medicine sellers often boasted that the basis of their formulations came from such respectable and approved agents listed in the pharmacopoeia, and frequently used this fact as a promotional tool.[15] Then, too, quack nostrums such as Ward's Pills in England and Brandreth's Pills in the United States were prescribed often by regular physicians, giving added cachet to items many regulars felt should have been shunned. Ultimately, treatments and prescriptions by either regulars or irregulars were relatively unreliable at least until the mid-nineteenth century, until medical science progressed sufficiently to be able to make a significant difference in the care of the sick.

More often than not, fringe medicine sellers kept the ingredients secret while the established physicians prescribed openly. But this was not always the case, and the orthodox did, on occasion, keep their prescribing to themselves. Such secrecy was universally deplored. The fact that physicians wrote their prescriptions in Latin, a language that the majority of their patients did not understand, was often criticized as being similar to the secrecy with which quacks surrounded their formulations. "Quackery is

founded on ignorance," wrote William Buchan, adding "the man who writes a medical prescription, couched in mystical characters and in an unknown tongue, countenances quackery, the very existence of which depends on disguise."[16] Finally, the orthodox and the fringe practitioners were not always at loggerheads. In the seventeenth and eighteenth centuries when wealthy patients used members of both groups to treat an illness, there were common consultations. There is evidence too that certain well-known British quacks such as William Brodum and James Graham had regular physicians dine at their table.[17] 🐝

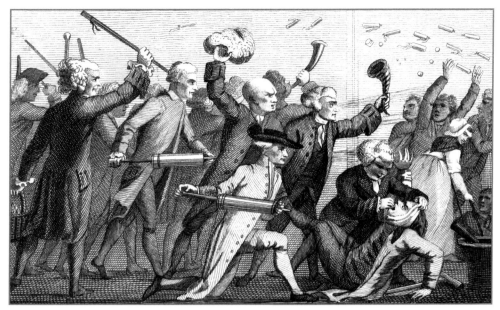

Come on! Begin the grand attack...,
c. 1804
H. SINGLETON, revised by
Barralet, after S. Seymour (English)
Engraving; plate 5 x 6⅜ in.
[12.7 x 16.2 cm]
From Thomas Green Fessenden's
Terrible Tractoration!!

Regulars vs. Irregulars.

Despite many common characteristics, there were distinct areas of conflict between the orthodox and the fringe. It is most important to realize, however, that hard and fast lines between the two groups have always been difficult, if not impossible, to draw. There remains a muddy and variable border separating them and at times the same individual might pass from one group to another. Further, neither regulars nor irregulars were static in their practices, and both their behavior and their skills changed considerably over time. While regulations began to be enforced in the middle of the nineteenth century, bringing about a marked division between the two groups, there was little to prevent the unlicensed from practicing and dispensing in earlier periods. Before the needed changes, the fact that unlicensed individuals could offer any sort of competition to the licensed physician was obviously not an

ideal situation to those properly qualified. Nor was the continuing interest in self-treatment by patients, a long-running trend which many physicians felt to be crucial to the proliferation of quackery. Such treatment was a necessity to the early settlers in America both because of the small number of trained practitioners, and the long distances between physician and patient, as well as for economic reasons. Indeed, *Every Man His Own Doctor* was the earliest medical handbook for laypersons written and published in America, first appearing in 1734. Books such as this encouraged individuals to take medical care into their own hands, and thus contributed to the growth of the nostrum trade.[18]

The commercial success of patent medicines brought both an economic and a cultural threat to physicians because sales of these products constituted an incursion on professional incomes and scientific authority. Successful proprietary products diminished the need for the professional services of physicians, apothecaries and pharmacists. This was further compounded when clients, especially influential clients, let it be known that they were pleased with the results of such products. Referring to his admiration for Dr. James's Fever Powders in a letter written in 1764, Horace Walpole said, "I have such faith in these powders that I believe I should take them if the house were on fire." During one of his many bouts with gonorrhea, James Boswell made a trip to London to take a course of Kennedy's Lisbon Diet Drink, a much-advertised nostrum for venereal disease. And Lord Byron extolled the virtues of both Acton's Corn-Rubbers and Opodeldoc Ointment.[19]

As the established and more powerful class, the regulars generally saw patent medicine men as agents of duplicity and disrepute, selling dangerous remedies at inflated prices by means of excessive advertising to an unsuspecting public.[20] Further, the regulars were invariably in a more powerful position, attributing ethics to themselves alone, setting rules and standards both locally

and nationally and acting under the assumption that only the orthodox were authorized to resolve medical issues. In early modern Italy, organized medical bodies issued licenses to itinerant medicine sellers in Rome, Venice, Mantua, Sienna, Turin, Verona and other cities as well, normally granting permission to those selling external remedies but denying licenses to many who proposed products meant to be taken internally.[21] The difficult question to answer in the period before the middle of the nineteenth century was whether such decisions were based on the reasons cited or on the competitive economic peril represented by nostrum sales. Similar bodies existed in France, where official permission was often needed for itinerants to set up their stages.[22] This was the case in other European countries and was even to be found in the United States in the twentieth century; for example, a license was issued to the peripatetic medicine seller A.W. Lithgow for the sale of his liniment by the authorities in Burlington, Vermont, in 1922 upon payment of a $2.00 fee.[23] At times, as when the Royal College of Physicians of London had the power to exclude those lacking its license from practice in the eighteenth century, they tended to turn a blind eye to unlicensed practice rather than pursue highly unpopular and futile attempts to enforce their legal monopolies.[24]

What were the concerns of the regulars? To them quacks were empirics, illiterate, ignorant, often foreign, those "who cried up their goods in the market, surrounded by zanies and monkeys, jokes and buffoonery, those who pasted bills upon walls, who puffed their wares in newspapers, who circuited the nation, who mass-marketed cure-alls and cathalicons."[25] They went about their business pretending to be doctors but had no formal education, in contrast to licensed physicians, surgeons and apothecaries who undertook often lengthy courses of study or, for the majority of the regulars who had no university training before the eighteenth century, apprenticeship.

They marketed secret formulas, which at times did more harm than good, and did not understand the theories underlying their products or treatments. They offered panaceas, universal cure-alls, an impossibility under any circumstance; they gave them high-sounding names, claiming they came from foreign lands. They falsely claimed their nostrums to be made of expensive and rare ingredients. They made up testimonials and created new diseases that did not really exist. They cleverly associated themselves with Copernicus, Galileo, William Harvey and other famous scientists whom they claimed were similarly attacked as frauds by their contemporaries. They sold medicines without any regard for the patient's medical history and without any concern for specific dosages, which should be tailored to the individual patient's condition and perhaps even modified daily. All of these accusations were used not only by the physicians, but at times by supporting journalists as well, in a continual but ineffective battle to marginalize the irregulars. In more recent years when medical understanding had improved there was a more telling and most necessary criticism—that delays in having a well-trained professional attend a seriously ill patient might have serious consequences. At times, establishment physicians openly accused fringe practitioners. In 1804, the eminent British physician John Coakley Lettsom (1744–1815) used the pages of a medical journal to attack the considerably less educated William Brodum (p. 173); Lettsom was eventually forced to retract his condemnation.[26]

But there were also concerns on the other side, with members of fringe groups criticizing the orthodox because of their heroic therapy, their excessive use of bleeding, their purging and their disproportionate prescribing of calomel. Such criticisms were heightened in the nineteenth century when many sectarian approaches such as phrenology, hydropathy, homeopathy and Thomsonianism became popular, when orthodox doctors

were called mineral doctors, mineralites, mercury dosers, drug doctors, calomel doctors, knights of calomel and other names. Critics saw individuals such as the "uneducated and unlicensed bone-setter as an early democratic symbol of protest against the arrogance of the orthodox medical specialists."[27] Visual representations of orthodox physicians at the time depicted them brandishing oversized lancets in bellicose poses, pressing poisonous pills on an innocent public, or mindlessly preparing drugs.[28] Political caricatures have always been especially savage in their treatment of physicians and apothecaries; in no case were their patients, normally the government in power or the nation itself, ever improved by orthodox treatments. Beyond such conflicts between the two camps there is, not unexpectedly, additional evidence of internecine rivalry between regular and regular and quack versus quack. To nostrum manufacturers, it was of constant importance to stress their credentials and they did so in their promotional pieces; a good example of this came late in the nineteenth century when a Vin Mariani booklet was boldly titled "The Effrontery of Proprietary Medicine Advertisers."

Because quacks did their best to imitate the ways of orthodox physicians in presenting theories and therapies in common, it frequently became difficult for clients to distinguish between the two. In unsophisticated times the results of treatment might well have ended the same anyway, but this is not to say that there was no difference between the orthodox and the fringe. Certainly their knowledge of anatomy and their superior skills in diagnosis separated trained physicians from their irregular counterparts, and these skills were at times decisive to the eventual outcome of a patient's illness. But in terms of the effectiveness of their therapy, members of both groups were capable of producing similar results. Finally, because of the wide disparity among medical training programs, from rural apprenticeships to

[29]

years spent at major universities such as Oxford, Padua, Paris, Montpellier and later Edinburgh and Leyden, there was often a greater difference among individual orthodox physicians than there was between the mass of empirics and their licensed counterparts. Matthew Ramsey, in his extensive study of French medicine, pointed out that "the best medical practice, unlike that of empirics, was grounded in an excellent grasp of anatomy and an improving understanding of physiology and pharmacology; and it reflected the accumulated clinical experience of European medicine, disseminated not only in courses, but also in the burgeoning medical periodical literature. The highly qualified physician was a far more skilled diagnostician than the empiric … and the trained physician was far likelier than the empiric to use dangerous drugs judiciously." [29] 🕭

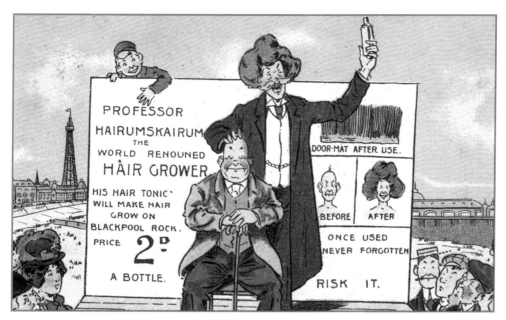

Detail from *Pa Getting Fresh Air at Blackpool*, c. 1905
ANONYMOUS (English)
Color relief print postcard;
3 9/16 x 5½ [9.1 x 14 cm]
Printed in England

Drugs on the Market.

For most of human history the quacks outnumbered the regulars. After all, the selling of medicines was an easy occupation to join and one with minimal specialized knowledge to obtain. There were no barriers to entry. As the editor of the Portsmouth, Ohio, *Journal* put it in 1824, "Any idle mechanic not caring longer to drudge at day labor, by chance gets a dispensatory, or some old receipt book, and poring over it, or having it read to him…he finds that mercury is good for the itch, and old ulsers [sic]; that opium will give ease; and that a glass of antimony will vomit. Down goes the hammer, or saw, razor, awl, or shuttle—and away to work to make electuaries, tinctures, elixirs, pills, plasters and poultices."[30]

Formulas were easy to come by. One could copy the prescriptions of reputable physicians or one could turn to pharmacopoeias, dispensatories or

books giving formulas for various conditions. Even illiterates were not frozen out, for they could ask someone to find an appropriate remedy. One might even do what William Radam did in preparing his Microbe Killer—just add some coloring and flavoring to plain water.[31] It was important to emphasize the mild nature of the nostrum, in order to contrast it with the harshness of mercury and other agents in the arsenal of the orthodox prescriber. This was of special significance in cures for venereal disease where proprietary medicines were invariably advertised as "containing no mercury," but on occasion analyses of their formulas revealed this to be untrue. Such products were advertised as being "safe, pleasant and effective, without confinement or hindrance to business and capable of being concealed even from close associates." These were vital considerations to many victims who demanded confidentiality.[32] In the same vein, it was essential to emphasize that the ingredients in the promoted preparation were of vegetable origin in contrast to the chemical nature of calomel and preparations containing antimony. The effects from the naturally-occurring vegetable ingredients were considered to be less drastic, but as the many side effects of high doses of Morison's Vegetable Pills, often chronicled in great detail in the pages of the British medical journal, *The Lancet,* showed, vegetable cathartics could be as dangerous as any abrasive chemical.[33]

Until entrepreneurs such as James Morison and Samuel Thomson came along in the early nineteenth century with their own specialized preparations following the novel theories they had originated, nostrums offered by the medicine sellers closely followed those used by the regulars. The strategy of the proprietary medicine vendors was to offer a ubiquitous and less expensive substitute for accepted drugs and to sell interchangeable products. Many of the popular British specialties, widely sold in the colonies prior to

the War of Independence—Anderson's Scott's Pills, Dalby's Carminative, Daffy's Elixir, and others—were, "in the nature of their composition blood brothers of preparations in the various pharmacopoeias and formularies."[34] Thus there was often little measurable difference in medication, whether prescribed by doctors or quacks, since both offered products that were capable of relieving symptoms and, on occasion, providing a placebo effect.

As is the case today, brand names were significant catalysts to sales and great importance was attached to them. Hippocrates, Galen, Boerhaave, Louis Pasteur, Paul Ehrlich, Richard Mead and countless other reputable physicians and scientists have had their names attached to nostrums to give them cachet, in some cases without benefit of the celebrity's approval (p. 183). But even without using specific names, the appellations "Doctor" and "Saint" were invoked regularly. Until the nineteenth century, Latin names such as the Pilulæ Radii Solis Extractæ of Lyonel Lockyer (p. 90) also carried with them a higher level of importance. There was always the appeal of the exotic and the remote, and a hundred years ago American shoppers could find products, or at least brand names, stressing their origins from Japan, Russia, Turkey, Venice, East India, Castille, Mecca and many other foreign locales.[35] To those in the United States, Native American names such as Wright's Indian Vegetable Pills, Modoc Oil and Kickapoo Indian Sagwa seemed to have special powers, evoking the charm of the noble savage. Their use proliferated in the years after the Civil War. Finally, even if the brand names did not include the famous, royalty, saints or Indians, the extensive advertising copy surrounding their marketing often discoursed on the products' potency and curative powers at great length. Whether they were compounded by quacks, establishment doctors or by the marketing firms that began to proliferate in the nineteenth century, it is important to realize

that proprietary medicines were among the first standardized, nationally marketed, brand-name products. In the history of mass production and distribution of manufactured products in the early history of the Industrial Revolution, proprietary medicine vendors played a significant innovatory role.[36] Their packaged goods, presented as standardized, were accepted by consumers because they were purportedly reliable, milder than the doctor's prescription, easy to take and provided the means for personalized choice and personalized administration. These were desired qualities that enabled men and women to take care of themselves without requiring professional help. The manufactured products usually cost less than compounded prescriptions, because mass-produced pills, to take only one example, were cheaper to make than those hand rolled by the pharmacist by the dozen. And even though almost all therapeutic advances were made by such establishment physicians and scientists as Edward Jenner, Friedrich Wilhelm Setürner, Joseph Caventou and Joseph Pelletier, once in a while members of the fringe were also able to make significant contributions. The Eau Médicinale of Husson, the earliest available use of colchicine in gout, is a prime example. ❧

Detail from *Analogous*, 1885
CHARLES GREEN BUSH,
(American)
Steel Engraving from
Harper's Weekly; 5½ x 4½ in.
[13.9 x 11.3 cm]

Advertising.

Before printing, nostrum sellers had only their skills at drawing
a crowd and their patter to convince the public to buy. Handbills and
broadsides, beginning in the sixteenth century, expanded their markets
considerably. Books and pamphlets conveyed more extensive product claims,
and later in the eighteenth century, newspapers and journals expanded sales
possibilities still further. Early handbills were crudely printed, crammed with
words, their layouts poor and their typeset statements rarely relieved by any
image. They often contained long lists of diseases treated and longer lists
of their products' successes. Their writers often attacked rival products with
statements that had earlier been applied to themselves. Directions to find the
proprietor or an agent were mandatory, as were notices that the product had
to bear the signature of the owner, all others being counterfeit.[37] At times
there was poetry, as in a late-seventeenth-century London bill:

"Good News to the Sick. Over against *Ludgate* Church, within *Black-Fryers* Gate-way, at *Lilies-Head*, Liveth your old Friend Dr. Case, who faithfully Cures the Grand P—, with all its Symptoms, very Cheap, Private, and without the least Hindrance of Business. *Note*. He hath been a Physician 33 Years, and gives Advice in any Distemper *gratis*.

> All ye that are of *Venus* Race,
> Apply your selves to Dr. *Case*;
> Who, with a Box or two of PILLS,
> Will soon remove your painful ILLS." [38]

Daniel Defoe described the seventeenth-century urban scene, recording "how the Posts of Houses, and Corners of Streets were plaster'd over with Doctors Bills, and Papers of ignorant fellows; quacking and tampering in Physick, and inviting the People to come to them for Remedies; which was generally set off, with such flourishes as ... Infallible preventive Pills against the Plague. Never Failing Preservatives against Infection. Soveraign Cordials against the Corruption of the Air. Exact Regulation for the Conduct of the Body, in case of an Infection; Antipestilential Pills. Incomparable Drink against the Plague, never found out before. An Universal Remedy for the Plague. The Only-True Plague-Water. The Royal-Antidote against all Kinds of Infection ..." [39]

Later, in newspaper and journal advertising, marketers stressed the scientific pedigree and medical skill of the nostrum's discoverer, and his or her association with royalty, with aristocracy or at least members of the upper class; the product's approval by establishment organizations; and past patronage by celebrities. The products were invariably safe and rapid in showing results. Until the nineteenth century, marketers expended great

effort to show that the product contained similar agents prescribed by regular physicians. At the same time, however, they stressed that the advertised specialty was safe, its action mild, and its formula free of harmful chemicals. The promotional appeal in these bills was often based either on inciting fear and anxiety or on raising hope in the readers' minds. These psychological approaches were, at times, accompanied by altruistic statements that the interest of the marketer was solely motivated by the public good and not at all by potential profits. When stamp duties were imposed, as in England in the eighteenth century and in the United States during and after the Civil War, proprietary medicine marketers used the presence of the stamps on their packages to suggest that the government gave the product official status and consequently its approval. Samuel Thomson, for example, used the fact that he received patents for his medications and for his medical system to claim that the President himself had guaranteed its efficacy.[40] Such creative and, at the same time, brazen acts have typified medicine sellers throughout their long and colorful history.

Testimonials expanded on these themes. Although they could come from anyone, those most preferred were signed by well-known physicians whose imprimatur was certain to be reflected in increased sales. William Swaim included a positive recommendation from the well-known and respected University of Pennsylvania professor Nathaniel Chapman (1780–1853) in his 1833 book, "A Treatise on the Alterative and Curative Virtues of Swaim's Panacea," (p. 75) until Chapman himself ordered Swaim to desist. Nonetheless, Swaim got at least four good years out of Chapman's original statement. Celebrities, clergymen and holders of political office were also valued as signers of such puffs but, in the absence of anyone else, successful users, either real or imaginary, would do. There were even merchants who

developed a business in supplying batches of testimonial letters, some generic, which could apply to any product in any therapeutic class. Certain proprietary products depended on testimonials as the backbone of their promotion. Angelo Mariani (1838–1914), for example, the discoverer and proprietor of Vin Mariani, got the approbation of more than 1,400 *fin de siècle* celebrities by his own original and creative measures. Mariani sent each a case of a dozen bottles and when a letter of thanks arrived, he published it along with a portrait and biography of the recipient. His list included popes, presidents, kings and queens, as well as notables such as Sarah Bernhardt, Thomas Edison and the composer Charles Gounod.

Newspapers, when they were first published, not only broadened the geographical horizons of the medicine sellers but they also brought with them a more literate and sophisticated audience. They began to grow in importance in the eighteenth century and soon enabled such pioneer British products as Dr. James's Fever Powders, Daffy's Elixir and Solomon's Cordial Balm of Gilead to be noticed in millions of copies of newspapers each year in the United States as well as in their native land. The same or similar advertisements would be placed in each issue of the newspaper. This continual repetition reinforced brand names in the minds of prospective purchasers. The flamboyant statements so prominent in earlier handbills had to be toned down for such readers, but advancing levels of understanding also played a part in upgrading the level of nostrum advertising. From the earliest days of newspapers, proprietary medicines were among the few brand-name products advertised, most of the space being filled by local merchants and services. Such advertising was essential to the success of newspapers and magazines which had space to fill, a particularly serious problem for rural publications and those with a small circulation devoted to special interests. By 1879 in the

United States there were more than 400 religious weeklies, each with the need for the steady flow of advertising revenue to keep them afloat. To emphasize the point, one editor confessed that without nostrum advertising, his paper would need two thousand subscribers rather than just a few hundred. It is probable that by the beginning of the Civil War advertising for popular medicines accounted for half of all the profits made by the American press: the newspaper made the patent medicine business and the medicine advertisements sustained the newspaper.[41]

At the same time, newspaper owners were continually taken to task for permitting almost anything to be claimed in their pages. Even before the Civil War, one physician complained about the papers abetting the fortunes being made by Swaim, Moffat, Perry Davis, and others who "are pursuing a similar course, and are reaping the same golden harvest. And all this is done because the American Press is under no legal or moral restraint, and is ever ready, for money, to aid imposters in deceiving and defrauding the public. By these means, men with a smattering of medical knowledge, or none at all, often become rich, whilst many learned and worthy men remain poor for no other crime than being honest."[42] 🐜

Detail from
The Great Lozenge Maker, 1858
JOHN LEECH (English)
Steel engraving;
9¼ x 7³⁄₁₆ in. [23.5 x 18.3 cm]
From *Punch*

Growth & Decline.

Quacks have been with us forever. In earlier historical periods, their number frequently exceeded the regulars. A study of the tax rolls of Paris in the thirteenth century counted 38 charlatans but only six physicians in a population of about 16,000. In the middle of the nineteenth century in Wisconsin there were three quacks to every regular. A later 1866 New Jersey survey reported "596 'regular' practitioners and 151 'irregulars' in the state. The 'irregulars' numbered 60 homeopaths, 36 eclectics, six Thomsonians, five Botanics, six 'electricians,' five cancer doctors, five clairvoyants, three root doctors, two of the 'Swedish movement,' two hydropaths, one Indian doctor and one 'inhalation' practitioner."[43]

Of the major Western countries, France, Italy, the Dutch Republic and Spain had always had controls. They insisted that quacks' activities be more or less circumscribed, acknowledging that quackery could never be eliminated and thus must be carefully regulated.[44] These controls never were universally efficient, however, operating quite well at certain times and places and much less so at others. But even with such an uneven regulatory apparatus, these European countries were able to avoid developing a free-wheeling marketplace where health practitioners of all stripes actively competed with each other for patients. It was far different in England and the United States, countries which had to await more recent times to provide some measure of control. As a result there were periodic public complaints that each country was overrun with quacks. Until the 1858 passage of the Medical Registration Act in England, anyone could claim to be a practioner of medicine; until 1809 in France it was not a simple matter to prevent the unlicensed from offering medical treatment, and up to 1842 in the United States, only four states— New York, New Jersey, Louisiana and Georgia—had any laws at all regulating medicine.[45] After these years it began to be somewhat easier to exclude the irregulars from the body of qualified physicians and apothecaries.

In the 1880s in the American Midwest one could distinctly identify different kinds of "doctors" in addition to the regulars, including eclectic, botanic, homeopathic, uroscopian, Thomsonian, hydropathic, electric, faith, spiritual, herbalist, electropathic, vitapathic, botanico-medical, physio-medical, physioelectric, hygeo-therapeutic and traveling. And this probably does not exhaust the list.[46] The reference point for the behavior of quacks and of all medicine sellers has always been the orthodox physician; in such comparisons, the fringe practitioner is forever found wanting. But if the marketplace is used as the reference point, the unorthodox will be discovered to be those who

developed many new marketing, publicity and advertising techniques; fashioned the arts of persuasion and salesmanship; created novel distribution systems; pioneered the emphasis on brand-name products; served as an economic link between the hinterland and the urban center; expanded markets; and helped to provide the entrepreneurship necessary for the growth of modern society. Until the nineteenth century, they did this in a world of limited medical knowledge with only a small number of effective pharmaceutical agents, and in the face of considerable opposition from those who thought they recognized better approaches. Nostrum proprietors learned how to become effective advertisers when technological advances in printing techniques provided them with new media in the eighteenth and nineteenth centuries, not only newspapers and magazines, but also illustrated broadsides, chromolithographed posters and eventually billboards, radio, television and the Internet. In many ways the larger United States nostrum manufacturer "during the early decades of the nineteenth century, blazed a merchandising trail. He was the first American manufacturer to seek out a national market. He was the first producer to help merchants who retailed his wares by going direct to consumers with a message about the product. He was the first promoter to test out a multitude of psychological lures by which people might be enticed to buy his wares. While other advertising in the press was drab, his was vivid; while other appeals were straightforward, his were devilishly clever. The patent medicine promoter was a pioneer, marching at the head of a long procession of other men with ships and shoes and sealing wax to sell."[47]

Showmanship and salesmanship were sufficient ingredients for the nostrum seller's success until early modern times. Based on the then-popular humoral theories that stressed proper balance, the majority

of nostrums sold in Europe were promoted as cures for almost everything. But by the eighteenth century, individual specialties such as worm killers, scurvy cures, venereal disease cures and the use of electricity began to predominate at the expense of such panaceas. With continued industrial and technological developments in the nineteenth century these concepts were not enough. The last third of the nineteenth century was critical in the formation of a strong medical profession and advances in pharmacology and physiology began to separate the orthodox from fringe practitioners, bringing with them a greater understanding of what pharmaceuticals could and could not do. The mid-century years also marked the beginnings of the ethical pharmaceutical industry, the promotion of pharmaceuticals exclusively to physicians and other health professionals.

To distinguish themselves from the continually growing crowded world of proprietary medicines, nineteenth-century manufacturers and other entrepreneurs launched a variety of novel approaches. Among the most important innovators were James Morison whose cathartic vegetable pills were touted as the only product necessary to cure all the ills of mankind; Samuel Thomson, whose system suggested that all disease is the result of one basic cause (cold) which may be removed by one general remedy (heat, aided by botanicals, principally *lobelia inflata*); and Samuel Hahnemann, whose homeopathy offered infinitely small dosages of botanical ingredients and a theory that like cures like (*similia similibus curantur*). These new sectarian systems were introduced in both Europe and North America, each claiming to be the only true salvation for good health. Some of the therapeutic ideas of the later Victorian period took on rather fanciful concepts—ozone boxes, electric belts, hydrotherapy, and curing disease by passing light through a blue glass were typical examples. These systems were

proposed as alternatives to orthodox medicine, newly termed allopathic medicine, to distinguish it from its many rivals. Thomsonianism, hydropathy and homeopathy were especially well received in the United States, where not only their simplicity and relative low cost, but a chronic shortage of professionals especially in rural areas, provided economic opportunity. Each of these sectarian systems had their heyday and some, such as homeopathy, are with us still. But ultimately, as medical science advanced into more modern times, the cumulative impact of pathological anatomy, diagnostic technology, cell science and the germ theory of disease gave doctors the whip hand. As a result, almost all of these alternative approaches have faded away.[48] The eventual consolidation of treatment of the sick in the hands of the physician was established by denying legitimacy to competing medical systems and practitioners and, in a sense, can be looked at in two ways. As one author recently observed, "Idealists cast the triumph of medical professionalism as the protection of vulnerable clients from the laissez-faire jungle; cynics, or realists, regard it rather as the raising of a monopolistic, self-serving oligarchy upon the backs of the sick."[49]

 As the types of products changed, so too did distribution patterns. At first the only source was the mountebank who gave his or her consultations free of charge but insisted on direct payment for the products sold. In the early modern period, the handbills of the medicine seller specifically noted where products could be obtained. Later, newspaper advertising gave lists of agents and retail outlets, eventually leading to a variety of mail-order schemes. It is interesting to note the fundamental importance of publishers, booksellers, circulating libraries and stationers as agents and distributors for proprietary medicine sellers. From the earliest days of printing, these businessmen, who as a rule were the publishers of the handbills and

advertisements of the peddlers, were the ones who moved the nostrum packages along with their books and pamphlets. Indeed, John Newbery (1713-1767), a leading British publisher, was also the agent for several proprietary products including the famous Dr. James's Fever Powders, and he unashamedly found ways to use one activity in the service of the other.[50] Another such dual publisher-agent in England was the Dicey firm. In several incarnations, it sold books and proprietary medicines, mainly Dr. Bateman's Pectoral Drops and Daffy's Elixir, from a variety of locations, one called the "Daffy's Elixir and French Hungary Water Warehouse at Cluer's Printing Office."[51] Perhaps the best known in the United States, but not the only member of this group, was Benjamin Franklin whose *Poor Richard's Almanacks* carried advertisements for proprietary products. In the early years of the United States, the bookstore or stationer's shop also had monopoly rights on certain proprietary medicines. For many of these agents, the selling of such medicines was not merely an occasional sideline, and in many ways it was the development of reliable and wide-ranging delivery systems by the booksellers and publishers in both England and the United States that transformed nostrum sales from local or itinerant operations into a nationwide industry. When newspaper advertising grew exponentially in the nineteenth century, such agents became mandatory for it was then impossible for a single source of an advertised product to be sufficient.

Although it began in only a small way, by the growth of mass production in the Victorian era, advertising became ubiquitous in the more affluent countries of Europe and North America, and proprietary medicines were in the forefront. There were not only newspapers and magazines that carried this huge amount of publicity, but pamphlets, almanacs, sheet music, the sides of country barns, the interiors and exteriors of shops and the sides

of public transportation bore advertisements as well. Almost anything that could carry advertising did so; one could not get away from it. The excesses of promotion for proprietary medicines, as well as the hyperbole and untruths in many of their messages, caused a strong reaction and ever-increasing demands for greater transparency, therapeutic rationality and, ultimately, controls. This could have been expected, and even though there had always been demands to reign in the freedom of the charlatan to overpraise his own creations, the alarming levels of nostrum promotion brought new urgency to the need.

There were frequent anti-quackery campaigns in Europe whenever orthodox physicians were threatened or when crusading writers and publishers were aroused. In the United States, these drives began in earnest during the administration of Andrew Jackson. Success was slow in coming. In England, a Medical Register was instituted in 1858 to separate the regulars from the irregulars. Campaigns by several magazine editors and muckraking journalists in the United States after the Civil War, as well as by an increasing number of physicians, were instrumental in sensitizing the public to the dangers of nostrum use. Perhaps the main influences in the developing need for change were the continual developments in medical understanding and in patient care as the nineteenth century advanced. "The age in which major medical discoveries were made for the first time explaining much disease in a genuinely scientific way was the very age in which patent medicines reached their apogee. The period in which the medical profession acquired the knowledge to demonstrate beyond question the folly of quackery was the very period in which the nostrum business achieved the largest sales and the most unscrupulous promotion America had yet seen.[52]

Further, during these years there were concomitant advances in chemical and analytical techniques, permitting scientists to better understand the composition of proprietary medicines and thereby overcome the owner's insistence on secrecy. Studies of popular products showed high levels of alcohol, the presence of opium derivatives and various toxic agents. The resulting publicity brought considerable alarm to users. Such publicity, however, could not be disseminated in the overwhelming majority of newspapers in the United States because of their dependence on nostrum advertising. Nonetheless, through the pages of *McClure's*, *Colliers*, *The Ladies' Home Journal* and other magazines, the message did get through. The confluence of these and related events succeeded in bringing about passage of the Pure Food and Drugs Act in the United States in 1906. This important legislation did manage to curtail much, but certainly not all, of the excessive advertising claims of proprietary medicines. Subsequent regulations brought further controls during the twentieth century, and similar regulations were necessary in other developed nations. ❧

The Persistence of Quackery.

Why has quackery endured? While a good case could be made for fringe products during most of mankind's history when the orthodox had little to offer, it is a more difficult matter to explain it in an age of sound scientific advance. But there are clues. For one thing, the quack, whose appeal is directed toward his audiences' hopes, fears and prejudices, scorns rational argument in advertising his wares, and is able to find some level of support in all societies. Secondly, medical care has always been expensive and has always been an expense individuals would rather not have to make. The relatively low-cost nostrum might be an acceptable substitute. At the same time, even though scientific medicine has made great strides, it still remains limited in its efficacy. Another rationale is that

one could obtain a proprietary product anonymously and no one else, including the physician, would ever know. Self-medication, crucial to the viability of quackery, has always had appeal for many men and women, and in areas without many professionals, exemplified by the years of colonization and westward expansion in the United States, the popularity of self-help publications offering medical advice (e.g., *Every Man His Own Doctor*) has been a necessity. A further reason to resort to alternative medications and alternative medical systems is based on the hope offered by the unproven panacea, employed when all else in the arsenal of medical science has not worked. Finally, there is an anti-intellectual aspect in the desire to find alternatives to orthodoxy, which acts in favor of the fringe practitioner.[53]

For these and other reasons, sporadic campaigns to eradicate quackery's baneful influence have never fully succeeded. Despite the passage of legal regulations to control the excessive claims made by fringe products and fringe practitioners, clever operators seem to be able to find a way around the letter of the law. Various twentieth-century acts in the United States—the 1906 Pure Food and Drugs Act, the Sherley Amendment of 1912, the Food, Drug and Cosmetic Act of 1938 and the Durham-Humphrey Act of 1951—have corrected many abuses, but extravagant claims for vitamins, food supplements and promised cures for conditions such as AIDS and cancer still exist. Not all mankind is rational, and many are still swayed by promises that cannot be substantiated. The proverb *Si populus vult deciperi, decipiatur* (If the people want to be deceived, let them), perhaps explains why. Despite necessary controls, proprietary medicine sellers today remain as innovative as ever. True, they have learned to modify their more extravagant claims in the face of current medical knowledge and in conformance with various laws and regulations which have proven necessary to curtail their unrestrained behavior. They have also learned to take advantage of

the anonymity of the Internet to claim excessive benefits for their products. But it is still necessary, as the press reminds us, for the Food and Drug Administration and the Federal Trade Commission to keep both ethical and proprietary medicine sellers in the United States in check.

Quackery has held its place in the history of medicine. Despite being strongly condemned by established physicians, and regularly circumscribed by legislative acts, it has managed to endure under all political systems. Its behavior has rarely been static, for it has steadily modified its offerings to adjust to new therapeutic discoveries and new means of communication. Quackery has shown that it can adapt itself to almost any prevailing political and regulatory system. Practices that many of us would consider unadulterated quackery can be found today in the pages of many newspapers and magazines as well as on the television screen. A visit to any health food store will provide the necessary evidence. Despite what we do, the quacks and their nostrums will be with us forever. 🦢

CATALOGUE

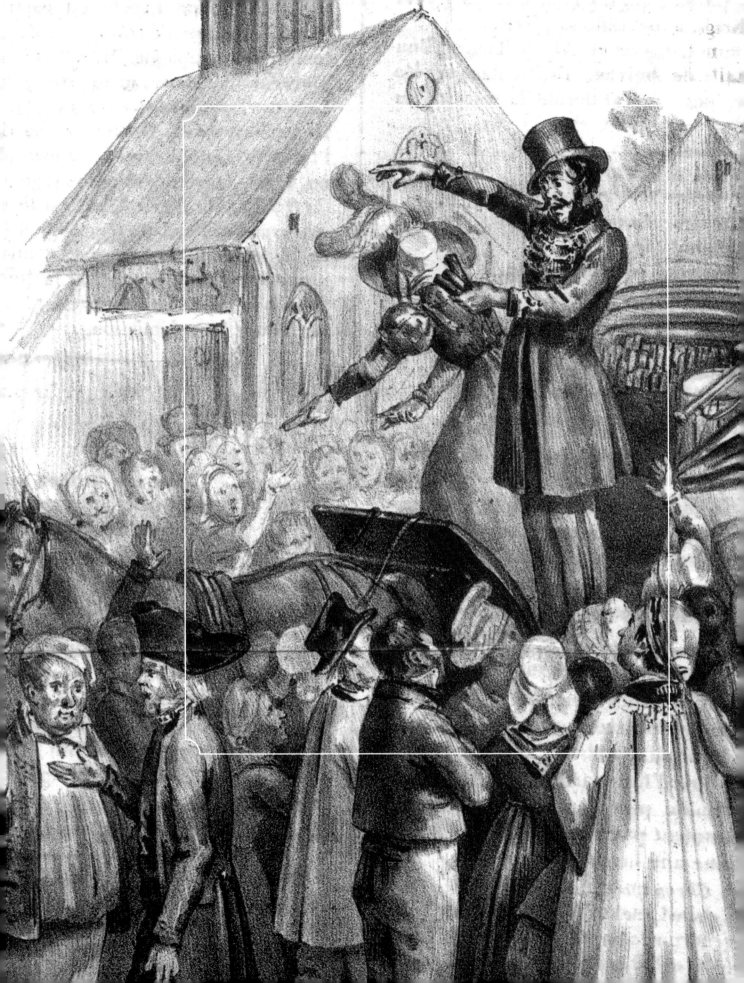

The Itinerant Quack.

In contrast to licensed physicians, the majority of quack doctors were itinerant, traveling on foot, horseback or in elaborate chariots until they arrived at a county fair or an urban square where they could begin to market their wares. Their peripatetic nature continued well into the twentieth century with rival medicine show troupes canvassing the United States and Canada, providing entertainment to attract prospective purchasers. Moving from town to town permitted the travelers to attract a much broader audience and also allowed the itinerants the opportunity to be long out of sight when, and if, it was discovered that their infallible remedies either did not work or had unpleasant side effects. As a trade-off, the itinerants could not develop any lasting relations with their clients, nor could they have the luxury of adequate time to prepare a proper diagnosis. They lacked personal ties strengthened by reputation and a stationary life, which brought economic advantage to those physicians and apothecaries who remained in a local area. The colorful dress and flamboyant manner of these travelers, coupled with the often elaborate design of their wagons and stages — as well as the bizarre antics of their comedians, musicians and performance artists — provided animated subjects for artists, as the many prints and paintings of itinerant medicine sellers over the last four hundred years demonstrate. In addition, posters and handbills announcing the times and places at which both these physicians and medicine sellers could be consulted provide evidence of earlier methods of medical care. ❧

No. 1

**Foire Annuelle de la Ville d'Alcala
(Annual Fair of the City of Alcala)**, c. 1850

GUSTAVE JANET (French, 1829–?)
After Baumann (French, nineteenth century)
Engraving; 8⅞ x 12⅝ in. [22.5 x 32.1 cm]

ESPAGNE

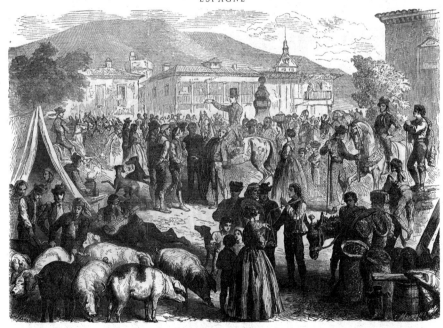

FOIRE ANNUELLE DE LA VILLE D'ALCALA

DESSIN DE GUSTAVE JANET, D'APRÈS BAUMANN

Il se tient chaque année à Alcala une foire célèbre dans toute
l'Espagne ; elle est le rendez-vous de tous les gitanos andaloux
qui amènent sur le marché des chevaux et des mules. Cette foire
est, après les ferias de Séville, une des plus pittoresques de
l'Espagne.

G. T.

The annual country fair in Alcala was one of the more picturesque events in
Spain. Although it was mainly known as a market for horses and mules, many
other activities took place. Here a bold medicine seller on horseback is shown
in the middle of the crowded square along with an aide who calls attention to
his arrival.

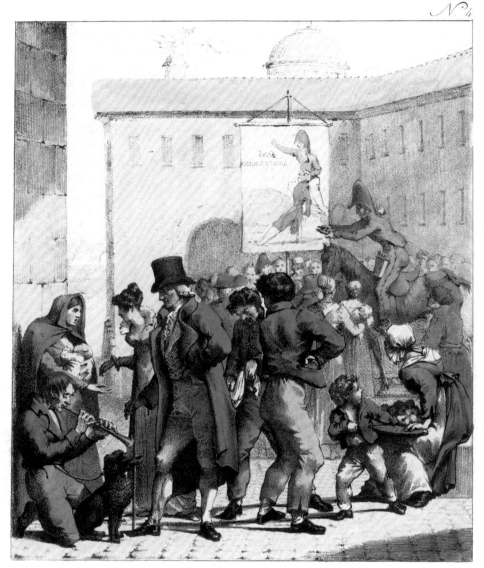

Contrastes
(Arracheur de dents (sans aucune douleur))

No. 2
Contrastes (Contrasts),
c. 1845

ANONYMOUS (French)
Color lithograph; 8⅝ x 7⅝ in.
[21.9 x 19.4 cm]

The contrasts to which the print refers are the various forms of activity going on in the marketplace at the moment the itinerant tooth puller has arrived on the scene. His large banner proclaims his expertise, while around him musicians play, breast-feeding mothers beg, little boys steal apples from a fruit seller, and pickpockets ply their trade.

No. 3

Le Marchand de Mitridate (The Mithridatum Seller), 1743

J. MOYREAU (French, 1690–1762)
After P. Wouvermens (Belgian, late seventeenth century)
Engraving; 14¼ x 18⅜ in. [36.2 x 46.7 cm]

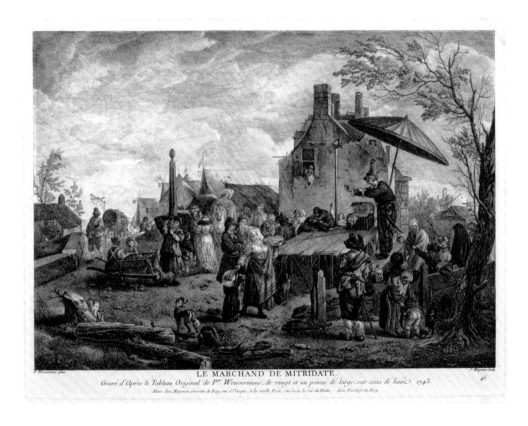

LE MARCHAND DE MITRIDATE.
Gravé d'Après le Tableau Original de P.re Wouvermens, de vingt et un pouces de large, sur seize de haut. 1743.
Rüe des Moyreau, Graveur du Roy, rüe St Jacque, à la vieille Poste, vis-à-vis la rüe de Platre. Avec Privilege du Roy.

Mithridatum, named after a second-century king, was a famous theriac, a poly-pharmaceutical concoction usually containing more than seventy ingredients, many of which interfered with others. Originally intended as an antidote for poisonous bites of insects and animals, it eventually became a universal antidote for poisons and a remedy for many illnesses. It was usually prepared by pharmacists under the watchful eyes of leading physicians to be sure they prepared it correctly.

Et, le timbre à la main, l'huissier, prêt à poursuivre,
Nos douzièmes échus, avide et mécontent,
Semble indiquer du doigt qu'un receveur attend.
Croyez-vous qu'à vos pleurs sa rigueur compatisse?
Sur vous s'étend déjà la main de la justice;
Dans votre obscur réduit, au plus haut escalier,
Déjà sa main saisit un chétif mobilier;
Vos planches de sapin l'une à l'autre liées
Ornent du Châtelet les publiques criées.

No. 4

François Fabre, Némésis Médicale Illustrée (The Illustrated Medical Nemesis), 1841

HONORÉ DAUMIER (French, 1808–1879)
Published by Bruylant-Christophe et Compagnie, Brussels

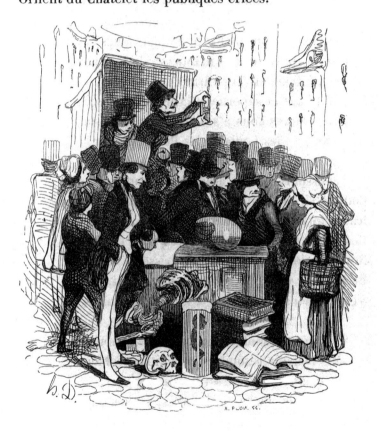

Fabre's satirical attack on the French medical system took the form of twenty-five verses on homeopathy, magnetism, midwives, pharmacists and phrenology among other medical subjects. The text is enlivened by thirty lithographs, drawn for the book by Honoré Daumier, such as this image of a medicine seller who has set up his platform in an urban setting.

No. 5

Le Charlatan Allemand (The German Quack), 1777

HEBNAN (French, eighteenth century) After Bertaux (French, eighteenth century)
Engraving; plate 10 x 7⅝ in. [25.4 x 19.4 cm]

No. 6

Le Charlatan François (The French Quack), 1777

HEBNAN (French, eighteenth century) After Bertaux (French, eighteenth century)
Engraving; plate 10 x 7⅝ in. [25.4 x 19.4 cm]

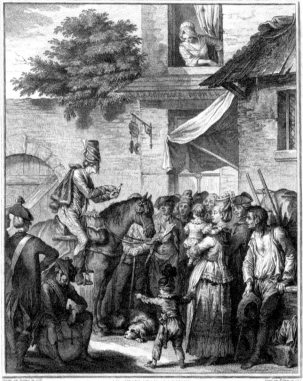 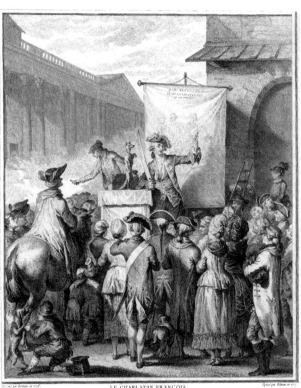

In this pair of prints, one itinerant quack attracts a stylish crowd in a populous area, the other draws a rural audience in a small town.

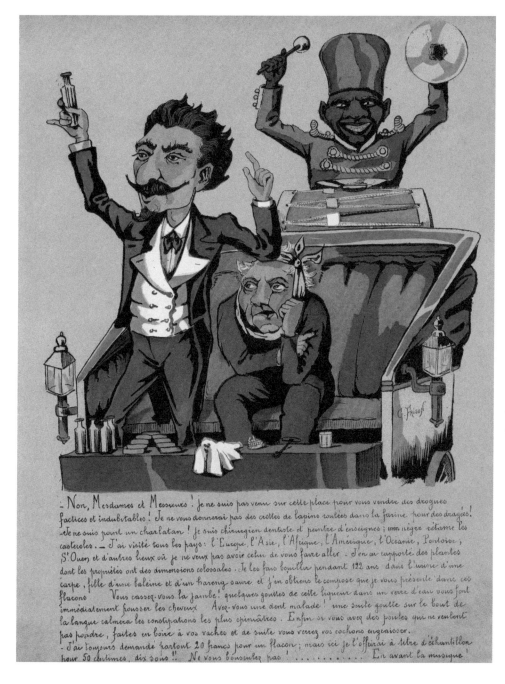

Non, Mesdames et Messieurs! Je ne suis pas venu sur cette place pour vous vendre des drogues factices et indubitables! Je ne vous donnerai pas des crottes de lapins roulées dans la farine. pour des dragées! Je ne suis point un charlatan! Je suis chirurgien dentiste et peintre d'enseignes; mon nègre rétame les casseroles. J'ai visité tous les pays: l'Europe, l'Asie, l'Afrique, l'Amérique, l'Océanie, Pontoise, St Ouen et d'autres lieux où je ne veux pas avoir celui de vous faire aller. J'en ai rapporté des plantes dont les propriétés ont des dimensions colossales. Je les fais bouillir pendant 122 ans dans l'urine d'une carpe, fille d'une baleine et d'un hareng saure et j'en obtiens le composé que je vous présente dans ces flacons. Vous cassez-vous la jambe! quelques gouttes de cette liqueur dans un verre d'eau vous font immédiatement pousser les cheveux. Avez-vous une dent malade! une seule goutte sur le bout de la langue calmera les constipations les plus opiniâtres. Enfin si vous avez des poules qui ne veulent pas pondre, faites en boire à vos vaches et de suite vous verrez vos cochons engraisser. J'ai toujours demandé partout 20 francs pour un flacon; mais ici je l'offrirai à titre d'échantillon pour 50 centimes, dix sous!! Ne vous bousculez pas! En avant la musique!

No. 7

Non, Mesdames et Messieurs! Je ne suis pas venu sur cette place pour vous vendre des drogues factices et indubitables! ... (No, ladies and gentlemen! I have not come to this place to sell you false and questionable drugs! ...), c. 1875

GUSTAVE FRISON
(French, 1850–after 1888)
Stencil-colored metal relief print; 9 x 8½ in.
[22.9 x 21.6 cm]
Philadelphia Museum of Art. The William H. Helfand Collection. 1993-105-62

This is one of several prints of the exploits of the unlicensed dentist Georges Fattet, who had a short-lived success in mid-nineteenth-century Paris. Fattet commissioned paintings, prints, and even caricatures about his flamboyant habits. Usually he wore a long brocaded dressing gown in his office, or traveled in a carriage shaped like a set of false teeth. The text extols the benefits of one of his remedies, a brew of exotic plants "boiled for 122 years in the urine of a carp," which he promises will mend broken limbs, grow hair, cure toothache and relieve constipation.

No. 8

The High-German Mountebank, 1794

ANONYMOUS (English)

Hand-colored engraving; 7⅞ x 9¾ in. [20 x 24.8 cm]

Published by Robert Sayer and Co., London

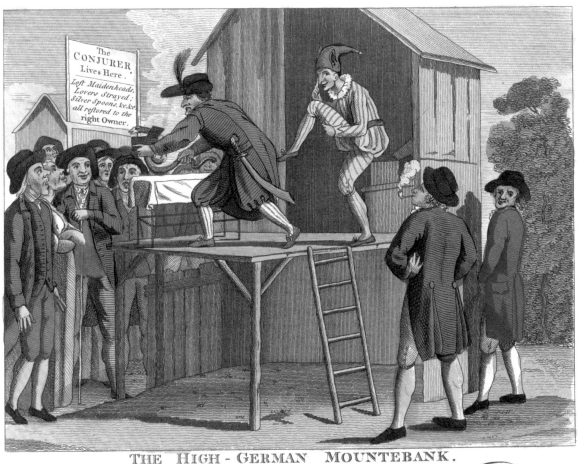

THE HIGH - GERMAN MOUNTEBANK.

(He is the 7ᵗʰ Son of a 7ᵗʰ Son of an Unborn Doctor)

And Cures all Diseases for the Small Sum of Half a Guinea, given to his Merryandrew.

Published 1ˢᵗ March 1794 by Robᵗ. Sayer & Cᵒ Fleet Street, London.

In the seventeenth and eighteenth centuries to be a seventh son of a seventh son meant being endowed with special occult powers of healing. To be a High-German medicine seller was an added plus because Germany was a country reputed to be advanced in its knowledge of treating disease. These mountebanks, each on a wooden platform, might be touting that they "cure all diseases for the small sum of half a Guinea."

No. 9

The Tower Hill Esculapius, 1782

ANONYMOUS (English)
After Robert Dighton (c. 1752–1814)
Engraving; 7 x 10⅞ in. [17.8 x 27.6 cm]
Printed and sold for Carington Bowles

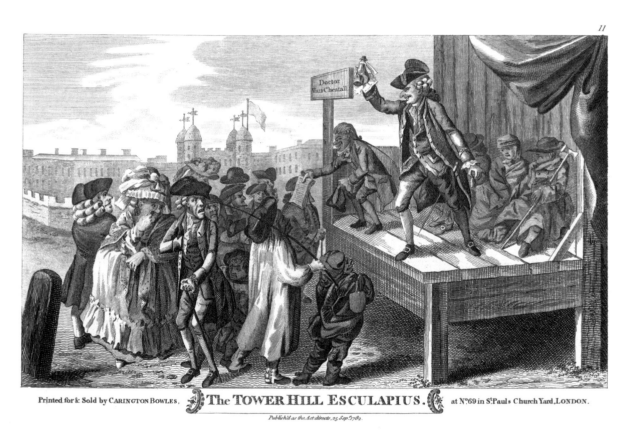

Printed for & Sold by CARINGTON BOWLES. The TOWER HILL ESCULAPIUS. at Nº69 in Sᵗ Pauls Church Yard, LONDON.

Publish'd as the Act directs, 25 Sepᵗ 1782.

No. 10

Admirez ce spécifique unique &. &. &.
(Admire this unique specific etc. etc. etc.), c. 1850

TEICHEIL (French, mid–nineteenth century)
Color lithograph; 10½ x 13⅛ in. [26.7 x 33.3 cm]
Printed by Lemereier, Paris

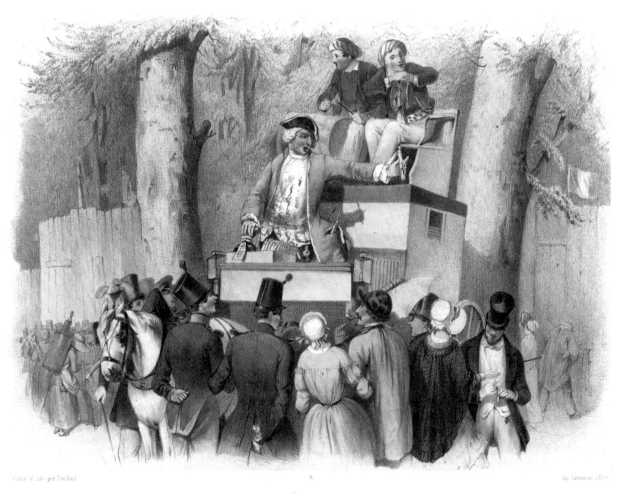

Convenient for medicine sellers, chariots served both as a means of transport
for the entourage as well as a platform from which to present a sales pitch.
These prints show the charlatan himself using his place above the audience to
make his presentation. In the earliest of these three images, accompanied by
his wife, the speaker emphasizes the extreme lengths he has traveled to find
the ideal herbs for his product.

No. 11

Ce vulnéraire est composé de simples que nous avons receuillis mon épouse et moi sur de hautes montagnes situées dix lieues plus loin que le soleil levant (This wound healer is composed of medicinal plants which my wife and I have gathered on high mountains ten leagues farther than the rising sun), c. 1840

ANONYMOUS (French)

Lithograph; 11⅞ x 8⅝ in. [30.2 x 21.9 cm] From *Le Charivari*

No. 12

A Quack Showing the Effects of His Nostrum on a Soldier, c. 1880

ANONYMOUS (French)

Chromolithograph; 11⅞ x 8½ in. [30.2 x 21.6 cm]

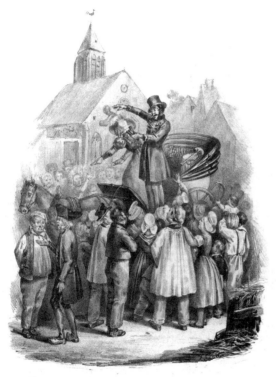

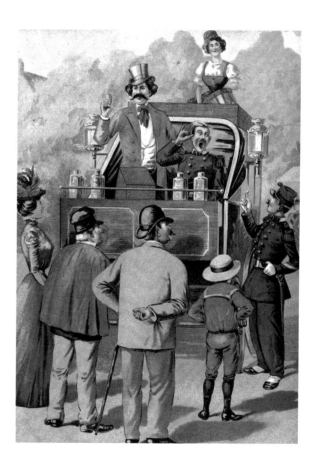

No. 13
The Travelling Quack, 1894

HARRY TUCK (English,
late nineteenth century)
Colored wood engraving;
8¼ x 6⅝ in. [21 x 16.8 cm]
From *The Million*, vol. 5, no. 124
(August 4, 1894)

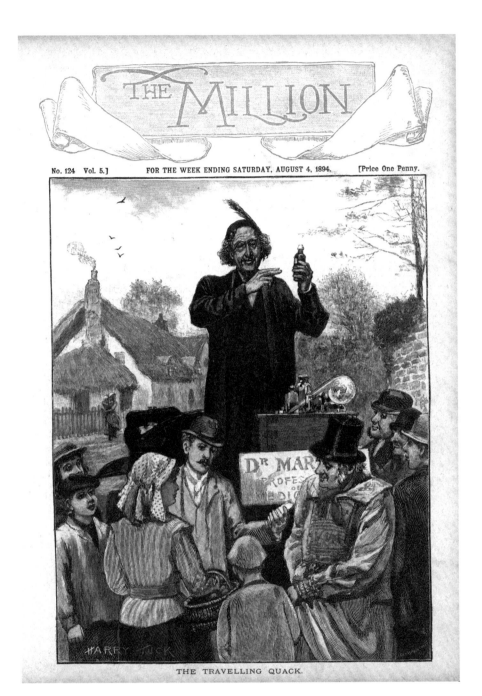

THE TRAVELLING QUACK.

While the "Professor of Medicine" shows off his nostrum, an assistant
handles the sales of those who have come to an English country village
to improve their health.

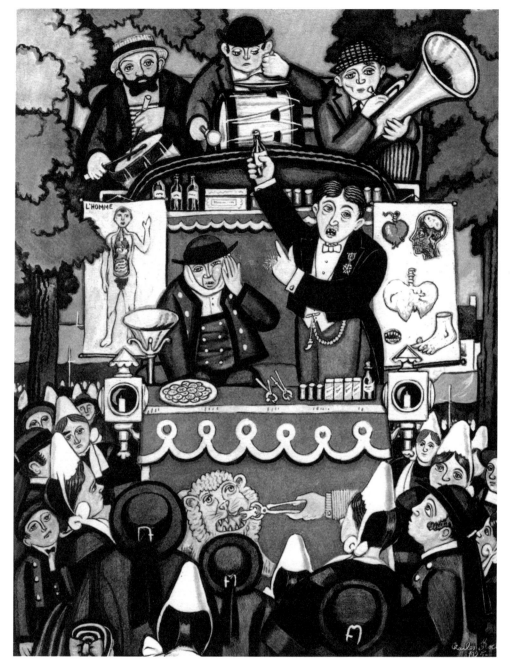

No. 14

**M. Benevant qui
arrache si bien les dents
á la foire de Pont l'Abbé
(Monsieur Benevant
who pulls teeth so well
at the Pont l'Abbé fair),**
1925

CHARLES ROCHER
(French, 1890–1962)
Lithograph; image 13¾ x 10⅞
in. [34.9 x 27.6 cm]

A twentieth-century view of a scene with a very old tradition. The relatively
recent itinerant medicine seller also pulls teeth. Like the itinerants in
previous centuries, he is accompanied by musicians. Despite their more
modern dress, the gaping audience looks on the festivities in the same
way as audiences always have.

No. 15

Dr. Liston, Oculist, Aurist, and General Surgeon, 1872

Four-page newspaper supplement; 12 x 8¾ in. [30.5 x 22.2 cm] From an unnamed newspaper, Fishkill Village, New York, vol. 7, no. 3 (Oct.-Nov. 1872)

To attract patients, Dr. Liston presented his program of visits to towns along the Hudson River. This newspaper supplement announces the schedule for the end of October and the beginning of November 1872. Certainly the practicing physicians of these municipalities would not have welcomed with open arms this "man of vast experience and with the brains to use it; conscientious, skillful, careful, prompt and with a success unparalleled." They undoubtedly would have resented the many claims made in the crowded text of his insert.

READ AND CIRCULATE.

THE WELL KNOWN AND POPULAR

INDIAN PHYSICIAN,
Dr. O. S. MARTIN,

Would respectfully inform the Ladies and Gentlemen of this place and vicinity that he has taken rooms at *D Van Inghen Hotel*

where he will remain *Sixty days*

after date, commencing *Nov 6* 1860.

Dr. M. solicits the favor of a call from all who are suffering under the hand of Disease, and who desire to obtain a

PERMANENT CURE.

Dr. M. makes no charge for an examination and advice as to what may be done.

Dr. M. tenders his most sincere thanks to his thousands of patrons and friends for their extensive patronage, and the many

TOKENS OF POPULAR FAVOR!

rendered him for his

UNRIVALLED SUCCESS!

in the cure of disease during the past six years, and hopes to continue the popular favor of the public by his successful endeavors to do good.

Office hours from 7 o'clock A. M. to 6 P. M.

Residence : Esperance, Schoharie Co., N. Y.

"REPUBLICAN" POWER PRESS, SCHOHARIE.

No. 16

The Well Known and Popular Indian Physician, Dr. O. S. Martin, Would Respectfully Inform …, 1860

Circular; 11 x 5¼ in. [27.9 x 13.3 cm]
Printed by "Republican" Power Press,
Schoharie, New York

Itinerant physicians used handbills to announce their arrivals. They frequently used forms for this purpose, writing in the address and dates of their stay. In this broadside, Dr. Martin advertises that he is an Indian Physician, a prescriber of drugs used by Indians. Apparently he felt that this might impress the townspeople, but his offers of permanent cures might have had an even greater appeal.

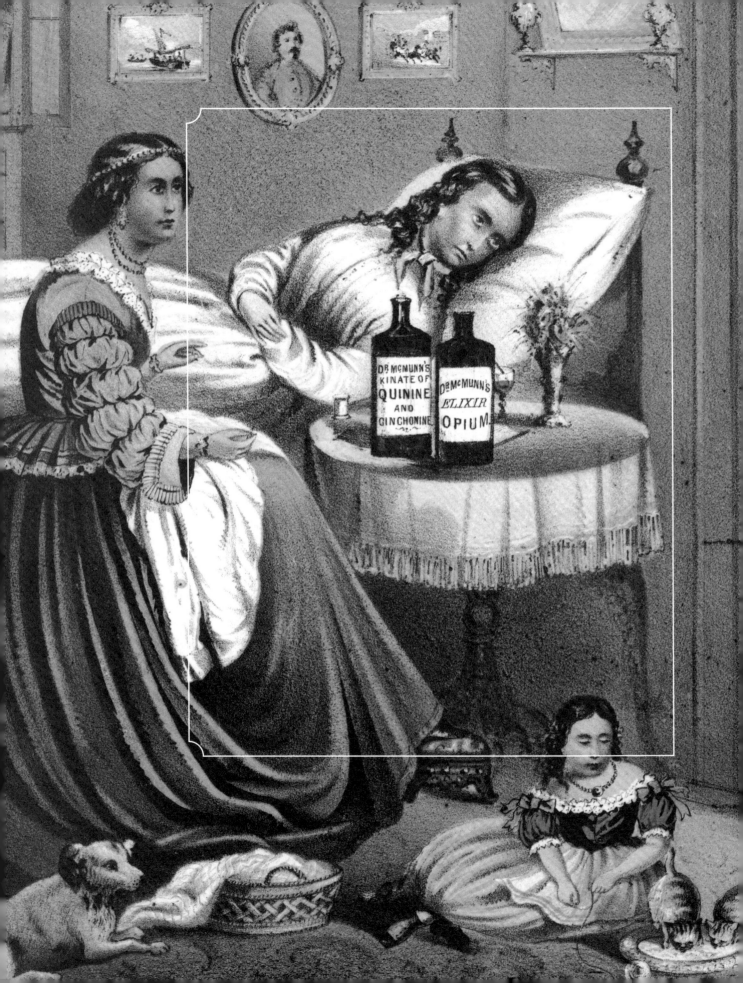

The Ways of the Quack.

In addition to their itinerant nature, there have always been other ways to identify quacks. They stressed their association with celebrities, aristocrats, the church and those in power, proclaiming their successes on broadsides, posters, affidavits, medals and diplomas. They made widespread use of testimonials, particularly from well-known physicians, royalty and the famous, and when these were not available, just about anybody. They tended to keep their formulas secret, but let it be known that they were similar to approved agents in the pharmacopoeias, and above all that their prescriptions contained only natural ingredients and no harmful chemicals such as mercury, arsenic and antimony. Quacks promised complete cures, claiming their nostrums to be universal panaceas, which no disease or malady could resist. And they advertised, often extensively, employing talented artists and writers to aid their efforts, and using inventive brand names that suggested the exotic, the foreign, and their nostrum's innate potency. Quacks also stressed their charitable nature, offering low prices or payment only upon cure. They called attention to themselves by their excesses, particularly in their elaborate costumes and flamboyant manner. Because they were in competition with established physicians and apothecaries, they tried to imitate the regular's methods by writing pamphlets, giving lectures and calling attention to the scientific nature of their work. They lost no opportunity to accuse others of being quacks, and their targets included respectable physicians as well as their less educated colleagues. Finally, they expanded their markets by using agents, often booksellers, printers and publishers, always emphasizing the necessity of assuring that the product purchased bore the distinctive signature, seal or other identification of the sole manufacturer of the nostrum, all others being counterfeit. All these, and still other character traits are revealed in the many books, pamphlets and advertisements of the medicine sellers and in the woodcuts, engravings and lithographs demonstrating their activities. 🐦

Mutual Accusation, 1774

JAMES BRETHERTON (English, c. 1750–?)
After Henry William Bunbury (English, 1750–1811)
Hand-colored engraving; 6⅜ x 11⅞ in. [16.2 x 30.2 cm]

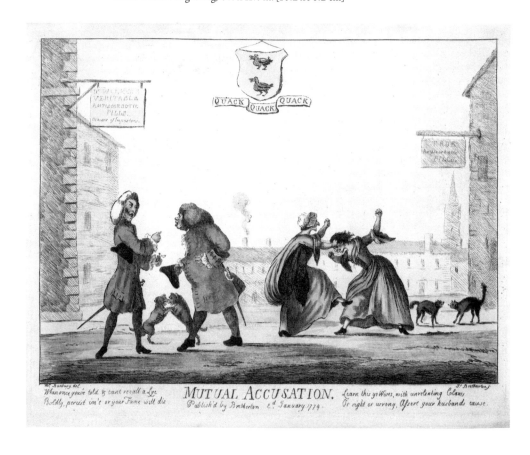

Quack doctors did not refer to themselves as quacks, but their rivals certainly did. This caricature of two quacks arguing over the merits of their rival antiscorbutic pills, one veritable and the other true, is a good example. For extra effect, their wives, dogs and cats are fighting too. The quacks wear full wigs, a practice generally favored by physicians.

No. 18

**Dr. McMunn's Kinate
of Quinine and
Cinchonine, in Fluid
Form and Always Ready
for Use**, c. 1865

ANONYMOUS (American)
Chromolithograph;
14¼ x 10 in. [36.2 x 25.4 cm]
Printed by Thomas & Eno,
New York

Two of Dr. McMunn's products are proudly displayed near the bedside of a sick
woman, and through the open doorway men harvest cinchona bark from which
its major alkaloids, quinine and cinchonine, will be made. These are natural,
not chemical ingredients, and even though the cinchona tree is indigenous to
Peru rather than North America, the scene is charming nonetheless.

No. 19

The Cerevisia Anglicana, or, English Diet Drink…, c. 1803

ANONYMOUS, (English)
Engraved broadside;
21 x 16½ in. [53.3 x 41.9 cm]
Printed in London

The Cerevisia Anglicana was first discovered and sold in 1742 and was, as Dr. Joshua Webster proudly pointed out, "strongly patronized by the late Dr. Benjn. Franklin of America (who was cured of an obstinate Scorbutic affection by its use)." The product cured all types of fevers including yellow fever, typhus, nervous fevers and "putrid and spotted fevers," plus many other conditions.

A

TREATISE

ON THE

ALTERATIVE AND CURATIVE VIRTUES

OF

SWAIM'S PANACEA,

AND ITS

APPLICATION TO THE DIFFERENT DISEASES OF THE

HUMAN SYSTEM.

INTERSPERSED WITH

REMARKS ON ITS PHARMACEUTIC EFFECTS

AS A

REMEDIAL AGENT.

———◦•◦———

BY WILLIAM SWAIM.

———◦•◦———

" The *first* step in the healing art is clearly to identify and distinguish the disease;
and the *second*, to appropriate the remedy in its purity and simplicity,
and with a due attention to the strength and constitution
of the patient."

———◦✳◦———

PHILADELPHIA.

J. BIOREN, PRINT.

1833.

No. 20
William Swaim, A Treatise on the
Alterative and Curative Virtues of
Swaim's Panacea and Its Application
to the Different Diseases of the
Human System, 1833

Published by J. Bioren, Philadelphia

Bookbinder-turned-nostrum manufacturer, William Swaim was one of the earliest of the large-scale advertisers in the United States. The Panacea, based on sarsaparilla syrup and blessed with a powerful name, was introduced in 1820. Soon a continuous barrage of pamphlets and small bound volumes kept its name in the public eye. Early publications included testimonials from well-known physicians, most notably Nathaniel Chapman (1780–1853), who later withdrew his published support.

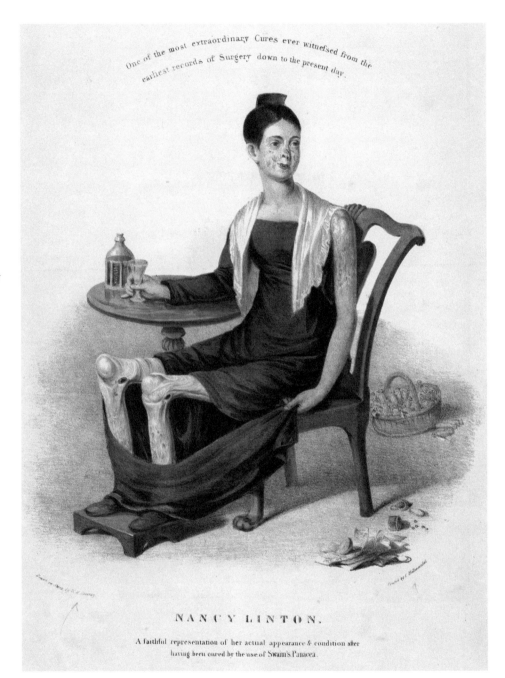

One of the most extraordinary Cures ever witnessed from the earliest records of Surgery down to the present day.

NANCY LINTON.

A faithful representation of her actual appearance & condition after having been cured by the use of Swaim's Panacea.

No. 21

Nancy Linton, c. 1833

C. HULLMANDEL (English, mid-nineteenth century)
From a drawing by W. H. Kearney
(American, nineteenth century)
Hand-colored lithograph;
14 x 10¾ in. [35.6 x 27.3 cm]

Surprisingly, the portrait of Nancy Linton shows how she looked after she had taken Swaim's Panacea; unfortunately there is no existing image of her before she began taking the cure. According to a lengthy description in Swaim's 1833 treatise (p. 75), Miss Linton appears to have had a severe case of scrofula (p. 110) since the age of twelve, and all previous treatments were unavailing.

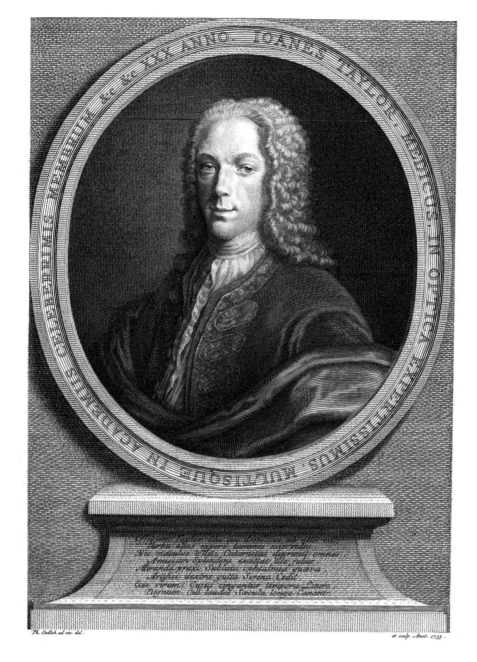

No. 22

Joanes Taylor, Medicus, in Optica Expertissimus, Multisque in Academiis Celeberrimis Membrum &c &c XXX Anno, 1735

PHILIPP ENDLICH
(Dutch, 1700–?)
Engraving; 11 x 8⅛ in.
[27.9 x 20.6 cm]

Taylor (1703–1772) is a good example of the ambiguity surrounding quacks in the eighteenth century. Styling himself "The Chevalier John Taylor, Ophthalmiator, Pontifical, Imperial and Royal," he lectured with grandiloquent phrases on "The Eye" throughout Europe. At the same time, he developed techniques for rapidly removing cataracts, is reputed to have operated on both Bach and Handel, and was appointed Oculist to King George II of England.

No. 23

Oui monsieur ... dévoué par état et par sentiment à la philantropie la plus pure ... (Yes sir ... Dedicated by my profession and my sentiments to the purest philanthropy ...), 1844

HONORÉ DAUMIER
(French, 1808–1879)
Lithograph; 9 x 7⅛ in. [22.9 x 18.1 cm]
From *Le Charivari* (November 18, 1844)

The respectable pharmacist can at times be a quack: "I have not hesitated to spend my nights nor to use up my retorts and stills, to discover a salve ... I have finally realized my dreams ... that is to say, the fusion of wood lice and slugs ... as my first care is to relieve suffering and coughing humanity, in spite of the high price of the raw materials, I will sell the box for only five francs."

Ch. Ph. me H.D. lith Chez Aubert, gal. véro dodat Imp. d'Aubert et de Junca

Apothicaire en Pharmacien.

Mon cher Bonnfeux, il fallait autrefois a un apothicaire quarante ans pour gagner 2000 f. de rentes vous marchiez nous volons nous. – Mais comment faites vous donc ? – Nous prenons du suif, de la brique pilée ou de l'amidon, nous appelons ça pâté Onicophane, Racahout, Nafé, Osmaniglou ou de tout autre nom plus ou moins charabia, nous faisons des annonces, des prospectus, des circulaires et en dix ans nous réalisons un million Il faut attaquer la fortune en face, vous la prenez du mauvais côté.

No. 24
Apothicaire et Pharmacien (Apothecary and Pharmacist), 1837

HONORÉ DAUMIER
(French, 1808–1879)
Lithograph; 9¾ x 9¼ in.
[24.8 x 23.5 cm]
From *Le Charivari*
(May 25, 1837)

Daumier's pharmacist was the model Gustave Flaubert used for M. Homais, the pharmacist in his 1856 novel *Madame Bovary*. Here he tells about making his fortune, "it took an apothecary in the old days forty years to assure himself an annual income of 2000 francs. . . . We take some suet, crushed brick or starch, we call it Onicophane Ointment, or Racahout, or Nafé, or Osmaniglou or any gibberish, then we advertise, send out prospectuses and circulars . . . and in 10 years we've made a million."

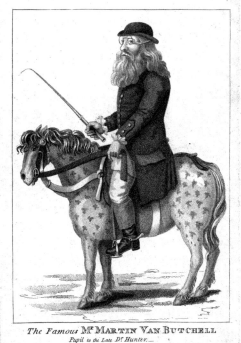

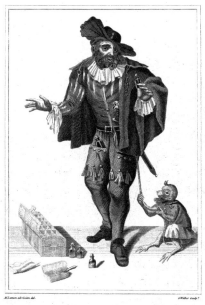

No. 25

The Famous Mr. Martin Van Butchell, Pupil to the Late Dr. Hunter, 1803

ANONYMOUS (English)
Engraving; plate 8⅜ x 5⅜ in. [21.3 x 13.7 cm]
Published by R. S. Kirby, London

No. 26

Hans Buling, 1793

G. WALKER (English, eighteenth century)
After M. Lamon (English, eighteenth century)
Engraving; plate 7⅞ x 5⅜ in. [20 x 13.7 cm]
Published by I. Caulfield

These prints depict two eighteenth-century medicine sellers who achieved fame by virtue of odd behavior. Martin Van Butchell wore a long beard, and paraded through London on a white pony painted with purple spots. He had his wife embalmed, and placed her in a case with a glass lid, which he kept in his sitting room. He offered "Real or Artificial Teeth from one to an entire set; also gums, sockets … fixed without drawing stumps or causing pain." Hans Buling drew an audience for his medicines through the antics of a pet monkey.

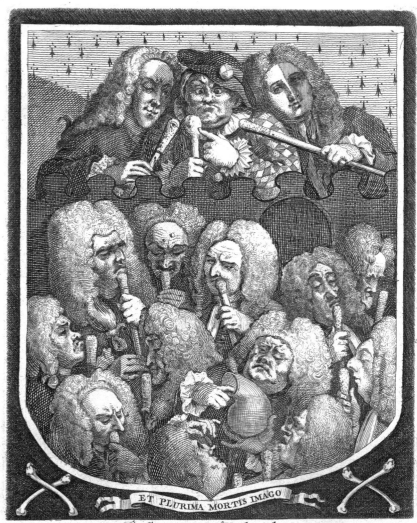

ET PLURIMA MORTIS IMAGO

The Company of Undertakers

Beareth Sable, an Urinal proper, between 12 Quack-Heads of the second & 12 Cane Heads Or, Consul-
tant. On a Chief Nebulæ, Ermine, One Compleat Doctor issuant, checkie Sustaining in his
Right Hand a Baton of the Second. On his Dexter & sinister sides two Demi-Doctors, issuant
of the second, & two Cane Heads issuant of the third; The first having One Eye conchant, to-
wards the Dexter Side of the Escocheon; the Second Faced per pale proper & Gules, Guardent. ——
With this Motto ——— Et Plurima Mortis Imago .

* A Chief betokeneth a Senatour or Honourable Personage, borrowed from the Greeke; & is a Word signifying a Head, & as the Head is the Chief Part in a Man , or the Chief in the Escocheon Should
be a Reward of such only, whose High Merits have procured them Chief Place, Esteem, or Love amongst Men. Guillim.
** The bearing of Clouds in Armes (saith Upton) doth import some Excellence.

Publish'd by W. Hogarth March the 3 1736

Price Six pence

No. 27
The Company of
Undertakers, 1736

WILLIAM HOGARTH
(English, 1697–1764)
Engraving; plate 10¼ x 7¼ in.
[26 x 18.4 cm]

Hogarth's print shows both quacks and pretentious physicians in an armorial
setting. The three at the top of the print are Joshua Ward, perhaps the most
famous quack of his time (p. 87); Sarah Mapp, a well-known bonesetter; and
John Taylor the oculist (p. 77). The bewigged physicians sniff the pomander on
their canes, but as the legend notes: *Et plurima mortis imago* (And many are the
faces of death). According to Hogarth, both physicians and quacks are in the
same Company of Undertakers.

THEY ARE COMING
THEY!
Who are THEY! What do THEY do!

READ, and you will KNOW!
DR. FARLIN

TELLS YOU AT A GLANCE every Ache, Pain or Disease that effects you. He also tells you how to CURE YOURSELF. He also tells you how to prevent diseases to which you are liable.

He also tells you all about your *Mental and Physical Powers*—which are STRONG and which are WEAK; how to restrain the Strong and how to strengthen the Weak.

He Lectures to Ladies and Gentlemen
EVERY EVENING AT 8 OCLOCK,
UPON THE

Laws of Life and Health

According to the Sciences of **PHYSIOLOGY** and **PATHOLOGY** in conjunction with his Native Traditions and Globe Encircled Observations and Experiences.

He is with a Corps of **Medical and Surgical Experts from Europe, India and America**, under the auspices of the

TRI-CONTINENTAL SYNDICATE
OF PHYSICIANS & SURGEONS,
Including the Celebrated Chemist and Formulator,

DR. ALONSON GALLOWAY,

Who after an extended European tour has decided to make the Flower City his permanent residence; also the World Renowned

DR. S. C. CRITTENDEN,

Late visiting Physician to the New York Infirmary and Charity Hospital. Late President of the National Medical Institute, Washington, D. C. Discoverer of Medicated Ozone and many other Valuable Remedies that have made his name famous throughout the entire medical world.

THEY use no Minerals, Alkaloids, or Bromides, that poison the system and produce a secondary disease worse than the first; but THEY use simple Vegetable remedies, garnered from Nature's Laboratory, that assist Nature's Vital forces to conquer Disease.

THEY do positively **Cure** all forms of **Chronic Diseases** of the **Blood, Nerves, Eyes, Ears, Throat, Lungs, Stomach, Liver, Kidneys, Bowels, Bladder and Sexual Organs.** Including Headache, Neuralgia, Rheumatism, Indigestion, Constipation, Piles, Epilepsy, Catarrh, Bronchitis and Lumbago.

Come and see them make the **LAME WALK**, the **BLIND SEE**, and the **DEAF HEAR,**

FREE!!

DR. FARLIN has for five years, after a general practice of fifteen years, made a specialty of **FEMALE DISEASES**, including Leucorrhœa, **Prolapsus Uteri, Fistula, Vaginitis** etc. He treats without local examination, save in aggravated cases where it is sometimes necessary; uses no caustic remedies, and places in *your* hands the means of curing yourself.

A POSITIVE CURE FOR SPASMODIC ASTHMA, PHTHISIC AND HAY FEVER, OR SUMMER CATARRH.

Free Lecture
Every Night at 8 O'clock.

No. 28

They Are Coming. They! Who Are They! What Do They Do! Read, and You Will Know! Dr. Farlin…, c. 1875

ANONYMOUS (American)

Broadside; 17⅞ x 5¾ in. [45.4 x 14.6 cm]

Printed in Rochester, New York

This broadside announces three lectures to be given by physicians who were part of a group of "medical and surgical experts from Europe, India and America." The audience could expect to "Come and see them make the lame walk, the blind see and the deaf hear." Such promises must have been difficult to achieve, even if presented to an audience that might be receptive to such claims.

PHRENO-MEDICAL COLLEGE,
OPPOSITE POWERS' BLOCK,
Over 8 State Street, Rochester, N. Y.

KNOW, HEAL AND PERFECT THYSELF.

AMUSING ENTERTAINMENTS.
ILLUSTRATED SCIENTIFIC LECTURES
—ON THE—

Problems, Mysteries and Poetry of Life.

THE MENTAL CONSTITUTION.

A New Method of Mind Reading and Self-Cure.

AN IMPROVED SCIENCE OF MIND.

Our Perfectability and Destiny.

MECHANISM and MARVELS OF MAN.

A New Mental, Social and Spiritual Science of Life,
BY THE JUSTLY CELEBRATED

Prof. FRANKLIN, M. D.

An Eminent Lecturer, intuitive veteran Physician of Body and Mind, Author of "The
Medical Counsellor," "Art of Health and Beauty," "Phreno-Medical Chart,"
"Compass Tree and Book of Life," " Science of Life and Mind,"
"Oracles of Truth for Every Youth."
—AT THE—

BUSINESS COLLEGE,

Over No. 8 State Street,

Friday, Saturday and Sunday, June 6th, 7th and 8th.

At 4 and 8 o'Clock P. M.

Afternoons at 4 o'Clock.

FOR LADIES ONLY.

SUBJECT:

HEALTH and BEAUTY, WOMAN'S SPHERE and DUTY.

PHRENO-MEDICAL COLLEGE,
OPPOSITE POWERS' BLOCK,
Over 8 State Street, Rochester, N. Y.

KNOW, HEAL AND PERFECT THYSELF.

AMUSING ENTERTAINMENTS.
ILLUSTRATED SCIENTIFIC LECTURES
—ON THE—

Problems, Mysteries and Poetry of Life.

THE MENTAL CONSTITUTION.

A New Method of Mind Reading and Self-Cure.

AN IMPROVED SCIENCE OF MIND.

Our Perfectability and Destiny.

MECHANISM and MARVELS OF MAN.

A New Mental, Social and Spiritual Science of Life,
BY THE JUSTLY CELEBRATED

Prof. FRANKLIN, M. D.

An Eminent Lecturer, intuitive veteran Physician of Body and Mind, Author of "The
Medical Counsellor," "Art of Health and Beauty," " Phreno-Medical Chart,"
" Compass Tree and Book of Life," " Science of Life and Mind,"
."Oracles of Truth for Every Youth."
—AT THE—

BUSINESS COLLEGE,

Over No. 8 State Street,

Friday, Saturday and Sunday, June 6th, 7th and 8th.

At 4 and 8 o'Clock P. M.

Afternoons at 4 o'Clock,

FOR LADIES ONLY.

SUBJECT:

HEALTH and BEAUTY, WOMAN'S SPHERE and DUTY.

No. 29

**Prof. Franklin, M. D.,
Know, Heal and Protect
Thyself**, c. 1880

ANONYMOUS (American)

Broadside; 24 x 4⅝ in.

[61 x 11.7 cm]

Printed by Phreno-Medical
College, Rochester, New York

Lectures were one way to keep the name of the healer in the public eye.
This illustrated broadside contains more than enough information to give
a good idea of the qualifications of the lecturer without attending. As it
suggests, "Dr. Franklin was never known to lose a patient; has healed
thousands given up by other physicians; is very intuitive and expert in
analysing character and diseases."

No. 30

Le Médecin du Roi de Perse (The Physician of the King of Persia), 1843

CHARLES JACQUE (French, 1813–1894)
Lithograph; 9⅞ x 7½ in. [25.1 x 19.1 cm]
From *Le Charivari*

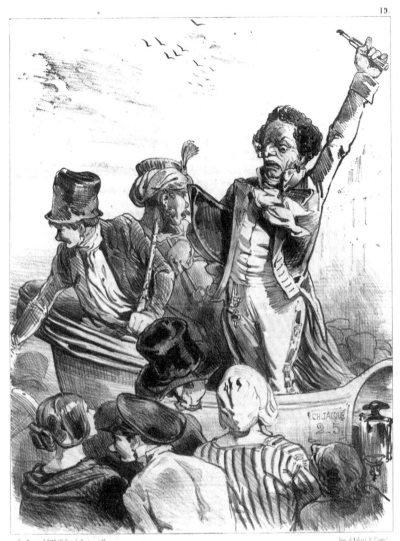

LE MÉDECIN DU ROI DE PERSE.

Oui messieurs et dames il n'est pas de malade qui résiste à mon baume... et je n'ai quitté la cour du roi de Perse dont j'étais devenu le médecin ordinaire que parceque tout le monde avait été si radicalement guéri que je n'avais plus rien à faire dans cette contrée vous pouvez écrire aux autorités du pays et leur demander si ce que je vous dis n'est pas l'exacte vérité

This is a parody on the excessive provenances of quack doctors. The "doctor" tells his audience, "there is no illness resistant to my balm, and I only left the court of the King of Persia because everyone had been so completely cured that I had nothing more to do in this country; you can write to the authorities of the country to ask if that which I tell you is not the exact truth!"

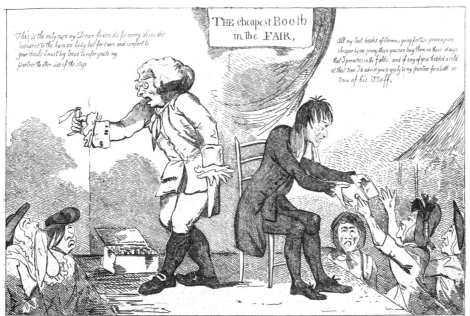

This is the only cure my Dear friends for every disorder incident to the human body but for cure and comfort to your Souls I must beg leave to refer you to my partner the other side of the stage

THE cheapest Booth in the FAIR,

All my last books of Sermons going for two pence a piece cheaper by one penny than you can buy them on those days that I preaches in the fields and if any of you ketch'd a cold at that time I'd advise you to apply to my partner for a bottle or two of his Stuff.

A LAUDABLE PARTNERSHIP or Souls and Bodies cured without loss of TIME

Pub. Sep. 3 1795 by S. W. Fores N° 50 Piccadilly the Corner of Sackville Street — Folios of Caracatures lent out for the Evening.

No. 31

A Laudable Partnership or Souls and Bodies Cured Without Loss of Time, 1795

GEORGE MOUTARD WOODWARD (English, 1760–1809)

Engraving; plate 9¾ x 13⅞ in. [24.8 x 35.2 cm]

Published by S. W. Fores, London

Similarities between the harangue of the medicine seller offering a cure for the body and the speech of the evangelist proposing a cure for the soul were apparent to many who watched their performances. At times the same individual could work in either field, persuasiveness and conviction being necessary for both professions. In this late-eighteenth-century caricature, both the quack and the preacher are together on "the cheapest booth in the fair."

CHING's
Patent Worm LOZENGES,

Patronized by the firſt Noblemen in the Kingdom, as well as the following honourable Ladies:

Who have given this Medicine to their own Children, as well as to the Poor of their reſpective neighbourhoods, with unparalelled Succeſs.

Her Grace the *Ducheſs of Leeds*—Her Grace the Duchess of *Rutland.* ——The Right Hon. the *Counteſs* of Darnley——The Right Hor. *Lady Caroline Capel*—The Right Hon. *Lady Elizabeth Spencer*—The Hon. *Lady Boſton*—The Hon. Lady *Say and Sele*—The Right Hon. the *Counteſs* of Shafteſbury---The Right Hon. the *Counteſs* of Mountnorris---The Right Hon. the *Counteſs* of Corke---The Right Hon. lady Lucy *Bridgeman*---Lady *Page Turner*---Lady *Lovett*, and many other Ladies of the firſt rank and character.

The reſpectability of the teſtimonies which Mr. CHING has been honoured with from perſons of the higheſt rank and character, fully prove both the ſafety and efficacy of his Medicine ; yet, as the following Letters may be of peculiar importance to thoſe afflicted with internal complaints, *which may not appear to proceed from Worms,* Mr. CHING feels it his duty to lay them before the public.

From the Honourable and Right Reverend
The *Lord Bishop* of Carlisle.

To Mr. CHING, *Apothecary,* CHEAPSIDE, LONDON.

SIR—I readily embrace the opportunity your Letter affords me, of adding my teſtimony to that of the LORD CHIEF BARON in favor of your Worm Medicine ; my eldeſt Son having a few months ago derived *very material benefit* from the uſe of it. He had been unwell for ſeveral weeks *previous to his taking it,* appeared pale and emaciated, was languid, and complained frequently of pains in his head and ſide. The Lord Chief Baron, who had accidentally ſeen him in this ſtate, *fortunately* recommended to me the trial of your Lozenges ; and that no time might be loſt, or any miſtake occur in obtaining the genuine Medicine, ſent me three doſes of it. The firſt of theſe occaſioned a viſible amendment, and after the ſecond doſe every unpleaſant ſymptom diſappeared, but I judged it right to give the third, as the two former had agreed ſo *uncommonly* well. From that time, my Son has been in perfect health, and I certainly attribute his cure *wholly* to the efficacy of the Worm Lozenges. I have ſince recommended your Lozenges in ſeveral inſtances, wherein I have the ſatisfaction to aſſure you, they have *uniformly* been of *great* ſervice. I ought to add, that from the nature of the effect produced by them in my Son's Caſe, I apprehend his complaints to have ariſen from an obſtruction between the ſtomach and viſcera.

I am, Sir, your obedient Servant,

Roſe Caſtle, Dec.. 7, 1798. E. CARLISLE.

From a NOBLE EARL.

To Mr. CHING, *Apothecary,* No. 4, CHEAPSIDE

SIR—I underſtand from my Apothecary that the effect of your Worm Medicine on my Servant was complete in removing an obſtruction in the firſt Paſſages and bowels, but there was no appearance of Worms ; ſhe had been unable to get up from her bed for above nine weeks ; if ſhe lay down or ſtood up, the pain about the region of the ſtomach was increaſed: ſhe had not ate ſolid meat for many weeks. Every medicine that two Phyſicians and an able Apothecary could venture to preſcribe, was given to her, but without proper effect. The warm bath alleviated the pain, but that was only temporary relief. After taking your medicine two days in ſucceſſion, ſhe got up and began to eat meat, and from that time ſhe mended apace. Whenever the bowels are obſtructed, your medicine alone relieves her. I am, Sir,

October 24, 1799. Your humble Servant,

Though Mr. CHING is not at Liberty to inſert the name of the Noble Earl, he has obtained his Lordſhip's Permiſſion to ſhew the original Letter to any of the Nobility who may doubt the authenticity of the above.

Duchesses, countesses, earls and bishops all concurred in the efficacy of Ching's Patent Worm Lozenges, but their testimonials also suggested that the product could work in other conditions too. As the proprietor noted, the product "may be of peculiar importance to those afflicted with internal complaints, which may not appear to proceed from worms."

RECEIPTS

FOR

Preparing and Compounding

THE

PRINCIPAL MEDICINES

Made Use of

By the late Mr. *WARD.*

Together with

An INTRODUCTION, *&c.*

By *JOHN PAGE,* Esq;

To whom Mr. WARD left his BOOK of SECRETS.

LONDON:

Printed for and sold by HENRY WHITRIDGE, at the South-West Corner of the *Royal-Exchange,* in *Cornhill.* 1763.

Sold also by Mr. MARSH, Bookseller, at *Charing-Cross*; by Mr. R. WITHY, Bookseller, near the *Royal-Exchange*; and at the *Magdalen-House,* in *Prescot-street, Goodman's-Fields*: At which three last-mentioned Places the late Mr. WARD's Medicines, now made publick, are appointed to be sold.

No. 33
John Page, Receipts for Preparing and Compounding the Principal Medicines Made Use of by the Late Mr. Ward, 1763

Published by Henry Whitridge, London

After the death of Joshua Ward (1685–1761), the formulas for his Pill and Drop were bequeathed to a good friend, John Page, a member of Parliament who had earlier been instrumental in enabling Ward to avoid a term in the Bastille in Paris. Page admitted that the chief ingredient in Ward's pill was antimony. In this pamphlet he promises to make Ward's products available at low prices with the profits going to two charitable institutions.

Dr. Brodum, Physician and Oculist, 1801

Four-page brochure; 7¼ x 4⅜ in. [18.4 x 11.1 cm]
Printed in London

THIS PAMPHLET
Delivered Gratis.

DR. BRODUM,
Physician and Oculist.

TO PREVENT tioned to observe
MISTAKES, well, that the
As there are Doctor's House is
more of the same No. 9, the seventh
Number in that door from the Le-
Neighbourhood the verian Museum.
Public are cau-

Stamp Duties on Bills, &c.
RECEIPTS.

If £ 2 0 0 and under . . £ 20 0 0—Two Pence
If . 20 0 0 ditto 50 0 0—Four Pence
If . 50 0 0 ditto . . . 100 0 0—Six Pence
If 100 0 0 ditto . . . 500 0 0—One Shilling
If 500 0 0 or upwards—Two Shillings
 Receipts in full of all Demands——Two Shillings ;
To be paid by the Person requiring such Receipts: and every Person
who gives or accepts a Receipt on paper not stamped according to the
above Duties, is liable to the penalty of 10l. if the sum be under 100l.
and 20l. if 100l. or upwards.

NOTES PAYABLE ON DEMAND.
If . . 2 0 0 and not exceeding 5 0 0—Six Pence
Above . 5 0 0 ditto . . . 30 0 0—One Shilling
Above . 30 0 0 ditto . . . 50 0 0—One & 6 Pence
Above . 50 0 0 ditto . . 100 0 0—Two Shillings
Above 100 0 0 ditto . . . 200 0 0—Three Shillings
Above 200 0 0 ditto—Four Shillings

MONEY BONDS.
For any Sum not exceeding £ 100 0 0—Fifteen Shillings
Above 100 0 0 and under 500 0 0—Twenty Shillings
If . . 500 0 0 ditto . . 1000 0 0—Thirty Shillings
If . . 1000 0 0 ditto . . 2000 0 0—Two Pounds
If . . 2000 0 0 ditto . . 5000 0 0—Three Pounds
If . . 5000 0 0 and upwards . . . Five Pounds

NOTES PAYABLE AFTER DATE.
If . . . 2 0 0 and not exceeding 5 0 0—One Shilling
If . . 30 0 0 ditto 50 0 0—One & 6 Pence
If . . 50 0 0 ditto . . . 100 0 0—Two Shillings
If . 100 0 0 ditto 200 0 0—Three Shillings
If . . 200 0 0 ditto—Four Shillings

Dr. Brodum announced the publication of a new edition of his book, *A Guide to Old Age,* in this small brochure. Like his colleague, Samuel Solomon (p. 172), he prided himself on the number of copies that had been distributed, in this case 30,000, and took pains to confirm the fact so that his claims would be believable.

By His Majesty's Royal Letters Patent.

Dr. BRODUM's
Nervous Cordial, and Botanical Syrup.

SOLD BY

JEBOULT and Co. late Bacon, No. 150, *Oxford-street.*
TUTT, *Royal Exchange.*
E. NEWBERY, *Corner of St. Paul's Church-yard.*
BOLTON, *Royal-Exchange.*
WILLIAMS, Perfumer to His Majesty, No. 41, *Pall-mall.*
NEWTON, *Great Russel-street, Bloomsbury.*
AIMICK and Co. *Haymarket.*
CHING and BUTLER, No. 4, *Cheapside.*
And of all the *Booksellers, Printers, Druggists,* and *Medicine Venders,* in the principal Market Towns in the Three Kingdoms.

A LIST OF CURES.

Lieut. W. PARDOE, OF HIS MAJESTY'S GUN VESSEL FEARLESS.

SIR,——It is with infinite satisfaction I acknowledge the excellence of your Botanical Syrup, which has entirely relieved me from the most EXCRUCIATING RHEUMATIC PAINS AND CONTRACTION OF THE JOINTS, which I have been afflicted with upwards of ten months.——Be assured I shall recommend your valuable medicine to the utmost of my power.

I remain, SIR, your very obedient humble Servant,

LIEUT. W. PARDOE, *Plymouth Dock, July* 31, 1800.

To DOCTOR BRODUM, *London.*

The following case was received by Mr Thomas White, Master of the Academy, COLCHESTER, *from a respectable gentleman, who was recommended to take Dr.* BRODUM's *Medicines by Mr. J.* COOPER, *Gentleman Farmer, at Levington, near Ipswich, who was himself radically cured by taking the* BOTANICAL SYRUP, *with a request from the Patient for its immediate Publication.*

A Gentleman who is induced from his connections with medical men, to refrain inserting his name and address, wishes from the purest motives of philantrophy, that his case may be made known to every asthmatic person in the kingdom.

For 18 years he had been severely afflicted with an *asthma,* that every winter rendered his life very uncomfortable ; the cough attendant on his complaint, generally attacked him at the beginning of every winter, and continued till the warm weather of the ensuing summer arrived, and so violent and alarming were its spasmodic effects, that many times it has thrown him down on the floor, deprived of all sensibility, and to all human appearance of life ; by the advice of Mr. Cooper, above mentioned, he waited on Dr. Brodum, took 3 bottles of his NERVOUS CORDIAL, to which alone he attributes the blessings of a perfect cure, having passed through the late winter, with scarcely a memento of his old troublesome companion, which had not given him a weeks respite in 18 preceding winters. *June* 2, 1801.

Mrs. Jewell, Linen-Draper, Brompton, near Chatham, was afflicted six years with a complication of disorders, which baffled the skill of several persons of the profession ; her body was swelled in a violent manner, so much as to be called by some the dropsy, some a bilious complaint, &c. her legs were in such a situation as at the ancles to spread over the shoes at times ; she was afraid, from an oppression in her breast, of being choaked for want of breath. In this condition her life became a burthen, being hopeless of any relief from medicine, but fortunately applying to Dr. Brodum, was perfectly recovered by his *Nervous Cordial.* Any person questioning the authenticity of the above, n application, or by letter, (post paid) may receive full satisfaction.

No. 35

Dr. Brodum's Nervous Cordial and Botanical Syrup, 1801

Eight-page brochure; 8¾ x 5½ in. [22.2 x 14 cm]

Printed in London

While nostrum manufacturers prior to the eighteenth century sold their products from their homes, subsequent improvements in communication required broader distribution for advertised specialties. Dr. Brodum listed his many agents on the last page of this brochure but added that they were available at "all the Booksellers, Printers, Druggists, and Medicine Venders, in the principal Market Towns" as well.

No. 36

Lyonel Lockyer,
An Advertisement Concerning
Those Most Excellent Pills,
Called Pilulæ Radiis Solis
Extractæ..., c. 1670

Four-page brochure;
8 x 6¼ in. [20.3 x 15.9 cm]
Printed in London

A N
ADVERTISEMENT
Concerning thofe moſt Excellent
P I L L S,
C A L L E D
Pilulæ Radiis Solis Extractæ:

Being an Univerſal MEDICINE, efpecially in
all Chronical and Difficult Diſtempers; as by
the enſuing Diſcourſe will moſt clearly appear.

✦✦✦✦✦✦✦✦✦✦§✦✦✦✦✦✦✦✦✦✦✦

Truly and only prepared by me LYONEL LOCKYER, *Licens'd Phyſician
and Chymiſt; and by me faithfully communicated to Mr.* Thomas Fyge,
Apothecary without Biſhopſgate, *and Mr.* John Watts, *my Nephew, who
refides with me in my Houſe, and to none other; from whom only, and
from ſuch as they ſhall appoint, you can have this true Solar Preparation
after my Death.*
N. B. *The Daughters of the above-mentioned Mr.* Thomas Fyge *being de-
ceaſed, have bequeathed all their Right and Share to Mr.* John Watts, *in*
Racquet Court, Fleet-ſtreet, *and Mrs.* Mary Whitehouſe, *in St.* Thomas's
Southwark, *who are now the only Proprietors and Preparers of the ſaid
Medicine.*

✦✦✦✦✦✦✦✦✦✦§✦✦✦✦✦✦✦✦✦✦✦

Courteous Reader.

HAVING, through the Bleſſing of God, (from whom alone
cometh every good and perfect Gift) been ſo ſucceſsful in my
Endeavours, eſpecially in the Chymical Preparation of Mine-
rals, which now is, and formerly hath been generally acknow-
ledged, by the moſt experienced Practitioners, to be more ef-
fectual for the extirpating and rooting out the firſt Cauſes of tedious and chro-
nical Diſtempers, which from the Difficulty of the Cures ariſing princi-
pally from the Want of good Medicines, prove generally the Shame of Phy-
ficians: Having, I ſay, by long Study, and many Experiments, at laſt at-
tained to a Medicine of excellent Virtue and Influence; it juſtly merits the
Title by which I denominate it, *viz.*

𝕷𝖔𝖈𝖐𝖞𝖊𝖗'𝖘 𝖀𝖓𝖎𝖛𝖊𝖗𝖘𝖆𝖑 𝕻𝕴𝕷𝕷.

The Pilulæ Radiis Solis Extractæ were popular in the seventeenth century,
and Lockyer guarded his formula carefully, making arrangements for it to pass
to trusted people "from whom only … you can have this true Solar Preparation
after my Death." He also wrote his own epitaph now on a wall in Saint Saviour's
Church in Southwark, London. Part of it reads: "His virtues and his Pills are
so well known, That envy can't confine them under stone. But they'll survive
his death, and not expire Till all things else, at th' Universal fire!"

POTTER'S
VEGETABLE CATHOLICON.

HERCULES, AIDED BY IOLAS, DESTROYING THE HYDRA.

———

A SOVEREIGN REMEDY IN

Diseases of the Liver: Debility resulting from intemperance and dissipation:
Old and inveterate Ulcers: Pains in the Bones, attended with swellings
of the joints: Indigestion: Blotches on the Face, Pimples, &c.
Syphilis: Cutaneous diseases generally, and Tetter in
particular: Mercurial and Scrofulous com-
plaints.

A CALM APPEAL

TO

THE PUBLIC;

IN WHICH

THE EXTRAORDINARY VIRTUES OF THIS MEDICINE ARE DE-
SCRIBED, AND A FEW CASES DETAILED, WHEREIN
ITS EFFICACY HAS BEEN TESTED.

INCLUDING THE

FIRST LETTER OF W. W. POTTER

TO THE

MEDICAL SOCIETY.

———

PHILADELPHIA,
October, 1828.

No. 37
W. W. Potter, Potter's
Vegetable Catholicon, 1828

Printed in Philadelphia

In this booklet on the significance of his Catholicon, Potter calls attention
to the unscrupulous actions of his competitors who sell many spurious
compositions as "possessing equal efficacy, or being the very same." To
protect the public, "the genuine Catholicon is put up in Patent Bristol
Bottles with a label representing Hercules, aided by Iolas, destroying the
Hydra." This image was not unique to Potter's product, both Swaim's
Panacea and Radam's Microbe Killer used it as well.

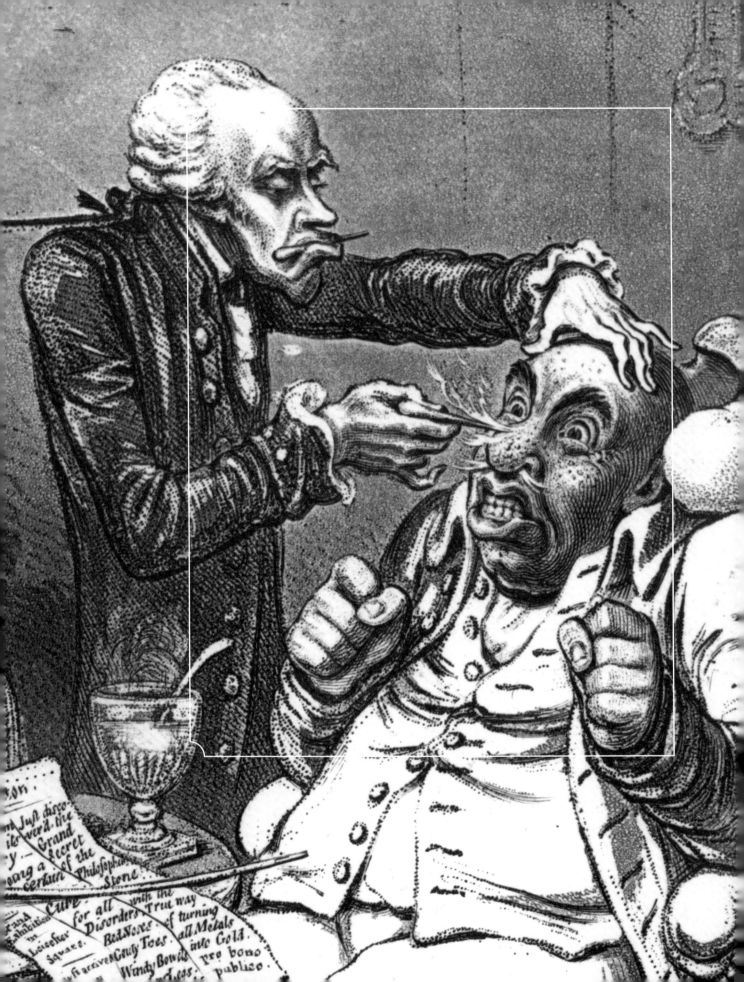

Systems.

In the treatment of pain and disease, there have always been alternative healers—folk healers, religious healers, cunning men, cunning women, those who could cure by the laying on of hands, those who could diagnose by feeling bumps on the head, studying a flask of urine, peering into the iris of the eye or looking at the lines on the soles of the feet. In therapeutics, however, in the years prior to the nineteenth century, proprietary medicines largely emulated the drugs prescribed by licensed physicians. But after the nineteenth century began, new sectarian ideas spawned new therapeutic approaches offering unconventional means of fighting disease. In 1810, Samuel Hahnemann published his theories that like cures like (*similia similibus curantur*) and that the dynamic effect of drugs is enhanced by giving them in infinitesimal dosages. In 1813, Samuel Thomson received a patent giving him the exclusive right to sell the botanicals, primarily lobelia inflata, which could remove cold, which he preached was the cause of all disease. In 1825, James Morison introduced his Hygeian System, based on the theory that impure blood was the source of all disease and that vegetable purgatives alone would provide relief. A Silesian peasant, Vincenz Priessnitz, and a Bavarian pastor, Father Kneipp, actively promoted Hydrotherapy for its creative uses of water. Taken internally as well as externally, water could treat a broad variety of physical and mental ailments. The use of magnetism for therapeutic purposes began in the eighteenth century with the magnetic fluid of Franz Anton Mesmer (p. 101) and the metallic tractors of Elisha Perkins (p. 111). Both treatments subsequently proved worthless, but grew in influence with nineteenth-century discoveries such as radioactivity and technological advances such as Pasteurization. Still other schemes and cults capitalized on the latest scientific findings, for medical entrepreneurs have always been quick to attach themselves to discoveries. Products such as Radam's Microbe Killer, composed almost entirely of tap water, exemplify such opportunism. 🙰

No. 38

Les Homéopathes: premier traitement—les doses et les guérisons infiniment petites (The Homeopaths: First Treatment—infinitely small doses and recoveries), 1843

CHARLES JACQUE (French, 1813–1894)
Lithograph; 9 x 7⅜ in. [22.9 x 18.7 cm]
Philadelphia Museum of Art. The William
H. Helfand Collection. 1993-105-79
From *Le Charivari*

LES MALADES ET LES MÉDECINS.

LES HOMÉOPATHES.
PREMIER TRAITEMENT. — LES DOSES ET LES GUÉRISONS INFINIMENT PETITES.

D'après ce que me dit votre langue je vois que vous avez besoin d'être purgé… voici un petit morceau de **manne** …vous en prendrez demain un léger fragment avec la pointe d'une aiguille et vous le ferez dissoudre dans une carafe d'eau vous avalerez une demi cuillerée de cette eau et vous jeterez le reste surtout n'avaler pas la cuillerée entière car sans cela vous seriez trop guéri … et alors je ne répondrais plus de vous !

In the text accompanying the print, directions to the patient ridicule the minute doses prescribed by homeopaths: "you need to be purged…Here is a little piece of manna…tomorrow you will take a small fragment of it with the tip of a needle and you will dissolve it in a jug of water…swallow half a teaspoonful of this water and throw the rest away…don't swallow the whole spoonful because you will be overly cured…then I will not be responsible for you."

No. 39

L'Homéo-pathos et les Homéopathes: Nous n'admettons que très peu de remèdes ... (Homeopathy and the Homeopaths: We only accept very few remedies ...), c. 1860

ED. MORIN
(French, nineteenth century)
After Gustave Doré (French, 1832–1883)
Color lithograph; 9¾ x 7¾ in.
[24.8 x 19.8 cm]
Philadelphia Museum of Art.
The William H. Helfand Collection.
1993-105-60

The homeopath in this image explains the homeopathic system and its predilection for extremely small doses: "We use very few remedies, we only administer them one at a time and yet we only give one hundred-millionth of a grain diluted in a glass of water…, so you see the medicine is infinitely small."

THE

INFLUENCE

OF THE

BLUE RAY OF THE SUNLIGHT

AND OF THE

BLUE COLOUR OF THE SKY,

IN DEVELOPING ANIMAL AND VEGETABLE LIFE;
IN ARRESTING DISEASE, AND IN RESTORING HEALTH IN ACUTE AND
CHRONIC DISORDERS TO HUMAN AND DOMESTIC ANIMALS,

AS ILLUSTRATED BY THE EXPERIMENTS OF

GEN. A. J. PLEASONTON, AND OTHERS,

Between the years 1861 and 1876.

———

Addressed to the Philadelphia Society for Promoting Agriculture.

———

" Error may be tolerated, when reason is left free to combat it."—Thomas Jefferson.
" If this theory be true, it upsets all other theories."—Richmond Whig.

———

PHILADELPHIA:
CLAXTON, REMSEN & HAFFELFINGER, PUBLISHERS.
1877.

No. 40
Augustus J. Pleasonton,
The Influence of the Blue Ray
of the Sunlight and of the
Blue Colour of the Sky, 1877

Published by Claxton, Remsen &
Haffelfinger, Philadelphia

General Pleasonton believed that light rays filtered through blue glass could arrest disease and restore health in both acute and chronic disorders for both humans and domestic animals. His treatise was, naturally, printed on blue tinted paper with dark blue ink "in an attempt to relieve the eyes of the reader from the great glare, occasioned by the reflection of gas light at night from the white paper usually employed in the printing of books."

No. 41

Blue Glass March, 1877

J. STEINEGGER (American)
Song sheet cover; 14 x 10¾ in. [35.6 x 27.3 cm]
Music by E. Mack, Philadelphia
Published by F. A. North & Co.

No. 42

Blue Glass Galop, 1877

ANONYMOUS (American)
Song sheet cover; 13⅝ x 10⅝ in. [34.6 x 27 cm]
Music by Samuel H. Speck, New York
Published by Millet & Co., New York

In the same year his book was published, General Pleasonton also inspired three songs. On the same cover used for both the "Blue Glass Schottische" and the "Blue Glass March," a man has been able to remove his crutches because of the positive action of light shining through blue glass.

No. 43

**S. Pancoast, Blue and Red Light:
or Light and its Rays as Medicine,** 1877

Published by J. M. Stoddart & Co., Philadelphia

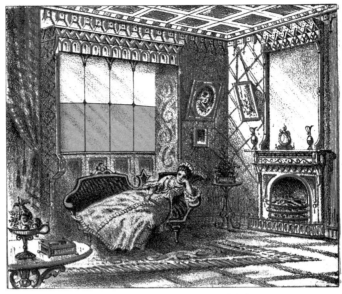

APPLICATION OF RED LIGHT, Full Bath.

APPLICATION OF RED LIGHT, Partial.

Not to be outdone by General Pleasonton (p. 96), who advocated treatment of patients by filtering light through blue glass, this work explained "How to apply the red and blue rays in curing the sick and feeble." The pages are printed with blue ink in a red border. Pancoast, a physician, gives full credit to Pleasonton, but claims that he deserves the merit and honor of broader discoveries, particularly in the treatment of nervous diseases.

FACHEUX RÉSULTAT DES TRAITEMENS SUIVIS PAR M. GOBETOUT, BOURGEOIS DE PARIS.

VIGNETTES PAR CHAM.

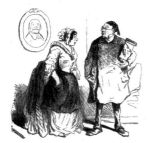

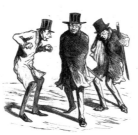

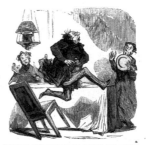

—Comment, monsieur Gobetou', vous allez suivre un traitement médical?... vous n'êtes pourtant pas malade! —Oui, madame, je me porte bien, c'est vrai, mais il y a des gens qui se portent très bien... je veux devenir comme eux.

S'étant mis, pour commencer, au traitement de la moutarde blanche, M. Gobetout fait éternuer toutes les personnes qui ont le malheur de se trouver sur son passage.

N'ayant pas veillé suffisamment à la qualité de la graine de moutarde qu'il devait avaler, le remède tourne au sinapisme à la grande frayeur des personnes chez lesquelles notre personnage se trouvait en ce moment.

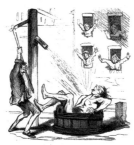

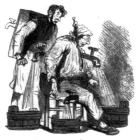

M. Gobetout renonce à la moutarde pour se livrer tous les matins au régime hydropathique au grand scandale de tous les voisins ayant vue sur sa cour.

M. Gobetout ayant abusé de l'hydropathie est traité par un marchand de robinets qui arrive heureusement à temps pour le sauver.

M. Gobetout s'applique une chaîne-électro-magnétique, ce qui fait qu'il ne peut plus causer un peu tranquillement avec un ami sans le plonger dans un sommeil non moins profond que somnambulique.

Renonçant à la chaîne électro-magnétique, M. Gobetout prend un médecin homéopathe dont il veut payer la première visite avec une partie infinitésimale d'une pièce de cinq francs.

M. Gobetout, ne se sentant pas mieux se fait analyser par l'inventeur de la médecine chimique.

Comme quoi le neveu de M. Gobetout finit par se trouver très bien de tous les traitemens suivis par son oncle.

No. 44

Facheux résultat des traitemens suivis par M. Gobetout, bourgeois de Paris (**Troublesome Result of Treatments Followed by M. Gobetout, Citizen of Paris**), c. 1845

AMÉDÉE-CHARLES-HENRI, COMTE DE NOÉ, [CHAM] (French, 1819–1879) Lithograph; 10¾ x 9 in. [27.3 x 22.9 cm] From *Le Charivari*

This satire on the variety of nineteenth-century medical sects illustrates the tribulations of poor Mr. Gobetout (Mr. Swallow Everything) as he is treated by a series of practitioners. Even though he feels good at the start, by the time he is finished with white mustard, a mustard plaster, hydropathic treatment, a Mesmeric tub, a visit to the homeopath and a chemical analysis, he is completely done in.

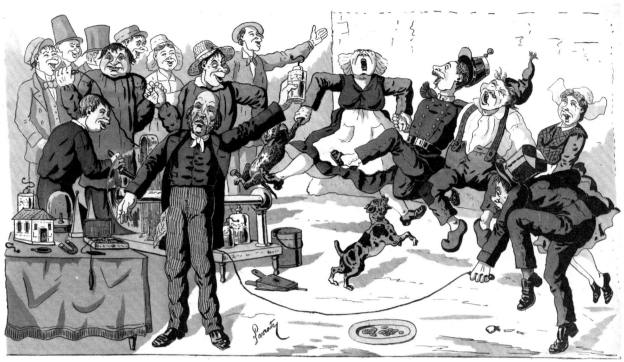

Avec mes connaissances, Mesdames et Messieurs, je devrais travailler dans un palais, et c'est par dévouement que je viens sur cette place propager ma science aux nombreux ignorants qui ont l'honneur de m'écouter.

Dans un instant, j'aurai celui de mettre le tonnerre de Dieu en bouteille; auparavant, je veux vous

faire éprouver à tous la douce et agréable sensation de l'électricité. Si parmi la société de crétins qui m'environne, il se trouve un bossu quelconque, qu'il approche sans hésiter, et je le *foudroie* instantanément.

Venez tous, ignorants que vous êtes, apprendre et vous instruire, ça ne coûte que deux sous; attention, je commence!!!

No. 45

Avec mes connaissances, Mesdames et Messieurs, je devrais travailler dans un palais…(With my knowledge, ladies and gentlemen, I should be working in a palace…), c. 1860

LAVRATE (French, ?–1888)
Color lithograph; 12½ x 19¼ in. [31.8 x 48.9 cm]

A prominent part of Mesmeric treatment was bacquets, a series of magnetic tubs containing a mixture of hydrogen sulfide with its odor of rotten eggs and other ingredients. Patients formed themselves into a ring, holding hands, with those on the ends holding iron conductors attached to the tubs. Lavrate's caricature gives a fairly good idea of such Mesmeric treatment, but his physician ridicules the ignorance of the patients being treated.

No. 46

Une Application utile du diamant magnétiseur
(A Useful Application of the Diamond Hypnotist), c. 1845

HONORÉ DAUMIER (French, 1808–1879)
Lithograph; 8⅜ x 10½ in. [21.3 x 26.7 cm]

maison Martinet, 172, r. Rivoli et 41, r. Vivienne

Lith.Destouches, 28, R.Paradis.Pse.Paris.

UNE APPLICATION UTILE DU DIAMANT MAGNÉTISEUR

– Ma femme est bien magnétisée !....... je peux filer tranquillement pour le bal de l'opéra....dors bien bobonne !....

Although Franz Anton Mesmer (1734–1815) announced his discovery
of the role of the magnetic fluid in the eighteenth century, interest in
hypnotism did not reach its peak of popularity in France until the 1840s.
Daumier published several caricatures on the craze, including this one in
which a man hypnotizes his wife so that he can attend a costume ball.

No. 47

Les Hydropathes: premier traitement—libation, absorption et... indigestion! (The Hydropaths: first treatment—drinking, absorption and...indigestion!), 1843

CHARLES JACQUE (French, 1813–1894)
Lithograph; 12 x 8⅜ in. [30.5 x 21.3 cm]
Philadelphia Museum of Art. The William
H. Helfand Collection. 1993-105-82
From *Le Charivari*

LES HYDROPATHES.
PREMIER TRAITEMENT — LIBATION, ABSORPTION ET INDIGESTION!

Buvez de l'eau buvez de l'eau, tout est là... aujourd'hui pour commencer le traitement nous nous contenterons de cinquante sept gobelets ... demain vous en avalerez soixante quinze après demain quatre vingt dix en suivant ce régime et cette progression avant trois mois vous serez complètement guéri croyez moi et buvez de l'eau

Hydropathy or water therapy became popular in the nineteenth century, used internally at spas where copious quantities were prescribed, or externally in the form of baths, showers, wrappings, douches and irrigations. In this print, the hydropath prescribes a dose of fifty-seven goblets to start, "tomorrow we will swallow seventy-five ... after tomorrow, ninety.... By following this diet and this progression, you will be completely cured in three months."

No. 48

Water Cure Polka, c. 1865

Song sheet cover; 14 x 10 ⅝ in.
[35.6 x 27 cm]
Music by Ch. Schuster, Boston
Published by Oliver Ditson,
Boston

Although the use of water as a cure for disease goes back to the time of Roman baths, its popularity in the nineteenth century can be traced to the work of Vincenz Preissnitz, a Silesian peasant whose pain from crushed ribs was relieved by cold water bandages. The growing proliferation of water-cure establishments in the United States generated popular literature and music, exemplified by the "Water Cure Polka," a piece of sheet music presenting a handsome wood engraving of a water-cure establishment managed by two physicians.

No. 49

Dr. I. Edrehi, Native of Turkey...Has for Sale...Amulets, Which Is a Preventative of Cholera, Scarlet Fever, and Other Contagious Diseases, c. 1845

Broadside; 7½ x 4½ in. [19.1 x 11.4 cm] Printed in the United States

No. 50

Basil Burchell, The True State of the Question, Concerning Dr. Chamberlen's Anodyne Necklace, c. 1825

Four-page brochure; 7½ x 4½ in. [19.1 x 11.4 cm] Printed in London

DR. I. EDREHI,

Native of Turkey, has the honor to announce to the Public that he has for sale, an excellent article, called—

AMULETS,

Which is a preventative of Cholera, Scarlet Fever, and other contagious diseases. It was extensively worn in England during the rage of Cholera in 1832, and was approved by the Medical Faculty, in that country.

The Amulet is a berry that grows upon a tree in a Botanic Garden, on Mount Lebanon, near Jerusalem. It has been patronized in the four quarters of the world. The Amulet is an excellent article to prevent the spread of contagious diseases. From its smell it is a preventative of fevers and general decline of the system. It is worn around the neck, for ornament as a necklace, and also around the wrist as a bracelet. From its strong odor it is an excellent preventive of Moths in clothing.

This article is patronized in England, France and Italy, and has likewise acquired universal patronage in America. No one should be without the Amulets.

They are sold at the following prices :—Necklace, $1, Double Size Necklace, $2; Watch Chains, $1 50.

This Turkish Amulet is the best thing to be found for Perfuming, the greatest ever in this country. This Amulet is good to wear, and to put into Ladies' Furs in the Summer, as many have lost their valuable furs by moths; for if one moth comes it breeds a hundred, so that it bites the whole thing to pieces. By putting the Amulets in the Furs, or other things in which moths infest, it will preserve them new and whole. The Amulet is known all over America, for its merit and goodness. It cannot be obtained elsewhere.

Residence, at _____

☞ *Also, Amulet Purses for Sale.*

This AMULET Acts as a Charm by Wearing it.

At BASIL BURCHELL's
Sole Proprietor, and Preparer of the Anodyne
Necklace to the late KING, for the ROYAL FAMILY,
79, LONG-ACRE,
Two Doors from Drury-Lane:
(And by his Appointment) *positively* no where else in *London*—are sold the

ANODYNE NECKLACES,

—Price 9 s.—

The True State of the Question,
Concerning Dr. CHAMBERLEN'S

ANODYNE NECKLACE,

For Children's Teeth, Fits, Fevers, &c.

THIS Remedy, the Invention of Dr. TANNER, a Physician of repute, having been by his directions used for some years in his private Practice in several Families of distinction, in order to give Ease to Children Breeding and Cutting their Teeth, is not an internal Medicine, which all Children are averse to take, but a Remedy prepared in the Form of a Necklace, to be worn loose about their Necks, which no Child will dislike even when it refuses all internal Physic, and which has invariably acted by a secret friendly *Sympathetic* Quality so efficaciously on Infants, who had only worn them

Dr. Edrehi's amulets were to be worn as a necklace or on the wrist as a bracelet. They were intended to ward off cholera, scarlet fever and all contagious diseases. They would also protect clothing from moths. Dr. Chamberlen's Anodyne Necklace was for teething. It had a long life thanks to extensive promotion dating from early in the eighteenth century. To stimulate sales, the proprietors promised that "a fresh Necklace must be more beneficial than one that has been worn for months."

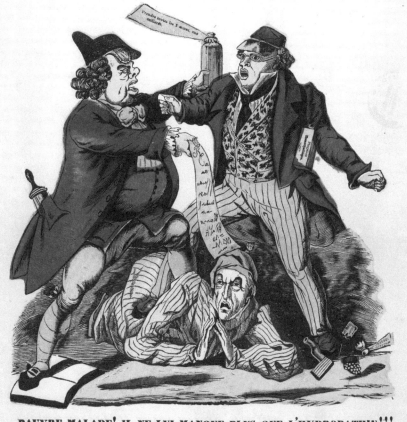

No. 51

La Guerre des médecins des 18e et 19e siècles (The Physician's Battle in the 18th and 19th Centuries), c. 1860

ANONYMOUS (French)
Color lithograph; 16¼ x 12⅞ in.
[41.3 x 32.7 cm]
Printed by Gangel, Metz

While a homeopath and allopath battle over the merits of their conflicting systems, the poor patient remains in severe distress. As the caption below this image notes, the patient appears to be missing only treatment by the hydropaths to reach the limits of his difficulties. A footnote explains that homeopathy provides cures by similars, thus "if you are poisoned, take poison."

A

GUIDE TO HEALTH,

BEING AN

EXPOSITION OF THE PRINCIPLES

OF THE

THOMSONIAN SYSTEM OF PRACTICE,

AND THEIR

MODE OF APPLICATION

IN THE

CURE OF EVERY FORM OF DISEASE;

EMBRACING A CONCISE VIEW OF

THE VARIOUS THEORIES OF ANCIENT AND MODERN PRACTICE.

BY BENJAMIN COLBY.

Second Edition, enlarged and revised.

Let us strip our profession of every thing that looks like mystery.—RUSH.

MILFORD, N.H.
JOHN BURNS.
1845

Colby was one of many popularizers of Samuel Thomson's system, a therapeutic program in which six botanical drugs were to be used in sequence. Thomson put forth his ideas in the 1820s in opposition to excessive use of calomel and other mineral drugs, and concurrently marketed his program by selling "rights" to agents for twenty dollars, an exorbitant sum at the time. Colby includes the verses to "Calomel," a song, made popular by the Hutchison Family Singers in the 1840s, which dramatized the horrors of calomel treatment for venereal disease.

THE CURAPATHIST.

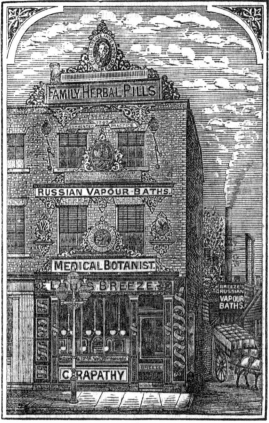

No. 53
**Louis Breeze,
The Curapathist,**
1878

Printed in London

ISSUED BY

LOUIS BREEZE, M.B.,
BROADWAY, STRATFORD,
LONDON.

PRICE ONE SHILLING.

ENTERED AT STATIONERS' HALL

Breeze was a late disciple of Thomsonianism. He advocated botanicals, air, light, electricity, exercise, rest, herbs and mechanical or surgical appliances as remedial agents for the ills of mankind, but almost no drugs. Like Samuel Thomson (1769–1843), he advocated free use of lobelia inflata as an emetic. Breeze offered an extensive product line, and his office and manufacturing building in London provided facilities for medicated vapor baths.

No. 54

Le Solitaire, (The Solitaire),
c. 1895

ARMAND JEAN-BAPTISTE
SEGAUD (French, born 1875)
Color lithograph; 48 ⅝ x 34 ⅝ in.
[123.6 x 87.9 cm]

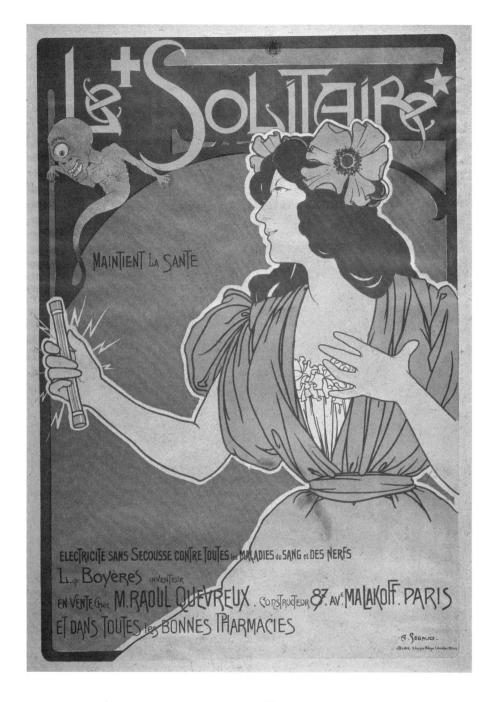

Le Solitaire was an apparatus invented by L. de Boyéres that was purported
to cure all blood and nerve disorders. Charlatans such as de Boyéres have
always thrived on advances in technology, using electricity, radium and even
moon dust as the bases for outlandish claims. Segaud has drawn a magnified
extraterrestrial figure as his interpretation of the microbe supposedly
destroyed by the rays emitted from Le Solitaire.

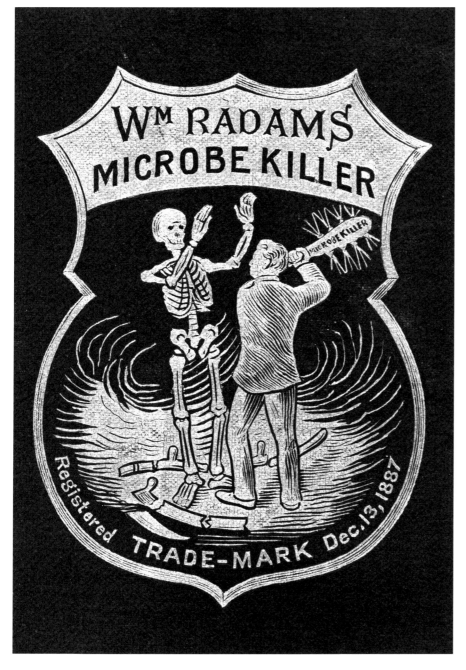

No. 55
**William Radam, Microbes
and the Microbe Killer,** 1890

Published by the Knickerbocker
Press, New York

Scientific advances have long served as sources for promotional ideas for proprietary medicines. Electricity, the germ theory, X-rays, radioactivity or any other new discovery can quickly find a counterpart nostrum using newly discovered technology as the promotional concept. Radam used the discoveries of Robert Koch and Louis Pasteur to promote his Microbe Killer. In the appendix, Radam gives his perspective on an independent analysis that showed that the Microbe Killer contained hydrochloric and sulfuric acids, results which he vehemently denied.

No. 56

**The True and Lively Pourtraicture
of Valentine Greatrakes Esq of
Assane in Ye County of Waterford
in Ye Kingdome of Ireland
Famous for Curing Several
Deseases and Distempers by the
stroak of His Hand Only,** 1794

ANONYMOUS (English)
Engraving; 7¼ x 5½ in. [18.4 x 14 cm]
Published by W. Richardson Castle

The true and truely Pourtraicture of Valentine Greatrakes Esq
of Affane in y.e County of Waterford in y.e Kingdome of Ireland
famous for curing several Deseases and distempers
by the stroak of his Hand only.

Pub.d March 20.th 1794 by W. Richardson Castle St. Leicester Square.

Scrofula, a malady characterized by chronic enlargement and degeneration
of the lymphatic glands, was long thought to be curable by the king's
touch. A durable superstition that began in the eleventh century, it was
mainly practiced by English and French kings. Though not a king,
Valentine Greatrakes developed a broad following, claiming that he,
too, could cure scrofula, the king's evil, merely by his personal touch.

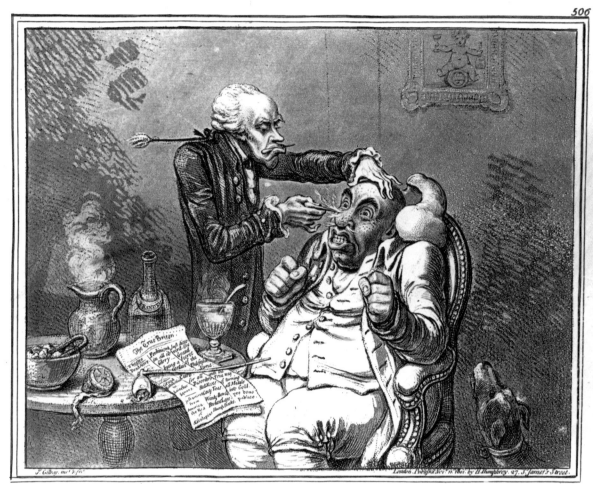

METALLIC-TRACTORS.

No. 57

Metallic-Tractors, 1801

JAMES GILLRAY (English, 1757–1815)
Hand-colored etching and aquatint; 9¾ x 12⅜ in. [24.8 x 32.9 cm]
Philadelphia Museum of Art. The William H. Helfand Collection. 1988-102-95

In this print, the operator applies metallic tractors to ease the pain of the carbuncles on this red-nosed patient resembling John Bull. The tractors, brass and iron instruments, were patented in the United States by Elisha Perkins (1741–1799), a Connecticut physician, who claimed his invention could draw out disease by electrical force. The newspaper notes that the instruments were "a certain Cure for all Disorders, Red Noses, Gouty Toes, Windy Bowels, Broken Legs, Hump Backs."

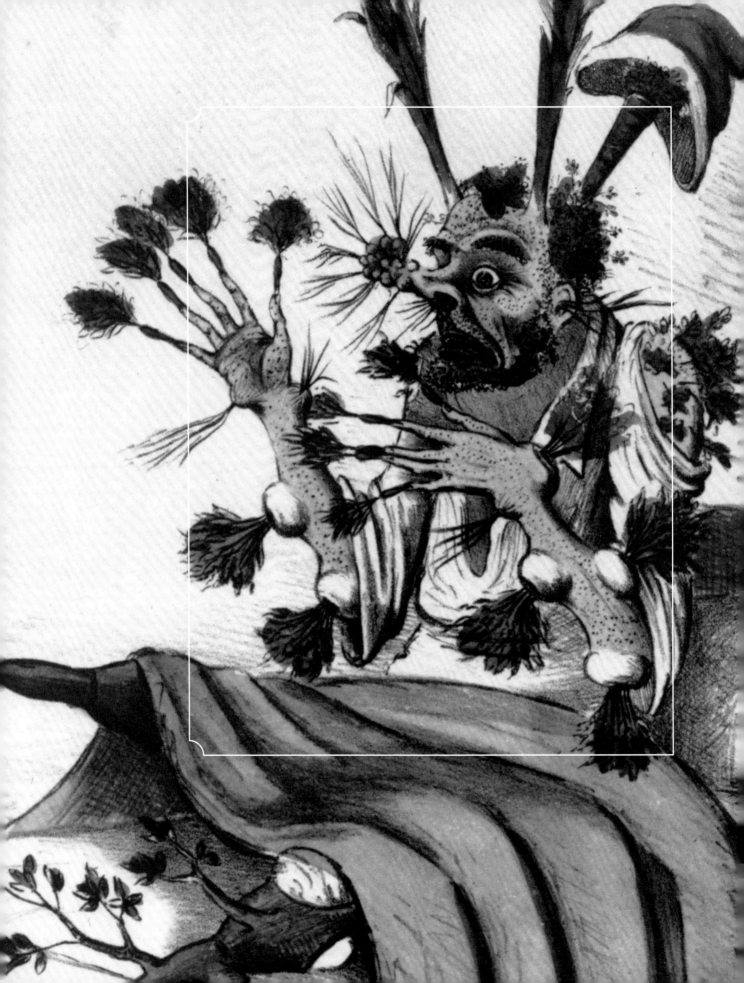

Morison's Pills.

James Morison (1770–1840) was one of the earliest proprietary
medicine sellers to adopt a unique strategy to differentiate his invention
from the more common varieties. Launching Morison's Pills in 1825, he soon
developed a marketing program in which orthodox physicians (the "Guinea
Trade" as he called them) were conceived as the enemy, and were attacked
for their propensity for charging high fees and for prescribing toxic chemicals.
Morison's pills contained no such harsh ingredients for they were made
exclusively of vegetable matter; they were available in two forms, plainly
labeled No. 1 and No. 2, one twice the dose of the other. There was no disease
or malady they could not cure, and if two pills did not work, then four were to
be taken. The pills contained laxatives—aloes, jalap, gamboge, colocynth and
rhubarb—in varying amounts, for the formula changed over the years, and at
times patients swallowed excessive quantities with occasionally fatal results.
Morison styled himself "The Hygeist," and stressed the importance of his
ten-point system, the Hygeian System, its essence being that all pain and
disease arose from impurities in the blood and that purgation by vegetables
was the only effectual means of eradicating them. On Morison's death in
1840 (reaching for a box of his pills, it was said), his successors continued
the successful strategies, adding a series of "Hygeian Illustrations," venomous
attacks on licensed medical practitioners. At the same time, caricaturists
reacted to the hyperbole in Morison's advertising by creating more than
25 prints in which the pills perform incredible acts such as restoring an
amputated leg or saving sailors from drowning. 🙰

No. 58

Mr. Morison, the Hygeist, President of the British College of Health, c. 1835

ANONYMOUS (English)
Lithograph; 8⅛ x 5 in. [20.6 x 12.7 cm]

MR. MORISON,
THE HYGEIST,
President of the British College of Health.

James Morison was born near Aberdeen in Scotland and after many years of travel in Europe and the West Indies, he returned and became interested in the proprietary medicine trade. His formula contained only natural ingredients, and he styled himself "The Hygeist," calling his business The British College of Health. He advertised his pills for all possible conditions by attacking the medical profession as the enemy, and at the time of his death in Paris, he had achieved a substantial commercial success.

No. 59

Charles de Saint-Félix, Morisoniana Français ou Nouvelle Doctrine Médicale de l'Hygeist Morison (The French Morisoniana or the New Medical Doctrine of Morison, The Hygeist), 1836

Published by Delaunay, Libraire, Palais-Royal, Paris

This 150-page work was part of Morison's campaign to inform the French about his career and his system. It includes a biography, details on the Pills' successes and reports from Dr. Thollausen, Morison's agent in Moldavia, recounting the problems faced in this expansion, "You will appreciate the difficulty I have encountered in extolling your method of curing the sick; the first time it was brought up, all the physicians were united to destroy the new system and to block its advance."

No. 60

James Morison, Morisoniana; or, Family
Adviser of the British College of Health, 1831

Published by the College of Health, London

MORISONIANA ;

OR,

FAMILY ADVISER

OF THE

BRITISH COLLEGE OF HEALTH.

BEING A COLLECTION OF THE

WORKS OF MR. MORISON, THE HYGEIST;

COMPRISING

" ORIGIN OF LIFE, AND TRUE CAUSE OF DISEASES EXPLAINED "
—"IMPORTANT ADVICE TO THE WORLD"—" LETTER ON
CHOLERA MORBUS OF INDIA"—"ANTI-LANCET," IN SIX
NUMBERS—AND " MORE NEW TRUTHS."

FORMING A

COMPLETE MANUAL

FOR

INDIVIDUALS AND FAMILIES

FOR EVERY THING THAT REGARDS PRESERVING THEM IN
HEALTH, AND CURING THEIR DISEASES.

THE WHOLE TRIED AND PROVED BY THE

MEMBERS OF THE BRITISH COLLEGE OF HEALTH,

AS THE ONLY TRUE THEORY AND PRACTICE OF MEDICINE;

And thus furnishing ample testimony that

THE OLD MEDICAL SCIENCE IS COMPLETELY WRONG.

WITH

AN APPENDIX,

CONTAINING

A SHORT TREATISE ON THE ORIGIN AND ERADICABILITY OF
THE SMALL POX,

Numerous well-authenticated Cures, and other interesting matter.

" Every one may now be his own doctor and surgeon, at a cheap rate, and enjoy a
sound mind in a sound body."

THIRD EDITION.

PRINTED FOR AND SOLD AT THE COLLEGE OF HEALTH

LONDON ;

AND BY ALL THE AGENTS IN TOWN AND COUNTRY

Price 10s.

1831.

In this collection of writings, Morison attacks the medical profession at every turn, beginning with the title page, which proclaims simply that "the old medical science is completely wrong." The book reproduces six issues of the *Anti-Lancet,* a publication in which Morison tried to show that his pills could be used in place of other agents for a broad variety of diseases.

FIFTH EDITION

OF THE

PRACTICAL PROOFS

OF THE SOUNDNESS OF THE

Hygeian System of Physiology,

GIVING INCONTROVERTIBLE TESTIMONY TO THE AFFLICTED,

OF THE

INESTIMABLE VALUE OF

MORISON'S VEGETABLE

UNIVERSAL MEDICINES,

Including, with other matter,

'The Origin of Life, and Cause of all Disease Explained;'

AN ENTIRELY NEW VIEW

OF THE

ORIGIN OF THE SMALL-POX VIRUS,

And of its being most certainly

ERADICABLE, OR RENDERED HARMLESS;

AND SUNDRY CASES OF CURE,

WITH MOST IMPORTANT INFORMATION

Connected with the Successful Promulgation

OF

THE HYGEIAN SYSTEM

IN

THE UNITED STATES OF AMERICA.

NEW YORK:

PRINTED BY W. MITCHELL, 265, BOWERY,

For Dr. H. SHEPHEARD MOAT; and to be had at the offices, 148, Fulton
Street, and at 50, Canal Street; and of every duly authorized Agent for
dispensing the Hygeian Medicines throughout the United States.

1834.

No. 61

**James Morison, Practical Proofs
of the Soundness of the Hygeian
System of Physiology..., 1834**

Fifth edition; printed by W. Mitchell,
New York, for Dr. H. Shepheard Moat

In this publication intended for the American market, Morison included
reports of his agents in several states attesting to the public acceptance
of his Vegetable Universal Pills, as well as discussions on the cholera
epidemic in India and on smallpox. As to cholera, Morison stressed that
"on the first symptoms of the disease … the patient take a strong dose of
the Vegetable Universal Pills, No. 2, 15 or 20 pills." This would have been
his recommendation for many other afflictions as well.

No. 62

Oh! Mam I've Got So Thin, That Only One Person Can See Me at a Time, c. 1835

ANONYMOUS (English)
Hand-colored lithograph;
9⅝ x 7⅜ in. [24.4 x 18.7 cm]

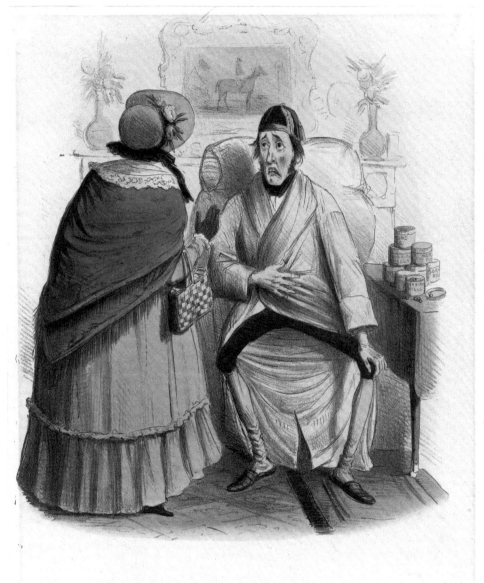

Oh! Mam I've got so thin, that only one person can see me at a time.

The reason for the patient's complaint lies in the huge dose he has taken of Morison's Pills. This was not surprising, for Morison recommended large doses, the average being 15 to 20 pills per day. In the introduction to *Morisoniana* (p. 116) he writes "patients have taken 30, 40 and 50 pills at a time in severe and urgent cases; and what was the consequence? Nothing but that they were sooner well." And in some cases dead.

No. 63

Singular Effects of the Universal Vegetable Pills on a Green Grocer! A Fact!, 1841

CHARLES JAMESON GRANT (English, mid-nineteenth century)
Hand-colored lithograph; 10¾ x 9⅞ in. [27.3 x 25.1 cm]
Philadelphia Museum of Art. The William H. Helfand Collection. 1988-102-100

No. 64

Hodgsons Genuine Patent Medicines—Morisons Pills, c. 1840

ANONYMOUS (English)
Color lithograph; 8⅛ x 5¾ in. [20.6 x 14.6 cm]

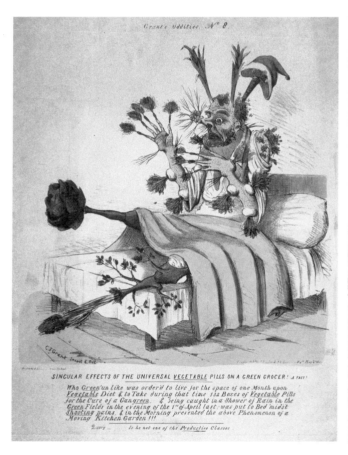

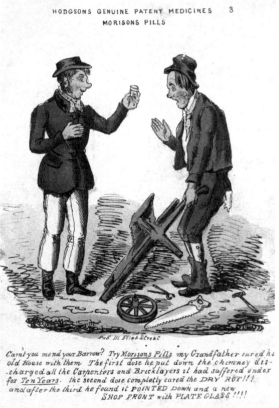

Morison's ubiquitous and excessive promotion for his pills, promising cures for almost all ailments, provoked considerable critical and satirical reaction. Grant's print shows the frightening—but humorous—side effects when a grocer was caught in the rain after having taken "132 Boxes of Vegetable Pills," an event which took place on the preceding April 1. Similarly, the conversation of two men points out other uses for the pills.

Extraordinary Effects of Morrisons Vegetable Pills!, 1834

CHARLES JAMESON GRANT (English, mid-nineteenth century)
Lithograph; 13 x 10⅝ in. [33 x 27 cm]

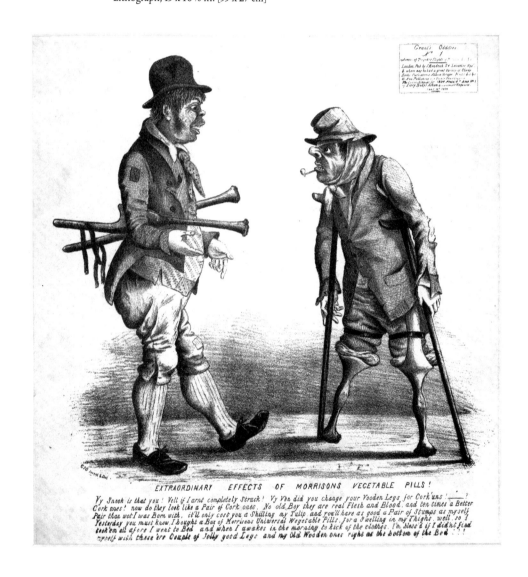

The caption notes significant side effects, "I bought a Box of Morrison's Uniwersal Vegetable Pills, for a Swelling in my Thighs. Well, so I took'em all afore I went to Bed and when I awakes in the morning to kick of the clothes I'm bless'd if I didn't find myself with these 'ere Couple of Jolly good Legs and my Old Wooden ones right at the bottom of the Bed!!!"

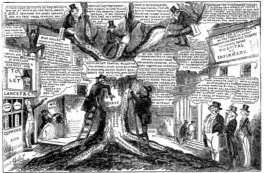

No. 66

Truth of the Hygeian System, Illustrated by Hygeists, c. 1840

ANONYMOUS (English)
Broadside; 13⅜ x 6¼ in. [34 x 15.9 cm]
Printed by Dean and Co., London

Here the makers of Morison's Pills metaphorically compare two trees, the first a healthy tree that is in a flourishing state because it is treated by the Morisonian system, which drains its roots of all impurities. In contrast, the tree under the care of physicians is full of decay. In the text there is a note that no chemist or druggist is permitted to sell Morison's Pills, only his agents have the right.

Medical Confessions of Medical Murder, c. 1840

ANONYMOUS (English)

Wood engraving; sheet 17⅜ x 22⅜ in. [44.1 x 56.6 cm]

Philadelphia Museum of Art. The William H. Helfand

Collection. 1988-102-14

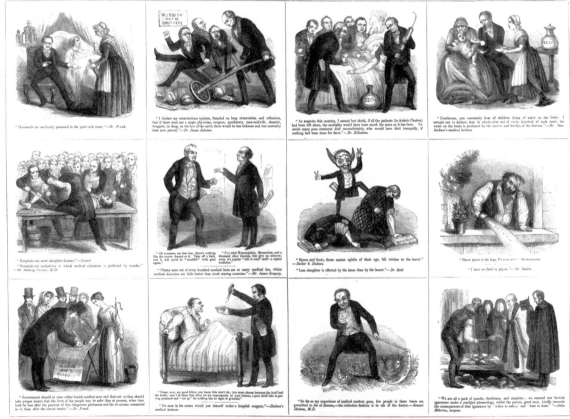

In their advertisements, Morison's successors steadfastly attacked the medical profession, but in this print they went further than usual. It shows twelve medical scenes, which illustrate statements from prominent physicians, often taken out of context, and one from William Shakespeare. The "confessions" denounce unnecessary surgery, excessive prescribing of patent medicines, ineffectiveness of hospitals and other baneful practices.

No. 68

Downfall of the Colleges of Discord; The Hygeian Hercules Cleansing the Augean Stables, 1846

ANONYMOUS (English)
Colored wood engraving; 20⅜ x 25½ in. [51.8 x 64.8 cm]
Printed in England

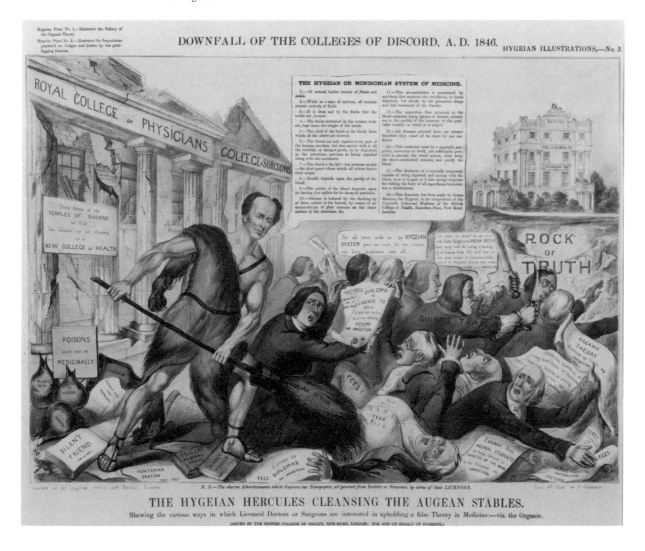

This engraving is another of the "Hygeian Illustrations," a series of savage attacks on the medical profession that were published as propaganda to denigrate orthodox medicine. In this crowded scene, physicians, termed the "Guinea Trade," as well as their fees, their diplomas and their "license to kill" are swept up by the broom of the Hygeian System. The Hygeian System's headquarters, the British College of Health, stands firmly on the "Rock of Truth."

No. 69
Cholera!, 1848

Broadside; 8¾ x 5¼ in. [22.2 x 13.3 cm]
Printed in London

CHOLERA!

Mr. KAINES having received the following Letter from Captain WHITE, whom he has known for the last twenty years, submits it to the Public.

20, *New Road, St. George's East,*
London, Oct. 5th, 1848.

" *To* Mr. J. KAINES,

20, NEW ROAD, St. GEORGE'S EAST, LONDON.

" SIR,—I have for a number of years past made use of Mr. Morison's Medicines, which I have proved to be beneficial in restoring to perfect health all to whom I have administered them. During my last voyage to St. Petersburg, where the Cholera was taking off the stage of life numbers of my countrymen from the doctors' treatment of the disease, I have thought well to inform you of the efficacy of your Pills in restoring me from a severe attack of the same. Two days previous to my leaving Cronstadt, I was attacked with severe purging, and was recommended to take laudanum and peppermint, which I did in connection with cholera tincture and brandy, for three days, which I can affirm only tended to augment the disease, by bringing on severe vomiting, with cramp in my legs and thighs, which made me suspect it would finally prove fatal, and having a small portion of Pills in my possession, I determined, from past experience, to try them as the last resource. I took fifteen of No. 2, and about ten hours after took twelve more, which allayed the vomiting and cramp; and after taking about forty Pills in all of the No. 2, I felt an inclination for food, and took a little boiled rice, as my stomach would bear it, and through the blessing of the Most High was perfectly restored. My Carpenter also had a slight attack, when one or two doses of six Pills each time proved sufficient in his case. You are, therefore, at liberty to give publicity to the same, so that others may be encouraged to give the Pills a fair trial.

I am, SIR,
Yours, respectfully,
THOMAS WHITE.

3, *Allington Place, St. George's East,*
London, Sept. 30, 1848."

In this small broadside, the marketers of Morison's Pills took advantage of fears over a potential cholera epidemic to call attention to their product. The interesting fact about the published letter lies in the number of pills consumed—a total of 40 of the stronger No. 2 pill, after which the patient not surprisingly "felt an inclination for food."

HEALTH SECURED

BY THE USE OF THE

HYGEIAN VEGETABLE
UNIVERSAL MEDICINES

OF THE

BRITISH COLLEGE OF HEALTH,

LONDON.

Which have obtained the approbation and recommendation of Thousands who have been cured

IN CONSUMPTIONS, CHOLERA MORBUS, INFLAMMATIONS, internally or externally; DYSPEPSIA, FEVERS, AGUE, INDIGESTION, BILIOUS or NERVOUS AFFECTIONS, and all diseases of the LIVER, YELLOW FEVER, GOUT, RHEUMATISM, LUMBAGO, TIC DOLOREUX DROPSY, ST. VITUS'S DANCE, EPILEPSY, APOPLEXY, PARALYSIS, PALSEY, GREEN SICKNESS, and all obstructions to which the Female form is so distressingly liable, and which sends so many of the fairest portion of the creation to their untimely graves; SMALL POX, MEASELS, WHOOPING COUGH, SCARLET FEVER, ASTHMA, JAUNDICE, GRAVEL, STONE, and all URINARY OBSTRUCTIONS, FISTULA, PILES, STRICTURES, RUPTURES, and SYPHILIS in all its stages; CONSTIPATED BOWELS, WORMS, SCURVY, ITCHINGS OF THE SKIN, KING'S EVIL, and all CUTANEOUS DISORDERS; in short, every Complaint to which the human frame is so direfully subject, under all their varied forms and names; as the HYGEIAN conviction is, that

MAN IS SUBJECT

TO ONLY

ONE REAL DISEASE,

THAT IS,

To the Impurity of the Blood,

from whence springs every Complaint that can possibly assail his complicated frame, and that is the perpetual struggle of this vital, pure stream of life, (the gift of Almighty power) to disencumber itself of its viscous, acrid humours, with which it has become commixed, through the negligence of parents; the ignorance, or maltreatment of the doctors; or the vicious, or gormandizing propensities of us all.

THIS valuable medicine, being composed only of vegetable matter, or medicinal herbs, and warranted on oath, as containing not one particle of mercurial, mineral, or chemical substances, (all of which are uncongenial to the nature of man, and therefore destructive of the human frame) is found to

No. 70

Health Secured by the Use of the Hygeian Vegetable Universal Medicines of the British College of Health, c. 1845

Four-page brochure; 9⅜ x 6⅛ in. [23.8 x 15.6 cm] Printed in New York

Morison's guiding principle was that that there is only one disease, an impure and imperfect circulation of the blood, and only one possible cure—Morison's Vegetable Pills. This simple fact explained why so many different conditions could be cured by his pills. He elaborated his system into ten major points, two of which were that purgation by vegetables is the only effectual mode of eradicating disease and that the stomach and the bowels cannot be purged too much.

No. 71

The Fox and the Goose, 1833

GEORGE CRUIKSHANK (English, 1792–1878)
Engraving; plate 7½ x 11 in. [19.1 x 27.9 cm]

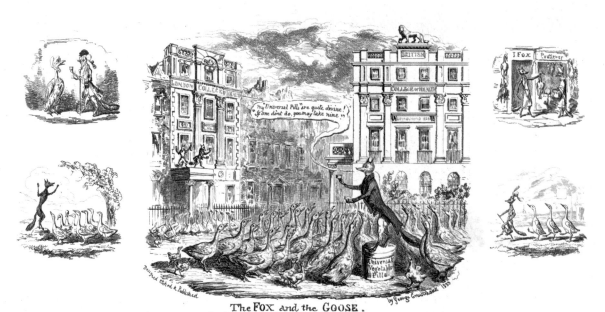

The FOX and the GOOSE.

A Fox there is who has such Knowledge
That his Dwelling House he calls a "COLLEGE"
And Geese flock to him from all quarters
Bringing Wives & Sons & Daughters
He tells the Geese, that their ills he's able
To cure with his Pills of Vegetable

He makes GOOSE pay his COLLEGE rent
And calls himself the "President"!

Another "COLLEGE" there is I ween
Which may in Newman Street be seen

And so Goose thinks he can, good lack!
For "Cackle" hath great faith in "Quack" —
So he lives on GOOSE each day I ween,
His House is built on "Ganders Green",
His Carriage Wheels on "Goose Grease" turn.
He Fat of Goose for oil doth burn.

And not in trifles over nice,
"Tis he himself enacts the Vice"!!

And there two Foxes,"Charles & John",
Carry the very same System on .

He plucks their feathers for his Bed.
On Down of Goose he lays his head.
He gets his Goose & eke his Stuffing
By Cramming Geese with Pills & Puffing:
He writes his Puffs with "Grey Goose quill"
Of "Goose-berry=fool" he has his fill.

And tho' 'tis strange 'tis also true,
He is himself the "Members" too!!!

In Cruikshank's parody on Morison's Pills, a fox stands on a package of the
Universal Vegetable Pills and tells the unsuspecting geese that "If one don't do,
you may take nine." The stately building of Morison's offices, the British College
of Health, stands in the background. Foxes also stand on the portico of the
London College of Health, the offices of legitimate physicians, offering rival
nostrums, but the listeners pay no attention.

THE

MORISONIAN MONUMENT

ERECTED IN FRONT OF THE

BRITISH COLLEGE OF HEALTH, NEW ROAD,

LONDON,

ON THE 31st OF MARCH, (DAY OF PEACE,)
A.D. 1856.

THIS MEMORIAL,
RAISED BY A PENNY SUBSCRIPTION,
HAS BEEN ERECTED A.D. 1856.
TO
JAMES MORISON,
THE HYGEIST.

MORISON

**Was the first to Protest against Bleeding, and
the Use of Poisons in Medicine.**

(SEE OVER)

No. 72

**The Morisonian Monument
Erected in Front of the British
College of Health,** 1856

Broadside; 8¾ x 5½ in. [22.2 x 14 cm]
Published by the British College of
Health, London

After Morison's death, a proposal was made to erect a monument in the founder's honor. Contributions were to be limited to no more than a penny each given by those who had taken the pills themselves with positive results and were thus grateful to Morison for his great discovery. On learning this, *Punch*, the English weekly, suggested that a slab of "monumental brass" be erected in the churchyard fullest of the Doctor's late patients.

Vin Mariani.

The active ingredient in Vin Mariani was cocaine, extracted from the leaves of Erythroxylon coca, a plant indigenous to Peru. Introduced in 1871 by Angelo François Mariani (1838–1914) who developed it while working in a Paris pharmacy, the formulation called for two ounces of coca leaves in each pint of Bordeaux wine "specially selected because of its peculiar distinctive qualities." Claims for the virtues of Mariani wine varied over the years but usually included statements of its value in treating influenza, insomnia, nervousness, impotence, melancholy and various problems of the stomach, throat and lungs. Mariani's contribution was not so much his skill at pharmaceutical preparation, but rather his genius in promotion and at projecting and keeping the name of his product in the public eye. He was a master at using testimonials from celebrities, and over the years he published the appreciations of kings, queens, popes, actors, actresses, musicians, writers, clergymen, politicians, and most notably, leaders of the medical profession. At times the sheer weight of his advertising brought accusations of quackery from some quarters. Beyond the testimonials, Mariani published limited-edition books of imaginative tales (*contes*) in which the administration of Vin Mariani led to happy endings. Colorful images appeared on posters and postcards by artists such as Jules Chéret, Albert Robida, Alphonse Mucha, William Bougereau and Lucien Lévy-Dhurmer, and books attested to the value, but said little of the potential evils, of the coca plant. The long success of Vin Mariani spawned many imitators, including Coca-Cola which substituted syrup and soda water for the wine; but other than Coca-Cola, all these products went out of favor early in the twentieth century when legal restrictions eliminated coca from their formulations. 🍃

No. 73
Album Mariani, 1891

First series
Published by G. Richard, Paris

The *Album Mariani,* a collection of celebrity testimonials, first appeared in Paris in 1891. The publication included 24 testimonials, the earliest in a series that would eventually exceed 1400. The pantheon of the first set of notables included the composer Charles Gounod, the actor Coquelin Cadet, the actress Rose Delaunay, and the writers Léon Claudel and Octave Uzanne. A statement by Oscar Roty, who later created several medals in honor of Angelo Mariani, accompanied a sketch of a mother giving her child a drink of Vin Mariani.

No. 74
Album Mariani, 1899

Volume four
Published by Librairie Henri
Flouri, Paris

EXECUTIVE MANSION,
WASHINGTON

William McKinley

June 14ᵗʰ 1898

My dear Sir:

Please accept thanks in the President's behalf and
my own for your courtesy in sending a case of the cele-
brated Vin Mariani,with whose tonic virtues I am al-
ready acquainted and will be happy to avail myself of
in the future,as occasion may require.

Very truly yours, Secretary to the President.

John Addison Porter

Over 1400 testimonials were included in the fourteen volumes published by
Mariani and his successors. Mariani and his aides first sent a case of twelve
bottles of the wine to people of note; when recipients wrote to thank him,
Mariani published a biography, a portrait and a portion of the response. He
also wrote to artists, commissioning them to make sketches that could also
be published. Although Mariani died in 1914, his own portrait and biography
were included in the 1925 volume, the last in the series.

No. 75
No. 75

**Eminent Physician's Portraits
& Biographical Notes,** 1902

Printed in Paris

Dr. MILNE-EDWARDS.
Member Academy of Medicine, Paris, France;
Director Museum of Natural History;
Commander Légion d'honneur.

ALPHONSE MILNE-ED-WARDS, born in Paris, 1835. Graduated M.D. in 1860 and Doctor of Sciences in 1861. Appointed Professor Paris College of Pharmacy in 1865, and at the Museum of Natural History in 1876. He was in charge of the four scientific expeditions, 1880 to 1883, on board the Government vessels, Travailleur and Talisman, when he made special studies of the distances, depths and currents in the ocean, etc., for which he was awarded the Gold Medal by the Geographical Society of France. In 1891 Director in Chief of the Museum of Natural History, and in 1897 President of the Geographical Society. In 1899 the Government awarded him the Medal, Commander of the Légion d'honneur. Among his principal writings: Histoire des Crustacés fossiles (1 vol.); Histoire des Oiseaux fossiles de la France (4 vols.); for this work he received the highest prize from the Academy of Sciences; Les Oiseaux disparus de Madagascar et des Iles Mascareignes (1 vol.); Histoires des Mammifère (en collaboration avec Alfred Grandidier) (6 vols.); Recherche sur la faune des regions Australes (for which he received the Bordin prize from the Academy of Sciences); Expéditions scientifiques du Travailleur et du Talisman (4 vols.); Expédition scientifique du Mexique (1 vol.); Directeur des Annales des Sciences naturelles (since 1874, 50 vols.); Directeur des Annales des Sciences géologiques (from 1869 to 1890, 22 vols.).

"Some of those under my charge have been greatly benefited by the use of Vin Mariani."　Dr. MILNE-EDWARDS.

[Drawn by Dr. Milne-Edwards from life in the Museum, representing an authentic scene, of which the Doctor said, "This illustrates more than words my appreciation of Vin Mariani."]

18

Thirty of the physicians included in the *Album Mariani* were included in a pamphlet sent to American physicians. In addition to brief biographies, there were discussions on "The Specific Value of Coca," "Extraordinary Proof of the Esteem in which the Medical Authorities Hold Vin Mariani" and "Shall Physicians Prescribe Proprietary Remedies?"

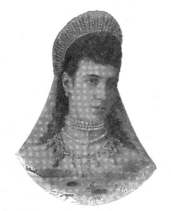

HER IMPERIAL MAJESTY THE CZARINA OF
RUSSIA.

Anitchkoff Palace, St. Petersburg, Dec. 6, 1894.
Her Majesty, Empress Marie Feodorowna, finding great
benefit from the use of your Tonic-Wine, requests that a case
of 50 bottles Vin Mariani be sent immediately, addressed to
Her Majesty the Empress.

By Order of the Court Physician.

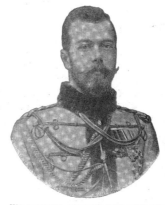

HIS IMPERIAL MAJESTY THE CZAR OF
RUSSIA.

In consequence of the benefits obtained from
Vin Mariani by the Emperor and Empress, a
great demand for this tonic has sprung up in
Russia.—*From the Court Journal, Jan. 12, 1895.*

(See letter on opposite page.)

No. 76

**Contemporary Celebrities
from the Album Mariani
of Paris, France,** 1901

Published by Mariani & Co.,
New York

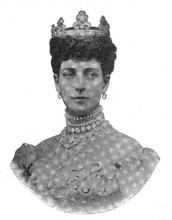

HER ROYAL HIGHNESS PRINCESS OF WALES

It is well known that the Princess of Wales derived in-
creased strength of brains and nerves from Vin Mariani, dur-
ing her last great trials.—*London Court Journal, Jan. 12,*
1895.

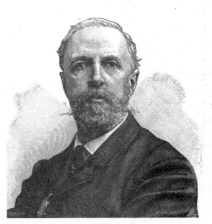

HIS MAJESTY OSCAR II, KING OF NORWAY AND
SWEDEN.

His Majesty appreciates and thanks Monsieur Mariani,
and I personally add my own high esteem for the Vin
Mariani.

BARON AUG. VON ROSEN.

7

The first six volumes of the *Album Mariani* appeared before 1901 and contained
approximately 450 biographies. From them, the compilers prepared this book
including more than 100 portraits and testimonials as well as reproductions
of artists' sketches showing people drinking Vin Mariani. In his introduction,
the proprietor complained, "To the occasional malicious attempts to injure
me ... I invariably have given no attention; the contents of these pages can
be considered my modest answer to all calumnious attacks."

No. 77

Mariani Wine. Tonic and Strengthener, 1892

Advertisement; 8 x 11⅜ in. [20.3 x 28.9 cm]
From *The Illustrated London News* (June 11, 1892)

Journal advertisements frequently reproduced portraits or comments from the testimonials of the well-known writers, musicians, artists and physicians that had been featured earlier in books and pamphlets. One of these two English advertisements shows the composer Charles Gounod along with four bars of music saluting Mariani Wine.

No. 78

Mariani Wine. Strengthener of the Entire System, 1893

Advertisement; 7 x 11½ in. [17.8 x 29.2 cm]

From *The Graphic*, London (April 8, 1893)

·MARIANI WINE·

STRENGTHENER
OF THE
ENTIRE SYSTEM,
AND
RENOVATOR
OF THE
VITAL FORCES

Specially prescribed in cases of

BRAIN EXHAUSTION,
 NERVOUS DEPRESSION,
 SLEEPLESSNESS,
NERVOUS DEBILITY,
 CONVALESCENCE,
 VOICE FATIGUE.

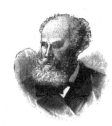

M. CHARLES GOUNOD

" The admirable wine which has so often rescued me from exhaustion."

Ch. Gounod

TESTIMONIALS.

Madame **SARAH BERNHARDT** says : " Mariani Wine has always largely helped to give me strength to perform my arduous duties."

M. AMBROISE THOMAS " joins his friend Ch. Gounod in singing the praises of the excellent Mariani Wine."

Sir MORELL MACKENZIE wrote : " I have used the Mariani Wine for years, and consider it a valuable stimulant, particularly serviceable in the case of vocalists."

Madame **ALBANI** declares Mariani Wine to be " invaluable in vocal fatigue."

The Cardinal **LAVIGERIE**, writing to M. Mariani, observed : " America furnishes the basis of your admirable wine, which has conferred on my White Fathers, the children of Europe, the strength and courage to undertake the civilisation of Asia and Africa."

Dr. FINCH alludes to " its power to sustain and feed the vital forces when the system is both mentally and physically overtaxed."

Dr. LEONARD CORNING, author of " Brain Exhaustion," says : " Mariani Wine is the remedy par excellence against worry."

Mr. **MARIANI** holds over 2,000 unsolicited Testimonials from physicians who recognise the value of his preparation.

Sold by all Chemists and Stores in the United Kingdom, or will be sent, carriage free, by the Wholesale Agents, upon receipt of remittance, viz. : per Bottle, 4s. ; Half-dozen, 22s. 6d. ; Dozen, 45s.

WILCOX & CO., 239, OXFORD STREET, LONDON.

N.B.—The Public are requested to ask for "MARIANI WINE," in order to avoid the substitution of imitations often worthless, and consequently disappointing in effect.

No. 79

Doctors Recommend Mariani Wine, 1907

Four-page brochure; 9⅛ x 4½ in. [23.2 x 11.4 cm]
Printed in London

In their continuous barrage of advertising, the marketers of Mariani Wine
stressed numerous testimonials from practicing physicians. This was the
case even after cocaine had been removed from the formula and its virtues
changed to encourage use during convalescence. Then Mariani Wine became
"a pure medicated wine, absolutely free from any injurious principles."

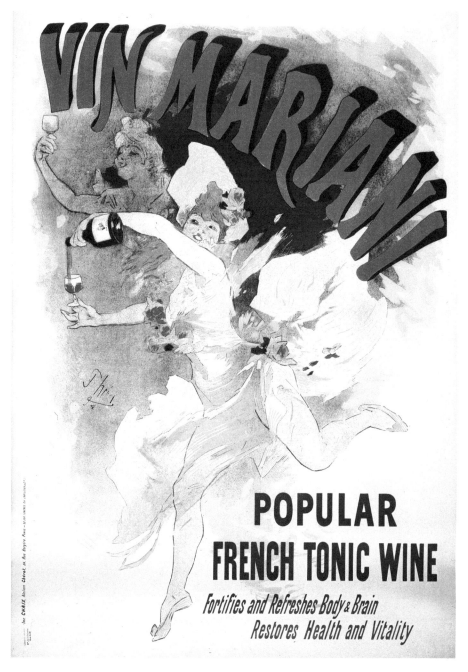

No. 80
Vin Mariani, 1894

JULES CHÉRET
(French, 1836–1932)
Color lithograph; 49 x 34⅛ in.
[124.5 x 86.7 cm]

Available in three different sizes, Chéret's poster was destined for
the English-speaking market; the two women shown are floating
on air, a style Chéret frequently used. Mme. Chéret was his favorite
model, easily recognized from her numerous appearances in this
and the majority of Chéret's images.

No. 81
Postcards in the Collection
Mariani, c. 1910

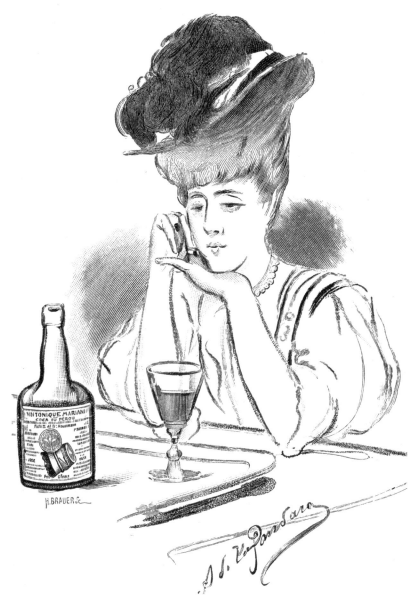

Dessin de A. de LA GANDARA, Artiste peintre,
pour *l'Album Mariani.*

Angelo Mariani commissioned more than one hundred artists and sculptors to prepare sketches to be used in advertising, the only stipulation being that a bottle of his product be included in the design. The list of artists included Leonetto Cappiello, Jules Chéret, Alphonse Mucha and Lucien Lévy-Dhurmer among others. Thirty cards each in five successive series were distributed to prospective purchasers, and today they have become desirable objects for collectors.

Typ. E. Pigeint, Paris

REPRODUCTION OF A COCA PLANT PRESENTED BY MR. MARIANI TO THE PARIS BOTANICAL GARDENS.

No. 82
Angelo Mariani,
Coca and Its Therapeutic
Application, 1890

Published by J. N. Jaros,
New York

In this work, Mariani discussed the therapeutic value of the leaves of the Erythroxylon coca plant pictured here. He also discussed the range of products in an ever-growing line: an elixir, pastilles, lozenges and a tea in addition to the original wine. There was also a grog, prepared by mixing Vin Mariani with boiling water, which was useful for severe cases of cold attended by convulsive coughing.

No. 83
**Maurice Bouchor,
Pervenche,** 1900

Illustrated by Léon Lebégue
(French)
Printed by Librairie Henri
Floury, Paris

Quant au cordial versé dans la bouche de Manches-Vertes, non seulement il eut le résultat que j'ai dit; mais par une secrète influence, il rendit les jeunes époux, en moins de quatre ans, père et mère de six fils et six filles, tous et toutes bien gaillards et bien gaillardes.

Août 1899.

In this story, with the aid of Vin Mariani, Robert, the lover of Pervenche, is miraculously saved. Pervenche, the title character, is a young woman destined to fall into the clutches of William of the twisted nose, ruler of a Norman village. The magical agent enables the happy pair to have twelve children in less than four years following their marriage! The tale is enlivened by colorful illustrations by Léon Lebégue.

La Rupture

A M. Angelo Mariani.

LÉON

Croyez-le, ma chère, il faut en finir :
Le bonheur passé ne peut revenir.
Nous avons ensemble épuisé la coupe
Où l'ardente soif de nos jeunes cœurs
Se désaltérait en longs traits vainqueurs.
Depuis trop longtemps, l'Amour et sa troupe
Nous ont dit adieu. Laissons-les partir

1

No. 84
Albert Christophle,
La Rupture (**The Breakup**),
1904

Illustrated by Albert Robida
(French, 1848–1926)
Printed by Librairie Henri Floury,
Paris

This is one of a series of *contes* (tales) published by Mariani in limited
editions (this story in three hundred copies), destined for bibliophiles.
Profusely illustrated by Albert Robida, *La Rupture* tells the sad tale of
a breakup of two lovers, Pauline and Léon, each of whom turn to Vin
Mariani for solace as they go their separate ways.

No. 85
**Jules Claretie, Explication
(Explanation)**, 1894

Illustrated by Albert Robida
(French, 1848–1926)
Printed by Librairie
Illustrée, Paris

« Tu pourras ensuite,

Jules Claretie (1840–1913) was a prolific writer of novels, plays and histories, as well as a member of the Académie française and a director of the Comédie française. The illustrator, Albert Robida, also a productive artist, worked as a caricaturist and book illustrator. *Explication* (Explanation) is a whimsical tale suggesting that Hercules, aided by the powerful effects of Vin Mariani, discovered America before Columbus.

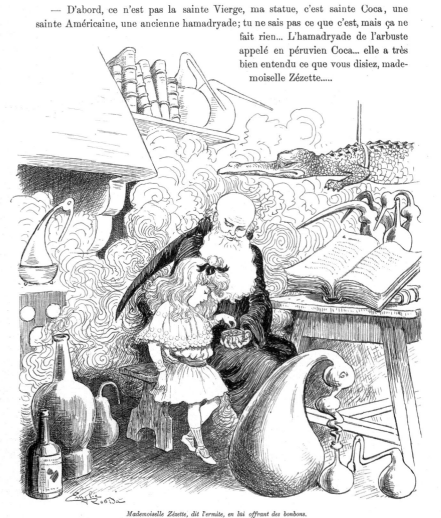

— D'abord, ce n'est pas la sainte Vierge, ma statue, c'est sainte Coca, une sainte Américaine, une ancienne hamadryade; tu ne sais pas ce que c'est, mais ça ne fait rien... L'hamadryade de l'arbuste appelé en péruvien Coca... elle a très bien entendu ce que vous disiez, mademoiselle Zézette.....

Mademoiselle Zézette, dit l'ermite, en lui offrant des bonbons.

31

No. 86
Albert Robida,
Le Château de la Grippe
(The Chateau of the
Grippe), 1904

Illustrated by Émilie Robida
Printed by Librairie Henri
Floury, Paris

The well-known illustrator Albert Robida wrote this fanciful tale and his daughter Émilie created forty images, in both black-and-white and color, that accompany her father's work. In it, the residents of Anémicmacville, all of whom regularly take copious quantities of medicine, have been devastated by a severe epidemic of influenza. A young girl, Zézette, discovers monks in a monastery who have the secret cure—Vin Mariani, of course.

No. 87

Figures Contemporaines, 1897–1921

Newspaper inserts; 12½ x 9 in.

[31.8 x 22.9 cm]

From *Le Temps*

A novel advertising technique used extensively by the Mariani firm was the distribution of inserts inside the daily newspapers published throughout France. The insert program ran for more than twenty years and included four- to sixteen-page supplements of portraits, biographies and signed testimonials taken from various editions of the *Album Mariani*.

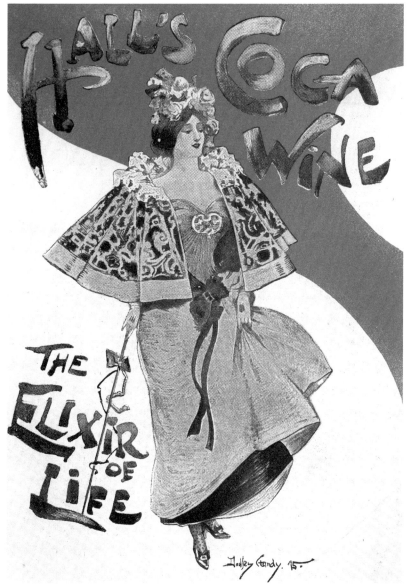

No. 88

Coca Wine Advertisements, c. 1895

DUDLEY HARDY (English, 1866–1922)
Colored lithograph; largest size 8¼ x 5 in.
[21 x 10.8 cm]

Printed by Ambrecht, Nelson & Co., London;
Caswell Hazard & Co., New York; Hall's Coca
Wine, London; Lorimer & Co., London; and
Wm. R. Warner & Co., Philadelphia

Angelo Mariani continually complained about competitors. In the 1890
edition of *Coca and Its Therapeutic Application* (p. 139), he wrote: "Owing to
the success obtained by our preparations of Coca for many years, imitators
and counterfeiters have dared to apply to their own valueless productions
the observations made with our special products. These … have given rise
to protests from many physicians." These examples are only a few that
raised the proprietor's ire.

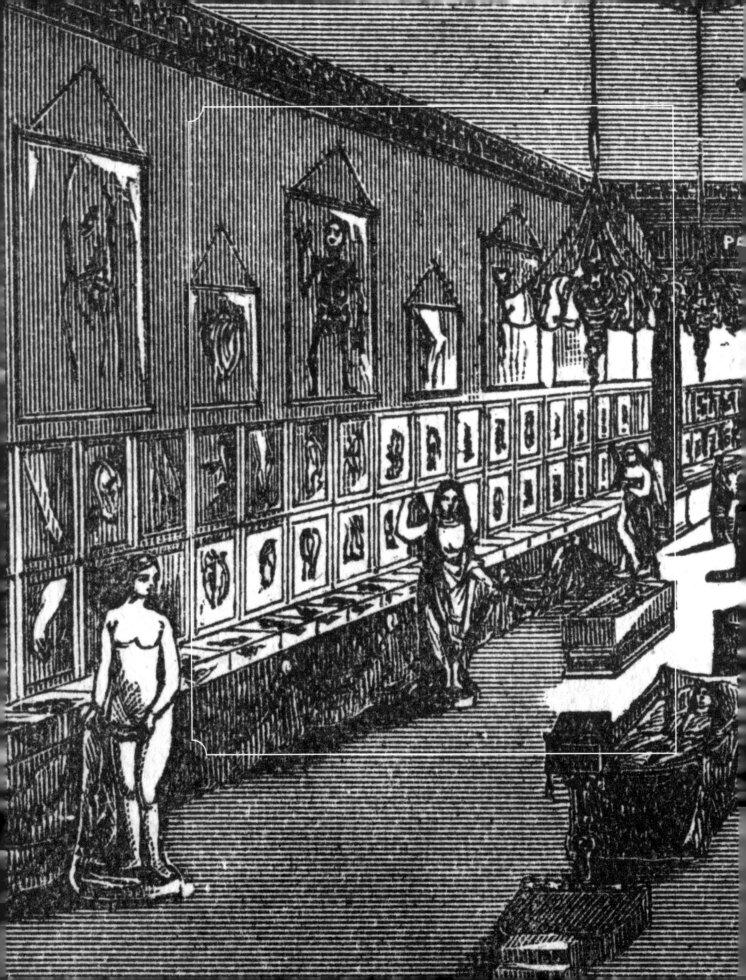

Anatomical Museums
& Medicine Shows.

Medicine shows and anatomical museums were two nineteenth-century ventures designed to separate attendees from their capital. The traveling medicine shows were a unique American contribution in which performers entertained to put their audience in a proper mood, and pitchmen, invariably called "Doc," then did their best to sell medicines. Taking their origins from the European itinerants, American medicine shows consisted of troupes of singers, musicians and entertainers, usually containing men and women dressed as Indians. The entertainment preceded the spiel of the pitchman and as a rule there was also a tailpiece, a one-act play or comedy skit, which held the audience in their seats until the selling pitches were over. The anatomical museum, in contrast, was a stable institution with a fixed address, which enticed young men (attendance was usually forbidden to women) to observe a variety of specimens, often wax models showing the effects of disease on the organs of generation of both sexes. There was a sufficient amount of anatomy and pathology to impart a scientific flavor to the exhibits. Many of the objects on view were formaldehyde-filled jars of fetuses, often with defects. Approaching the visitor in the act of viewing such examples, attendants would suggest that such misshaped creatures were the result of earlier improper acts, and that to avoid the consequences of such earlier experiences, a "doctor" was on hand to advise proper treatment. In such a way were budding fortunes made. ☙

No. 89

The Quack Doctor, 1871

F.O.C. [FELIX OCTAVIUS CARR] DARLEY (American, 1821–1888)

Lithograph; 9 x 8¾ in. [22.9 x 22.2 cm]

From *Every Saturday* (January 14, 1871)

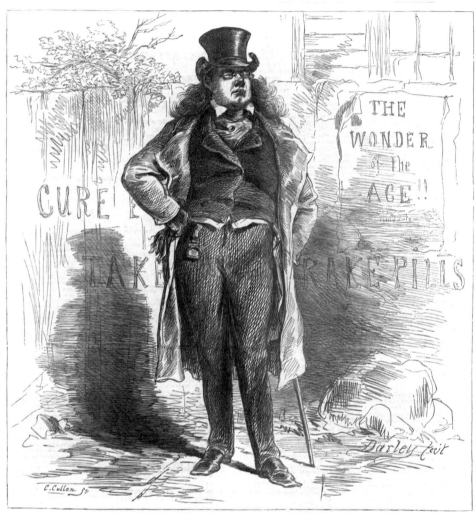

THE QUACK DOCTOR. — DRAWN BY F. O. C. DARLEY. (SEE PAGE 30.)

The Quack-Doctor "is probably the greatest general in all the noble army of strategists against the pocket-books of mankind … he single-handed and alone, with a mere box of pills, or a bottle of bitters, or a few rounds of buchu, or a plaster, or a salve, or by looking at his victims with his eyes blindfolded, can put to rout all the diseases, pains, aches, and blues, that curse human-kind. And we, most of us, are so impressed with his modest assertions, that we open our mouths, swallow his concoctions, make him rich enough to be one of the first families…."

COMING!

The King of All

Comedy
Concert
Companies

COL. T. A. EDWARDS,
One of the First White men to Introduce Indian Medicines

DON'T MISS IT

Indian Medicine Show

Company Introduces its Remedies by giving a series of
Moral and Refined Entertainments
Consisting of Vocal and Instrumental Melodies, Entertaining Sketches, Laughable
Afterpieces, Mirthful Comedy, Classical Music, under Model Management.

Comedians, Actors, Singers, Dancers.

It will do you good to see them—some are Negro delineators, some Irish, some Dutch, all
Artists of Merit and Ability
High Class Motion Pictures

The Entertainments given by

The Indian Medicine Show Co.

Is not to be confounded or classed with other so-called Indian Medicine Companies
Its Reputation and Responsibilities are too great.

A T_____

O N_____

No. 90

Coming! Indian Medicine Show, c. 1920

Broadside; 20⅞ x 7 in. [53 x 17.8 cm]

Colonel T. A. Edwards, here described as "the King of All Comedy Concert Companies," was one of the first white men to introduce Indian medicines. He was also a circus performer and Civil War spy before he founded the Oregon Indian Medicine Company in 1876. He advertised his key product, Ka-Ton-Ka, as well as other products, as being manufactured by Indians at the Umatilla Reservation in Oregon, but in truth they were made in Pittsburgh and later in Corry, Pennsylvania.

No. 91

Violet McNeal, Four White Horses and a Brass Band, 1947

Published by Doubleday & Company, Inc., Garden City, New York

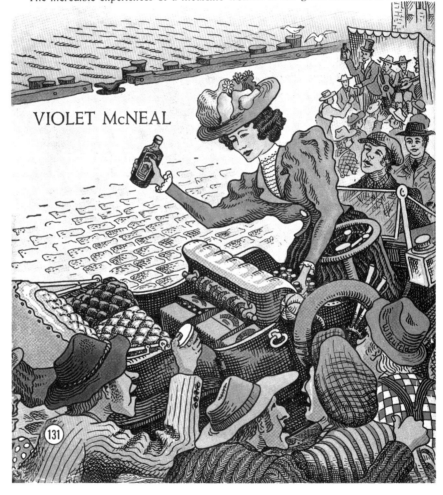

As Princess Lotus Blossom, the author became the pitchwoman for Vital Sparks, Tiger Fat and other proprietary products sold in a medicine show that traveled between Minneapolis and Seattle during the early years of the twentieth century. The book is an autobiography of Violet McNeal, one of the few women to have worked as the "Doc" in the medicine show world.

THE Fabulous KELLEY

CANADA'S KING of the MEDICINE MEN

THOMAS P. KELLEY JR.

With an Introduction by GORDON SINCLAIR

No. 92
Thomas P. Kelley, Jr.,
The Fabulous Kelley, 1974

Published by General
Publishing Company, Limited,
Don Mills, Ontario

This is the biography of a medicine showman who traveled the United States and Canada, beginning in 1886, selling East India Tiger Fat, Passion Flower Tablets and the Shamrock Tape-Worm Remover. Kelley would ask, "how many are there of you standing before me who, unknown to yourselves, are harboring death within your digestive organs in the form of a vile and slimy entity known to medical science as a Taenia Solium?"

No. 93

Indian Scout Life. The Modoc War. The Adventures of Donald McKay, 1887

Printed by the Oregon Indian Medicine Company, Corry, Pennsylvania

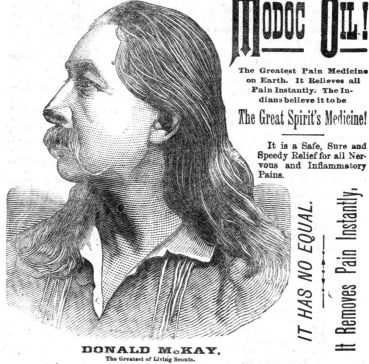

MODOC OIL!

The Greatest Pain Medicine on Earth. It Relieves all Pain Instantly. The Indians believe it to be

The Great Spirit's Medicine!

It is a Safe, Sure and Speedy Relief for all Nervous and Inflammatory Pains.

IT HAS NO EQUAL.

It Removes Pain Instantly.

DONALD McKAY,
The Greatest of Living Scouts.

MODOC OIL IS CERTAIN TO CURE

Toothache in One Minute, Headache in Five Minutes, Earache in Ten Minutes, Sore Throat in One Night, Neuralgia in from Three to Five Minutes, Sick Headache in Ten Minutes.

MODOC OIL can be used INTERNALLY as well as EXTERNALLY without the least danger. It has never been known to injure anyone young or old. One of the most valuable properties of this Oil is its adaptability in painful diseases of children. Should your babe show symptoms of pain in the stomach or bowels, wet immediately a flannel cloth and lay it on the seat of pain. Relief will certainly follow in less than ten minutes. As this medicine is very powerful, in administering it internally to children due care should be exercised. For a child one year old a half teaspoonful is the dose, and for one of two years a teaspoonful, in a little water. For Diarrhœa, Dysentery, Bloody Flux and all Pains of the Stomach and Bowels, MODOC OIL is a sure and speedy cure. Every family should always have a bottle within reach. It is a doctor in the house. For sale by all druggists. MODOC OIL is made and sold only by the

OREGON INDIAN MEDICINE COMPANY,
CORRY, PENN'A.

Price 25 cts. per bottle, or large sized bottles 50 cts.

Although Colonel Edwards's portrait is on the cover, this pamphlet's text is devoted to Donald McKay, who from 1852 to 1874 is reputed to have been a government scout, guide, interpreter and eventually the conqueror of a band of Modoc Indians. As the overprinting on the cover shows, it was given to prospective attendees at an Oregon Indian Medicine Company show with "seats reserved for ladies."

No. 94

Regular Annual Tour of the
German Medicine Co., 1897

Four-page advertisement; 14 x 10⅛ in.
[35.6 x 25.7 cm]
Printed in Cincinnati

This publication was distributed to those who came to the German Medicine
Company show in 1897. Frank P. Horne's company was one of the largest
suppliers of medicines to showmen, and his firm capitalized on the high
regard with which German universities were held as well as on the reputation
of the High German doctors who sold their medicines in London and other
English cities in earlier years. In its most active period, the German Medicine
Company had more than one hundred shows on the road at one time.

No. 95

Kickapoo-Indian Guide to Health, c. 1885

Four-page advertisement; 16 x 11 in.
[40.6 x 27.9 cm]

Printed by Healy & Bigelow,
New Haven, Conn.

The largest of the traveling medicine show troupes were those selling Kickapoo Sagwa and related products purportedly developed from Indian recipes. Formed in 1881 by John E. Healy of New Haven and "Texas Charley" Bigelow, a former medicine show worker, they sent mixed groups of Indians—none of them Kickapoo—and whites to sell their products, fielding as many as seventy-five units at any one time in the late nineteenth century.

[154]

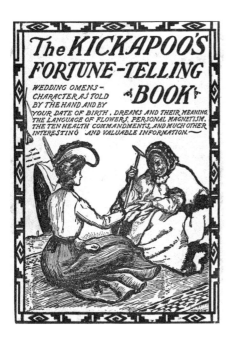

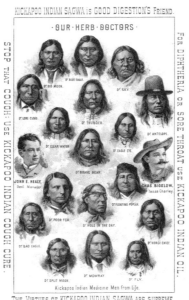

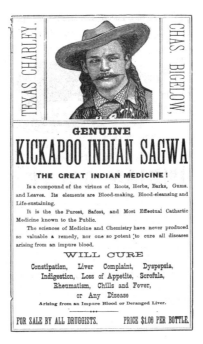

As these examples show, Healy and Bigelow were also prolific advertisers, always stressing the Indian roots of their Kickapoo products. In the first of the chromolithographs in their book of scenes, the proprietors included their portraits with those of Kickapoo Medicine Men, but in truth, Indians had little to do with their formulations.

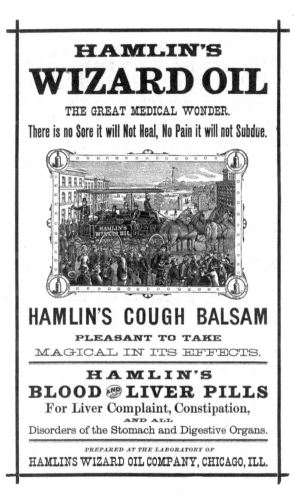

No. 100

Hamlin's Wizard Oil. The Great Medical Wonder. There Is No Sore
It Will Not Heal, No Pain It Will Not Subdue, 1884

Printed by Hamlins Wizard Oil Company, Chicago

No. 101

Humorous and Sentimental Songs as Sung throughout the U.S. by Hamlin's
Wizard Oil in Their Concert Troupes Open Air Advertising Concerts, c. 1885

Printed by Hamlins Wizard Oil Company, Chicago

Wizard Oil contained camphor, ammonia, chloroform, sassafras, cloves and
turpentine. It was purported to cure just about everything, including cancer.
The company, founded in the 1870s, provided troupes that gave musical
performances throughout the United States. The covers of both pamphlets
illustrate the type of horse-drawn wagons used by the company. Each wagon
was a rolling stage with a built-in parlor organ.

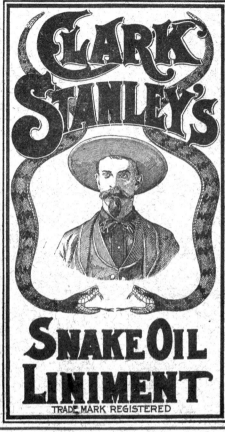

No. 102

Clark Stanley, True Life in the Far West by the American Cowboy, 1906

Published by Messenger Printing Co., Worcester, Mass.

This well-illustrated book on cowboy lore is really a lengthy advertisement for Clark Stanley's Snake Oil Liniment. Stanley worked a medicine show, traveling from city to city advertising and selling his famous Snake Oil Liniment. As he said, "My way of advertising was by killing Rattle Snakes in full view of the public." He would then proceed to prepare the oil from the tallow.

No. 103

Dr. Kahn's Original and Unrivalled Anatomical Museum, c. 1875

Broadside; 10 x 4⅞ in.
[25.4 x 12.4 cm]
Printed by W. J. Golbourn, London

No. 104

Dr. Kahn's Grand Museum of Anatomy, Science, and Art, 1879

Advertisement; 9 x 4⅞ in.
[22.9 x 12.1 cm]
From *The Medical Eclectic* (May 1879)

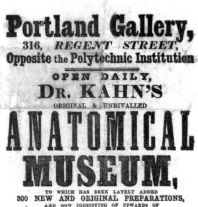

Portland Gallery,
316, *REGENT STREET*,
Opposite the Polytechnic Institution
OPEN DAILY,
DR. KAHN'S
ORIGINAL & UNRIVALLED
ANATOMICAL MUSEUM,

TO WHICH HAS BEEN LATELY ADDED
300 NEW AND ORIGINAL PREPARATIONS,
AND NOW CONSISTING OF UPWARDS OF
SEVEN HUNDRED SUPERBLY EXECUTED, AND HIGHLY INTERESTING MODELS.

No. 1—Natural preparations, showing the formation of the Human Being, from ten days up to its full development.
No. 2—Models in wax, showing the Anatomy of the Muscles, Arteries, Veins, and Nerves.
No. 3—Extraordinary freaks of nature.
No. 4—Microscopic Embryology.—One hundred and nine Wax Models, showing the progress of Fœtal Life, from the first moment of existence. (This is the only series of the kind in Europe.)
No. 5—A Model the Size of Life, showing the mode in which the famous Cæsarean Operation is performed.
No. 6—A magnificent Full-length Figure in wax, of a Young Lady of Munich, Eighteen Years of Age, showing the evil effects of Tight Lacing.
No. 7—A beautiful Wax Figure, termed the APOLLO BELVIDERE, which is taken to pieces. Recently executed by DR. KAHN.
No. 8—Highly Magnified Models of the Five Senses, which will be taken to pieces, and explained in a popular and universally intelligible manner.
No. 9—SIXTY FIGURES, exhibiting all the principal varieties of Mankind, which DR. KAHN has added since he last had the honor of exhibiting in London; and which he begs respectfully to state, are entirely original, nothing of the kind ever before having been executed by any other person.

The MUSEUM IS OPEN for GENTLEMEN
Every day, from 11 till 5, and from 7 till 10, except Fridays, when the Morning Exhibition closes at 2, the Evening remaining open as usual.
A PART ONLY OF THE MUSEUM IS OPEN
FOR LADIES,
Every Friday, from half-past Two till Five o'clock, during which time Gentlemen will not be admitted.
☞ Popular Explanations are given during the Day and Evening—To the Male Visitors, by an English Medical Gentleman; and to Visitors of the other sex, by a Professional Lady.

ADMISSION ONE SHILLING
NONE BUT ADULTS ARE ADMITTED
Printed by W. J. Golbourn, 6, Princes Street, Leicester Square.

DR. KAHN'S
GRAND MUSEUM

—OF—
ANATOMY, SCIENCE AND ART,
No. 688 BROADWAY,
Between Great Jones and Fourth Sts., NEW YORK.

ONE VISIT TO THIS UNRIVALLED AND
MAGNIFICENT PALACE OF WONDERS
WILL CONVINCE EVERY ONE OF THE
SUPERIORITY OF THIS INSTITUTION TO THAT OF EVERY OTHER.

FOR GENTLEMEN ONLY.
ADMISSION, - - - - - 50 CENTS.

N. B.—Every Visitor to the Museum is presented with a copy of DR. KAHN'S LECTURES. [Jan., 1878 tf.]

These three notices advertised anatomical museums. Suprisingly, two of these notices use the same woodcut, although the museums advertised are in different places, run by different families, and (no doubt) look nothing alike. The exhibits included whatever the proprietors could find that might be of interest to young men, but featured oddities and aborted fetuses in jars of formaldehyde or other preservatives. Explanations of the causes of such exhibits were given "to the Male Visitors by an English Medical Gentleman," and to women by a Professional Lady.

FOR
MEN ONLY!

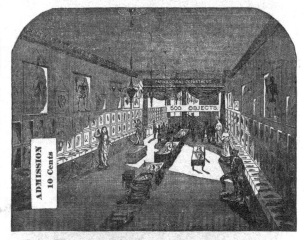

ADMISSION 10 Cents

500 OBJECTS.

Dr. Hay's College Of Anatomy

(Geo. S. Eldred, Proprietor,)

Showing all parts of the Human System both Male and Female in Health and Disease. Showing Every Disease that the Flesh is heir to, from the sole of the feet to the crown of the head.

This is not a Painting, Skeleton, Manikin or any Cheap Catch-penny affair, but an Educational Institution, made of Wax. Everything is Life Size just as you would see them on the Dissecting Tables in the largest college in the land.

It teaches the Young to Guard Against the Errors of Life. It shows all the VENEREAL DISEASES, the Jewish operation of CIRCUMCISION, FREAKS OF NATURE from all parts of the Globe. STONE IN THE BLADDER and a Hundred other Diseases that mankind is subject to. It shows the ravages of the Most Fearful and Loathsome Diseases that human beings may become heir to. Let the Young and the Old take a timely warning and visit this College of Anatomy, that you may become familiar with the dangers of life which are awaiting you to make you their prey at any moment from childhood to the grave.

When we consider the dangers besetting the path of the unwary and manifold temptations to which the rising generation are exposed, then no intelligent and unprejudiced mind can fail to perceive the advantage derived, and the benefits which must inevitably result from the careful study of an Anatomical College.

The equine, even without the gift of reason, possessed by man, when standing upon a precipice, will involuntarily shrink back, when the yawning abyss appears before his vision; why would not man, endowed with reason, be forewarned, when viewing the desolation and misery in store for him if he leaps into the Cesspools of Vice, which fringe the narrow path, leading to happiness and the preservation of a healthful body and mind. Volumes could be written on this subject without exhausting it, but as, after all, seeing is believing, I invite the public to visit my College of Anatomy, now on exhibition in this city.

BOYS UNDER 17 YEARS NOT ADMITTED. ADMISSION 10 CTS

Kitchel's Liniment Print, Coldwater, Mich.

No. 105

For Men Only! Dr. Hay's College of Anatomy, c. 1870

Broadside; 11¾ x 5⅞ in. [29.8 x 14.9]
Printed by Kitchel's Liniment Print,
Coldwater, Michigan

ON AND AFTER THIS DATE,
Admission Reduced to **50** cts.
PACIFIC ANATOMICAL
MUSEUM
And **GALLERY** of
NATURAL HISTORY AND SCIENCE
Formerly Eureka Theatre, Montgomery St., San Francisco.

Admission, **50** Cents!

For Gentlemen Only!

This Truly Elaborate and Magnificent Collection
OF ALL THAT IS
Strange, Wonderful & Curious
— IN —
SCIENCE, NATURAL HISTORY AND ART,
IS NOW OPEN TO THE PUBLIC!

The Proprietor has, at a very great OUTLAY of MONEY, TIME and LABOR, rendered
this Institution
The Most Complete, Scientific and Useful in the World!

HERE MAY BE SEEN EVERY FORM OF
Human, Comparative, Floral and Botanical **ANATOMY**!
The FLY, the BEE, the FISH, the GORILLA, the HORSE, the HUMAN Family.
And in short every conceivable Form or Preparation likely to impart Knowledge or Instruction.

The Dying Zouave!
A Beautiful Full-Length MOVING, BREATHING FIGURE!

The Famous Du Chaillu.
GORILLA
The only one ever Exhibited **ALIVE** in the World!

WONDERS OF EVERY KIND!
INCUBATION!
Showing the CHICKEN, from the FIRST HOUR to the LAST DAY of its Embryotic State.

Francis & Valentine, Printers, 517 Clay St., San Francisco.

No. 106

Pacific Anatomical Museum, c. 1865

Broadside; 14 x 7¼ in. [35.6 x 18.4 cm]
Printed in San Francisco

This woodcut image gives some idea of the exhibits shown in the Pacific
Anatomical Museum. A featured gorilla, images of incubation and full-size
models of men and women, as well as large framed illustrations on the
walls must have attracted a good deal of attention from the male visitors.
The Museum's proprietor was Dr. Louis J. Jordan, author of *The Philosophy
of Marriage* (opposite), a book that includes this same woodcut.

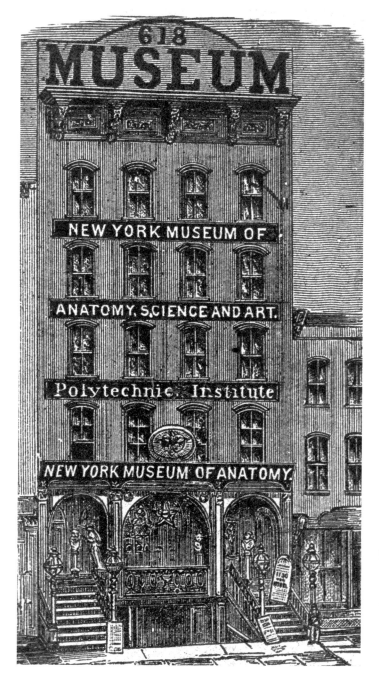

THE

PHILOSOPHY OF MARRIAGE,

BEING

FOUR IMPORTANT LECTURES

ON THE

FUNCTIONS AND DISORDERS

OF THE

NERVOUS SYSTEM,

AND

REPRODUCTIVE ORGANS.

ILLUSTRATED WITH CASES.

BY DR. L. J. JORDAN,

MEMBER OF THE ROYAL COLLEGE OF SURGEONS, LONDON,
DOCTOR OF MEDICINE, EDINBURGH, AND DEMON-
STRATOR OF ANATOMY AND SURGERY.

Permanent Residence, No. 211 Geary St. bet. Stockton and Powell

OPPOSITE UNION SQUARE,

SAN FRANCISCO, CAL.

No. 107

P. J. Jordan, The Philosophy of Marriage, Being
Eight Important Lectures on the Functions and
Disorders of the Nervous System ... Delivered
at the New York Museum of Anatomy, 1871

Published by the New York Museum of Anatomy, New York

No. 108

Louis J. Jordan, The Philosophy of Marriage,
Being Four Important Lectures on the Functions
and Disorders of the Nervous System ..., 1865

Published in San Francisco

Jordan, listed on the title page of *The Philosophy of Marriage* (above right) as a
member of the Royal College of Surgeons, London, was the proprietor of the
Pacific Anatomical Museum. Other museums of anatomy in the United States
and Europe were also under the direction of a Dr. Jordan who may, or may not,
have been the same person. The earlier example, here in its 48th edition,
stresses the evils of masturbation, the treatment of which could be undertaken
by Dr. Jordan on payment, either in person or by mail, of his five dollar fee.

MAN'S MISSION ON EARTH:

BEING A SERIES OF LECTURES

DELIVERED AT

DR. JOURDAIN'S

Parisian Gallery of Anatomy,

ADDRESSED TO

THOSE LABORING UNDER THE BANEFUL EFFECTS OF SELF-ABUSE, EXCESSES, OR INFECTION.

ALSO,

A FAMILIAR EXPLANATION

OF THE

VENEREAL DISEASE,

SHOWING THE DANGER ARISING FROM NEGLECT OR IMPROPER TREATMENT IN DISORDERS OF THE GENERATIVE SYSTEM.

BY

R. J. JOURDAIN, M.D.,

BOSTON:

ROCKWELL & CHURCHILL, PRINTERS.

1871.

GREAT EUROPEAN MUSEUM.

708 Chestnut Street, Philadelphia.

R. J. La GRANGE, M. D., Proprietor.

———

From amongst numerous gratifying testimonials from the Press, we select the following two, having no more space at our disposal.

N. Y. Daily Graphic, Sept. 7, 1877.

The European Museum, at 708 Chestnut St., Philadelphia, is one of the most complete collections in this country. It is divided into departments, properly classified and arranged with systematic care. Chief among these are the anatomical, pathological and ethnological departments, and academical moving wax figures in groups of life size. The entire spacious building on Chestnut Street is occupied by the museum, which forms a varied and interesting

No. 109

R. J. Jourdain, Man's Mission on Earth: Being a Series of Lectures Delivered at Dr. Jourdain's Parisian Gallery of Anatomy, 1871

Published by Rockwell, & Churchill, Boston

No. 110

R. J. La Grange, Secrets Revealed. A Course of Lectures, 1884

Published in Philadelphia

These two publications are typical of a genre designed to entice young men to the anatomical museum—a place for gentlemen only—for consultation with the author and subsequent treatment. Both Dr. Jourdain and Dr. La Grange review a series of problems that result from masturbation. Dr. Jourdain's work includes a woodcut showing the interior of his museum.

REVELATIONS

OF

QUACKS AND QUACKERY:

A SERIES OF LETTERS,

By "DETECTOR,"

REPRINTED FROM

"THE MEDICAL CIRCULAR,"

BY THEIR AUTHOR,

F. B. COURTENAY,

MEMBER OF THE ROYAL COLLEGE OF SURGEONS OF ENGLAND, AND FORMERLY SURGEON TO THE
METROPOLITAN INFIRMARY FOR THE CURE OF STRICTURE OF THE URETHRA.

———————————

LONDON:

"MEDICAL CIRCULAR" OFFICE, 20, KING WILLIAM STREET,
STRAND, W.C.

———

Price 1s. 6d.; by post, free, 1s. 7d.

No. 111

F. B. Courtenay, Revelations of Quacks and
Quackery; A Series of Letters by "Detector,"
Reprinted from "The Medical Circular," 1865

Published in London

Under the authorship of one "Detector," a series of letters on various patent
medicine frauds appeared in the pages of the English journal, *The Medical
Circular* in the mid-1860s. Their author later collected them into this volume
and into at least seven subsequent editions in which he named certain of the
more notorious practitioners then active in London. Several of those singled
out, such as Dr. Kahn, operated anatomical museums, a practice which Dr.
Courtenay termed the "quack museum dodge."

Selling Sex Cures.

The sale of products for venereal disease and impotency has always been a lucrative field for quacks, providing good and continuing business because sexually transmitted diseases were widespread, and to most of those infected, secret and shameful. With so few effective products available for most of human history, and with severe side effects from regimens of antimony and mercury—two effectual treatments widely used by orthodox physicians—patients were prime candidates for anything touted as useful in treating or preventing syphilis or gonorrhea. At times proprietary medicines were advertised as not containing mercury when in fact they did, but in most cases sarsaparilla, sassafras and guaiac were the main ingredients included in their formulations. Still another reason for the irregular's success with these products was the patient's understandable desire for secrecy, accompanied by feelings of remorse or guilt, and a reluctance to go to their regular physicians for treatment. In the late eighteenth century, a separate class of products originated to cure various sexual problems brought about, so they claimed, by masturbation. Samuel Solomon's (?–1819) Cordial Balm of Gilead, which was extensively promoted and relatively expensive, became a leading product in this large class. Women were not neglected by the medicine sellers, even though the market for their products was smaller. Long before Lydia Pinkham (1819–1883) arrived on the scene there were female specialists offering products that were designed to induce either abortion or conception. Most advertisements for these products relied on euphemism. ❧

No. 112

James Graham Lecturing, 1785

JOHN KAY (English, 1742–1826)
Engraving; image 5¾ x 5⅛ in. [14.6 x 13 cm]

J. KAY *Invent et Fecit*.

Known as the "Emperor of Quacks" in late-eighteenth-century London, James Graham had some medical training and spent time in North America before establishing himself in London. In his Temple of Health, he sold his Elixir of Life, Imperial Pills and Nervous Aetherial. One room held the Grand Celestial Bed in which "children of the most perfect beauty could be begotten" and for which desirable couples paid five hundred guineas per night to use.

No. 113

Hyacum et Lues Venerea (Guaiac and Venereal Disease), 1570

PHILIP GALLE (Dutch, 1537–1612)

After Jan van der Straet [Stradanus] (Flemish, 1523–1605)

Engraving; 8½ x 11⅛ in. [21.6 x 28.3 cm]

From *Nova reperta*

HYACVM, ET LVES VENEREA .
Grauata morbo ab hocce membra mollia Leuabit ista sorpta coctio arboris .

The guaiacum tree was native to America and the early discovery of its value in treating syphilis brought one of the first potential substitutes for mercury. Not surprisingly, it quickly became a key agent in many secret medicines. This print, one in the series of twenty images in the *Nova reperta*, a sixteenth-century review of recent important discoveries, showed how guaiac was manufactured from the crude resin and later administered to a sick man as his physician watched.

No. 114

James Pidding, Proofs of the Efficacy of De Velno's Vegetable Pills, 1800

Published by J. Evans & Co., London

PROOFS OF THE EFFICACY OF

De Velno's Vegetable Pills,

as the most *safe* and *certain* Cure for

THE SCURVY,

SCORBUTIC ERUPTIONS, SCROPHULA or KING'S EVIL, LEPROSY, and other Disorders, arising from CONTAMINATED BLOOD, or OBSTRUCTED PERSPIRATION;

WITH

some pertinent Remarks on the Utility of

Sea Bathing;

demonstrating the Propriety of taking ALTERATIVE MEDICINES during that Period, and the *Danger* of ANTIMONIALS or MERCURIALS; giving, at the same Time, satisfactory Reasons for relying with Confidence on the *Safety* and *Efficacy* of DE VELNO's PILLS, as an ALTERATIVE, PURIFIER, and

Sweetener of the Blood.

AN unexaggerated ftatement of the remarkable cure of E. ELLISTON, Efq. lately refiding at No. 35, Mortimer-ftreet, Cavendifh-fquare, but now of Queen Anne-ftreet, Eaft, who had been eighteen years troubled with a moft inveterate Scorbutic Humour, and was on the eve of being doomed to a hazardous, and, at all events, an unnecef-fary *falivation*. This Gentleman, from the pureft motives of humanity and philanthropy, *requefted* his cafe fhould be publifhed, and has always very readily communicated the particulars to any perfons of refpectability, making application at his houfe: an honourable example for imitation.

HIS CASE DESCRIBED.

Mr. ELLISTON had for *eighteen years* been fubject to fcorbutic fymptoms, but for the laft eighteen months they had increafed to fuch a degree as to be ferioufly alarming. Innumerable large fpots or eruptions, of a deep red, about the fize of peas, and hard, appeared in *clufters* on various parts of the body, thighs, arms, hands, head, and particularly on the forehead, which was dreadfully *disfigured*. In fhort, language can but faintly depicture his real condition. But appearances were only of trifling import, when compared with the violent heat and itching which inceffantly tormented him. In this fituation he confulted his *Phyfician* and *Surgeon, both* men of refpectability and eminence, who, after a *confultation,* decided on the *neceffity of his fubmitting* to a courfe of phyfic, alluding to *Mercury,* which would *confine* him to his room for fome weeks. Mr. E. being advanced in years (more than *fifty* of which had been fpent in the naval fervice of his country) told them he would take time to confider of it, as he could not but with great reluctance fubmit to *confinement*. He advifed with his friends on the fubject, fome of whom recommended him to try De Velno's Vegetable Pills, which he very fortunately confented to, and, by perfevering in them, *and them alone*, he has received a perfect cure. During this courfe he had not an *hour's* confinement, nor was he reftricted to any regimen or diet, except temperance; on the contrary, he perceived no effect whatever from the Pills, except that of gradually recovering from his complaint, and daily acquiring an addition of health, ftrength, and fpirits.

ANOTHER PROOF.

J. MEREDITH, Coachman to Lord SELSEY, Lower Grofvenor-ftreet, was for a confiderable time tormented with a moft defperate Scorbutic Leprofy, hideous to the fight, and itching moft infufferably; in reality, at leaft three-fourths of the furface of his body, from his head to his feet, were completely incrufted with leprous fcales. By perfeverance in De Velno's Vegetable Pills, without any confinement, or limitation in diet, he is perfectly recovered.

Although this brochure advertises Velno's Pills for scurvy, its main use was for the treatment of venereal disease. The term "Sweetener of the blood" was a euphemism for such an indication. The text notes that "for the one class of diseases, which, although they appear in various shapes, have all their origin from the same cause, [the proprietor] is able to pronounce it an infallible and specific remedy."

TRAITÉ

DES

MALADIES VÉNÉRIENNES,

ANCIENNES, RÉCENTES, OCCULTES OU DÉGENÉRÉES,

ET

MÉTHODE

DE LEUR GUÉRISON

PAR LE ROB ANTI-SYPHILITIQUE:

Avec l'Histoire raisonnée des autres moyens employés jusqu'ici par les gens de l'art ;

SUIVI

d'un choix de cures étonnantes, opérées par ce remède, et des pièces justificatives.

Par le Cit. BOYVEAU LAFFECTEUR, médecin, rue de Varennes, fauxbourg Germain, n°. 46.0.

Vires acquirit eundo. VIRGIL. Enéid.

A PARIS.

L'an VIII de la République.

No. 115
Boyveau Laffecteur, Traité des Maladies Vénériennes, 1797

Author's copy
Published in Paris

Laffecteur outlines methods of curing syphilis before and after his discovery in 1779 of a new and efficient product, the Rob Laffecteur, destined to become one of the most celebrated popular treatments for venereal disease toward the end of the eighteenth century. The product's later arrival in America, accompanied by a high price of seven to eight dollars a bottle, had some influence on William Swaim who incorporated its active ingredient, sarsaparilla, into his own nostrum (p. 75).

No. 116
Cordial Balm of Gilead Prepared by Dr. Solomon, c. 1800

Broadside; 20¼ x 7⅞ in. [51.4 x 20 cm]
Printed in Liverpool

Just Imported,

A Valuable Supply of that most excellent Medicine the

CORDIAL BALM OF GILEAD,

PREPARED BY
DR. SOLOMON,
Of the University and College of Physicians, and Author of the "GUIDE TO HEALTH,"
GILEAD-HOUSE, NEAR LIVERPOOL.

Sold also by the following Agents, and by one Vender in every principal town in the United States,

PRICE THREE DOLLARS A BOTTLE!

New-York, R. BACH and Co. 128, Pearl-street, wholesale agents for all the United States of America. J. and M. Paff, 137, Broadway. Brooklyn, Long-Island, Thomas Kirk, printer. Albany, Samuel Dexter, druggist.
New-Jersey, Princeton, J. Harrison, post-master.—Elizabethtown, S. Kollock, printer.
Pennsylvania, Philadelphia, G. Shaw and Co. 129, Chesnut-street; J. J. Malcolm, 27, South Second-street.
Maryland, Baltimore, A. Aitkin, 2, South-street.
Massachusetts, Boston, Thomas Bartlett, 13, Cornhill. Salem, T. C. Cushing, printer. Newbury Port, B.

Emerson, post-master. Portland, Dr. S. Irvin, druggist. Northampton, Simeon Butler, printer.
Connecticut, New London, S. H. P. Lee, druggist, Bank-street. Hartford, Hudson & Goodwin, printers. New Haven, Joseph Darling, druggist.
Virginia, Richmond, William Pritchard, bookseller. Petersburgh, N. Fitz. Alexandria, J. and J. D. Westcott, printers, Royal-street. Norfolk, Dr. Frederick Heerman, Main-street.
Rhode-Island, Providence, J. Carter, jun. printer.—Newport, Charles Fike, druggist.
North Carolina, Wilmington, A. T. Brown, Front-street.

Georgia, Savannah, George Hatrell.
South Carolina, Charleston, Dr. Joseph Kirkland, 237, Meeting-street.
New Hampshire, Portsmouth, C. Peirce, printer.
Canada, Quebec, Mons. Lehoullier.
Newfoundland, Port de Greve, D. O'Connor.
New Providence, Nassau, Wilson.
Barbadoes, P. N. Garner.
Jamaica, Kingston, Dr. Alvarengo.
Jersey, R. Healy.
Guernsey, S. Taylor.
And by whomsoever the General Agents, R. Bach and Co. of New-York, appoint in America.

" To administer to a Mind diseased, pluck from the Memory a rooted Sorrow,
" Raze out the written Troubles of the Brain, and with some sweet oblivious Antidote
" Cleanse the foul Bosom of that perilous stuff which weighs upon the Heart."

It is notorious, that various disorders of the human frame are brought on by dissipation in youth, and the gross violation of those rules which prudence dictates for the preservation of health, and laying a foundation for a long and happy life, with a firm and strong constitution. The blessings of health are no sooner lost than painful experience teaches the inestimable value of it, and the unhappy patient looks around, too often, alas! in vain, for the means of its recovery!

The CORDIAL BALM OF GILEAD is universally acknowledged to be peculiarly efficacious in all inward wastings, loss of appetite, indigestion, depression of spirits, trembling or shaking of the hands or limbs, obstinate coughs, shortness of breath, and consumptive habits. It thins the blood, eases the most violent pains in the head and stomach, and promotes gentle perspiration. By the Nobility and Gentry this medicine is much admired, being pleasant to the taste and smell, gently astringing the fibres of the stomach, and giving that proper tenity which a good digestion requires. Nothing can be better adapted to help and nourish the constitution after a nocturnal debauch with wine, &c. This Cordial is highly esteemed in the East and West Indies for nourishing and invigorating the nervous system, and acting as a general restorative on debilitated constitutions, arising from bilious complaints contracted in hot climates. Those who have the care and education of females, the studious as well as the sedentary part of the community, should never be without the Cordial Balm of Gilead, which removes diseases in the head, invigorates the mind, improves the memory, and enlivens the imagination.

It is the most absolute remedy for such diseases as are attended with the following symptoms, namely—a great straitness of the breast, with difficulty of breathing; violent palpitations of the heart, sudden flushes of heat in various parts of the body; at other times a sense of cold, as if water was poured on them; flying pains in the arms and limbs, back and belly, resembling those occasioned by the gravel; the pulse very variable, sometimes uncommonly slow, at other times very quick; yawning, the hiccough, frequent sighing, and a sense of suffocation, as from a ball or lump in the throat; alternate fits of crying and convulsive laughing; the sleep unsound, and seldom refreshing, and the patient often troubled with horrid dreams. Much has been said by interested individuals against medicines that are advertised; but there is a very important observation to be made respecting the Cordial Balm of Gilead, that unless its operation was gentle, safe, and efficacious, it could not have obtained the unexampled demand it has acquired; for, as it has rarely the great advantage of a persuasive advocate at the ear of the patient, so nothing but his conviction of its virtues, by its salutary effects, can induce perseverance, and yet reasonable perseverance is certainly most requisite to enable even the happiest combination of chemicals and galenicals to root out chronic diseases, and restore the valetudinarian to health.

The CORDIAL BALM OF GILEAD most wonderfully cherishes nature, and will support the life of the aged and infirm. In all inward decays, debility, lowness of spirits, relaxation in either sex, whether hereditary or owing to youthful imprudencies, this medicine will afford the most wonderful relief.

Its well-known characteristic of promoting longevity has been long maintained; for, by keeping the constitution, as it were, in continual repair, it preserves the body in health and vigour, and prevents premature decay. It requires no particular confinement, nor attention to diet.

This lengthy and wordy advertisement prepared for the American market lists names of agents in principal cities in the United States, Canada and the Caribbean. A line at the top has been erased and the words "Just Imported" have been written in. In the section on English Government Security against Counterfeits, charges are expressed in both dollars and pounds.

THE CELEBRATED
CORDIAL
Balm of Gilead,

PREPARED BY

DR. SOLOMON,

GILEAD-HOUSE, NEAR LIVERPOOL.

No. 117

Samuel Solomon,
The Celebrated Cordial
Balm of Gilead, c. 1817

Printed in Liverpool

THE well-known character which this medicine has so long and in-variably maintained, amongst all classes of mankind, as the most GENERAL RESTORATIVE for

Debilitated Constitutions,

And nourishing and invigorating the

Nervous System,

Recommends it to the Afflicted, whether their bodily strength be ex-hausted, or their vigour and vivacity impaired, as a medicine of the most salutary and powerful efficacy, its primary object being to relieve those persons who, by an immoderate indulgence of their passions, have ruined their constitutions, and brought on a perfect TABES DORSALIS, or in their way to the consummation of that deplorable malady, are affected with any of those previous symptoms that betray its approach, as the vari-ous affections of the nervous system, obstinate gleets, involuntary emis-sions, excess, irregularity, obstruction of certain evacuations, weakness, total impotency, barrenness, &c. But the relief the Cordial Balm of Gilead generally administers, is not confined to these alone; the valetu-dinarian by birth, who has received from his parents the inheritance of a diseased and unprolific frame; the delicate female, whom an immured and inactive life, together with the immoderate use of tea and other weak and watery aliments, has, without any fault of hers, brought on all the calamitous symptoms of a consumptive habit, and are without timely assistance sinking into an untimely grave! Such as these, under Divine influence, the Cordial Balm of Gilead will restore to all the com-forts of life.

This remedy is resorted to by the first nobility and gentry in the united kingdom; nor has its merit been lessened by the hand of time, the test of all things; every day adds more encomiums to its exalted virtues than can possibly be published. It is universally admired, being pleasant to the taste and smell; gently astringes the fibres of the stomach, and gives that proper tensity which a good digestion requires. As nothing can be

This is one of many pamphlets advertising Samuel Solomon's cure for the results of masturbation, scrofula and related ills. Although published in England, there are testimonials from the United States included as well. A sea captain writes from Philadelphia, noting that three bottles "have perfectly strengthened my constitution and given me better spirits than I ever enjoyed before in my life, for which I am in duty bound to pray for you."

No. 118

Samuel Solomon, A Guide to Health; or, Advice to Both Sexes, c. 1780–95

57th edition
Printed in London

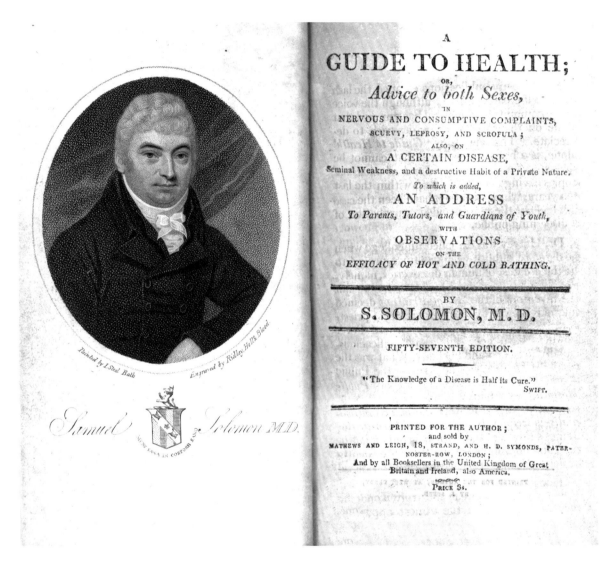

A

GUIDE TO HEALTH;

OR,

Advice to both Sexes,

IN

NERVOUS AND CONSUMPTIVE COMPLAINTS,

SCURVY, LEPROSY, AND SCROFULA ;

ALSO, ON

A CERTAIN DISEASE,

Seminal Weakness, and a destructive Habit of a Private Nature.

To which is added,

AN ADDRESS

To Parents, Tutors, and Guardians of Youth,

WITH

OBSERVATIONS

ON THE

EFFICACY OF HOT AND COLD BATHING.

BY

S. SOLOMON, M.D.

FIFTY-SEVENTH EDITION.

" The Knowledge of a Disease is Half its Cure."

SWIFT.

PRINTED FOR THE AUTHOR ;

and sold by

MATHEWS AND LEIGH, 18, STRAND, AND H. D. SYMONDS, PATER-
NOSTER-ROW, LONDON ;

And by all Booksellers in the United Kingdom of Great
Britain and Ireland, also America.

PRICE 9s.

Painted by I. Sted. Bath. *Engraved by Ridley. Hel18. Blood.*

Samuel Solomon M.D.

MENS SANA IN CORPORE SANO

Solomon's *Guide to Health* eventually went through sixty-six editions, largely because printing runs were small. The frontispiece showed a portrait that changed at least ten times in the various editions, but Solomon's coat of arms was not present in the earlier printings. The text covered the sequela of "a certain disease" and offered the Cordial Balm of Gilead as a cure. Solomon, based in Liverpool, had agents throughout the world selling his successful and relatively expensive product.

William Brodum, The Guide to Old Age;
or, a Cure for the Indiscretions of Youth, 1802

Printed by Lewis and Co., London

WILLIAM BRODUM, M.D.

F.R.H.S.

London Published November 6th 1802.

THE
GUIDE TO OLD AGE;
OR,
A CURE
FOR THE
INDISCRETIONS
OF
YOUTH.

By WILLIAM BRODUM, M.D.

VIRGINIBUS PUERISQUE CANTO.——VIRGIL.
To Youths I write, and Virgins uninformed.

THE FIFTY-SECOND EDITION,
CORRECTED AND CONSIDERABLY IMPROVED.

London:

Printed by Lewis and Co. Paternoster-row,

FOR THE AUTHOR, AND SOLD BY HIM AT NO. 9, ALBION-
STREET, NEAR THE LEVERIAN MUSEUM,
BLACKFRIAR'S-BRIDGE;

And may be had of all the Booksellers in the Three Kingdoms.

1802.

ENTERED AT STATIONERS' HALL.

Although Brodum's two products, the Botanical Syrup and the Nervous
Cordial could be used for almost anything, the bulk of his *Guide* is devoted
to venereal disease and to men's and women's diseases. Both Brodum and
Samuel Solomon had bogus medical degrees, obtained from the Marischal
University in Aberdeen, which was close to and easily confused with the
University of Aberdeen, a legitimate medical institution.

No. 120

Madam Winneford's Magnetic Maternal Wafer, Woman's Specific Against Sterility, Leucorrhœa etc., c. 1870

Four-page brochure; 8⅜ x 5⅜ in.
[21.3 x 13.7 cm]
Printed by Universal Dispensary,
Grand Rapids, Michigan

No. 121

An Open Letter to Mothers Concerning Dr. Wrightsman's Sovereign Balm of Life, 1883

Four-page brochure; 8⅜ x 5½ in.
[21.3 x 14 cm]
Printed by Senger & Lipe,
Franklin Grove, Illinois

Most promotions of products for sexual problems were directed to men, even those for syphilis and gonorrhea, but there was also a significant market for products for women. "Ladies who have been denied the pleasures of maternity may have their wishes fulfilled by the use of these Wafers," claimed the makers of Madame Winneford's product, while the Sovereign Balm of Life promised to "produce an easy and speedy delivery in child-birth." Would that everything were so simple.

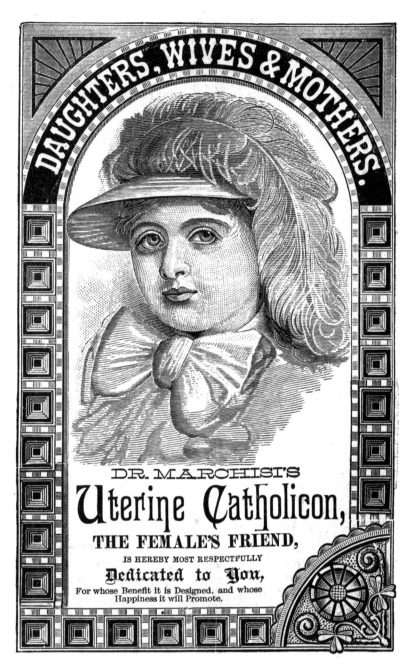

No. 122

Daughters, Wives & Mothers.
Dr. Marchisi's Uterine Catholicon,
the Female's Friend, c. 1875

Four-page brochure; 7¾ x 5 in.
[19.7 x 12.7 cm]
Printed by Dr. J. B. Marchisi Company,
Utica, New York

No. 123

Andrew Stone, A Treatise on
the Causes of the Early Physical
Degeneracy of American People,
and the Early Melancholy Decline
of Childhood, and the Youth
of Both Sexes, c. 1856

Published in Troy, New York

A TREATISE

ON THE

CAUSES

OF THE

PREMATURE DECAY

OF AMERICAN YOUTH:

ON

MASTURBATION,

OR SELF-ABUSE,

Spermatorrhœa, or Seminal Weakness,

IMPOTENCE,

And other Diseases of the Sexual Organs

IN MALE AND FEMALE.

And could I write the epitaph, it should be: Here lies a female youth of 16 years, an early victim to the degrading vice of SELF-POLLUTION, of which, she is but a sad instance of thousands.—*Page 9.*

By ANDREW STONE, M. D.,

PHYSICIAN TO THE HYGIENIC AND LUNG INSTITUTE, NO. 96 FIFTH ST., TROY N. Y,

(COPYRIGHT SECURED.)

The title page differs from the cover, for the pamphlet is "A Treatise on
the Causes of the Premature Decay of American Youth: on Masturbation,
or Self-Abuse." The author states that his work "is no quack humbug, issued
for the purpose of pandering to depraved appetites, passions and prejudices
of the race, but a statement of *facts.*"

No. 124

William H. Parker, The Science of Life; or, Self-Preservation, 1881

155th edition
Published by the Peabody Medical Institute, Boston

W. H. PARKER, M. D.

THE SCIENCE OF LIFE;

OR,

SELF-PRESERVATION.

A MEDICAL TREATISE

ON

NERVOUS AND PHYSICAL DEBILITY, SPERMATORRHŒA,
IMPOTENCE, AND STERILITY,

WITH

Practical Observations

ON THE

TREATMENT OF DISEASES OF THE GENERATIVE ORGANS.

BY WILLIAM H. PARKER, M. D.,

No. 4 BULFINCH STREET, BOSTON,

(OPPOSITE REVERE HOUSE,)

*Doctor of Medicine, Chief Consulting Physician of Peabody Medical
Institute ; Author of a Treatise on Diseases of the Throat
and Lungs, a Treatise on Nervous and Mental
Diseases ; late Surgeon in the United
States Army, etc.*

BOSTON:
PUBLISHED BY AUTHORITY OF THE PEABODY MEDICAL INSTITUTE.

LATEST EDITION.

In the introduction to this 155th edition, Dr. Parker writes "And while the poor, wretched victims of Onanism and all dependent nervous afflictions have been inquiring almost despairingly, 'Is there no balm in Gilead?' …Let my last words of solemn warning be,—Avoid all Quacks, Charlatans, Empirics, Pretenders, and Bogus Medical Institutes Throughout the World."

No. 125

Information for Men, 1906

Four-page advertisement;
13¼ x 10¼ in. [33.7 x 26 cm]
Printed by L. B. Hawley,
Rochester, New York

For ten dollars, Dr. Hawley sold the Erector, a mechanical treatment for functional impotency and an apparatus that provided a similar result to Viagra today. He explained his motivations carefully, "In giving this literature to the public, my sole motive is to place a somewhat delicate subject before the large army of unfortunates in such a plain, practical, yet at the same time professional way, as to inspire them with confidence."

TRADE THERAPION; MARK.

THE CURE OF CURES.

————

A FEW PRACTICAL OBSERVATIONS ON

THE VARIOUS DISORDERS

TO WHICH THE

URINARY AND GENERATIVE SYSTEMS ARE LIABLE;

WITH

PLAIN RULES FOR THEIR SAFE & PROMPT REMOVAL

BY MEANS OF

THE NEW FRENCH REMEDY

THERAPION,

BY

PROFESSOR LE CLERC.

————

PUBLISHED AND SOLD BY THE PROPRIETOR.

Price ONE SHILLING.

ALL RIGHTS RESERVED,

No. 126
LeClerc Medicine Co., Therapion;
The Cure of Cures, 1880

Printed in London

Mercury, perhaps the only effective remedy for syphilis and other venereal diseases until the advent of arsenicals and penicillin, was an effective agent that brought with it a considerable number of side effects. Proprietary medicine manufacturers invariably made a point that their remedy for such conditions did *not* contain mercury, however, but because their formulas were secret they did not disclose what their nostrum contained in its stead. Therapion was one example of the many products following this approach.

The latest and most successful method of treating disease is my

MAGNETISM

As supplied by "Appareil Magnetique."

Stroud Green,
August 24th, 1901.
Dear Sir, — I am delighted with the Appliance, and have already derived great benefit from their use. Since my return to London I have weighed myself and find that I have gained 5 lbs. Considering that I have done a good deal of cycling, I think this is very good, as the hot weather is not calculated to increase one's weight.

Please accept my best thanks. Yours faithfully, A. F. R.

GENTS' ABDOMINAL BELT.

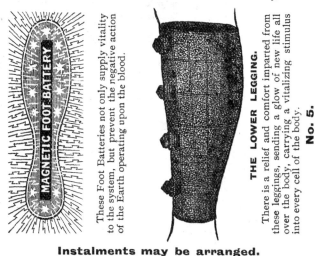

MAGNETIC FOOT BATTERY

These Foot Batteries not only supply vitality to the system, but prevent the negative action of the Earth operating upon the blood.

THE LOWER LEGGING.

There is a relief and comfort imparted from these leggings, sending a glow of new life all over the body, carrying a vitalizing stimulus into every cell of the body.

No. 5.

Instalments may be arranged.

For Particulars write :

THE MAGNETIC NERVE INVIGORATOR CO.,

JONATHAN NICHOLSON, 27, Great Eastern House, Bishopsgate Street, London, E.C.

No. 127
Jonathan Nicholson, "Manhood," Lost and Regained, 1902

Published by the Magnetic Nerve Invigorator Co., London

The object of this book is to warn "those engaged in the meshes of folly, giving a clear description of the results which follow in the steps of neglected physical righteousness." Treatment is provided by wearing various magnetic appliances made by the publishers of this book.

PERFECT MALE AND FEMALE FIGURES.

"THE human frame, as a machine, is perfect,—it contains within itself no marks by which we can possibly predict its decay; it is apparently intended to go on forever."

Dr. Monröe.

No. 128

Harmon Knox Root, The People's Medical Lighthouse, 1853

8th edition
Printed in New York

Dr. Root's 472-page illustrated book was dedicated to convincing the public to purchase his medicines, which were "composed of the best ingredients that this and foreign lands can produce, and ten times cheaper, purer, stronger, and more effectual than any Medicines used." The most extensive section deals with sexual matters and includes chapters on prostitution, procreation of the sexes at will and gives advice to pregnant ladies.

Les Adieux au Palais Royal (Farewells at the Palais Royal), 1816

ANONYMOUS (French)

Engraving; image 7⅜ x 11¼ in. [18.7 x 28.6 cm]

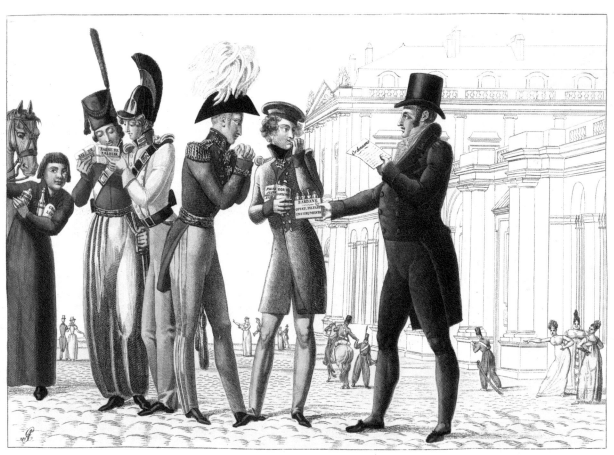

LES ADIEUX AU PALAIS ROYAL
ou Les Suites du Premier Pas.

A Paris chez Martinet, Rue du Coq.

Déposé 8e

As the occupying forces are preparing to leave for active duty in Paris following the defeat of Napoleon and his troops, they are issued enough medicines to cure any possible ailment they might receive. At the time, the area surrounding the Palais Royal was rife with prostitutes, explaining the fact that among the products is a bottle of the Rob Laffecteur (p. 169) a popular remedy for syphilis.

No. 130

Harvey & Co., Short Account of Sir Astley Cooper's
Vital Restorative, 1865

Printed in London

No. 131

Harvey & Co., Short Account of the Vital Restorative, the
Only Acknowledged Successful Remedy for the Removal
of General, Local, and Nervous Debility..., 1869

Printed in London

SHORT ACCOUNT OF

Sir Astley Cooper's

VITAL RESTORATIVE,

THE ONLY ACKNOWLEDGED

SUCCESSFUL REMEDY

FOR THE REMOVAL OF

General, Local, and Nervous Debility,

CONFIDED TO

MESSRS. HARVEY AND Co.,

Surgeons,

44, WEYMOUTH STREET,

(One Door from)

PORTLAND PLACE, REGENT'S PARK,
LONDON, W.

1865.

SHORT ACCOUNT

OF THE

VITAL RESTORATIVE

THE ONLY ACKNOWLEDGED

SUCCESSFUL REMEDY

FOR THE REMOVAL OF

General, Local, and Nervous Debility,

CONFIDED TO

MESSRS. HARVEY AND CO.,

Surgeons,

19, BERNERS STREET, OXFORD ST.,

LONDON. W.

1869.

To market their product for "the removal of General, Local and Nervous
Debility," the proprietors of the Vital Restorative appropriated the name of
the eminent surgeon Sir Astley Paston Cooper (1768–1841). Not surprisingly,
Dr. Cooper objected, and the later 1869 edition did not mention his
contribution. On being consulted by prospective male patients, the firm
requested a urine sample which generated a letter insisting on an immediate
interview to treat a condition for which the Vital Restorative was imperative.

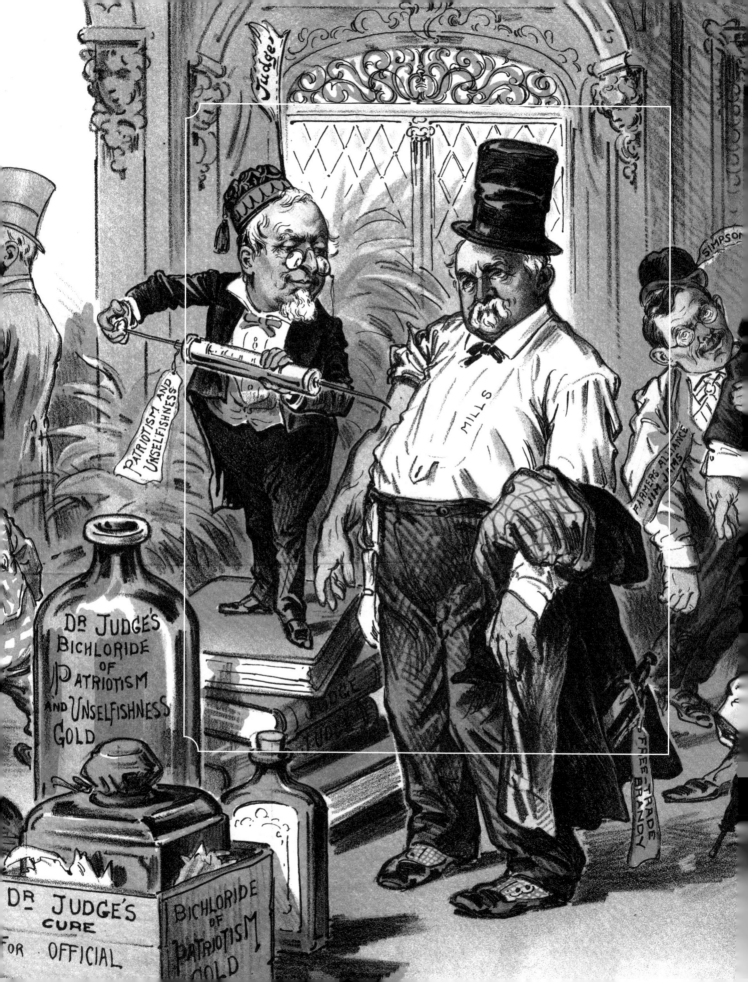

Addiction & Electricity Cures.

The fact that no pharmaceutical agent has yet been discovered to successfully end addiction to narcotic drugs, alcohol or tobacco has not deterred quacks from promoting purported cures. Most of them contained scopolamine, strychnine, belladonna alkaloids or related products; some offered cures in three days, cures that could be taken at home, or cures that could be applied secretly in the victim's food so that he (invariably a husband, brother, or son) would be unaware of the attempt. A particularly insidious group of products were those narcotics that substituted a higher dose of opium or morphine for the normal dose the addict was taking, or those that contained a higher level of alcohol than the drunkard had been used to drinking. Perhaps the only advertised system of curing addiction that had any success, even partial, was the Keeley System, developed by Dr. Leslie E. Keeley (1834–1900) in the late 1870s. Using bichloride, or double chloride of gold (a non-existent molecule in the eyes of his detractors), as the active ingredient, the program relied more on almost continual supervision of the sufferer and the camaraderie with like-minded patients brought together for several weeks of intensive therapy. Certain aspects of the Keeley System were later adopted by the founders of Alcoholics Anonymous. In addition to the addiction cures, there have been other categories of advertised products which have also been ineffective, a major group being those which relied on electricity for their appeal. In the nineteenth century, a large industry was created to provide electrical belts, electric insoles, electric brushes and even electrically driven chairs to improve health; none of their large and varied output can be demonstrated to have accomplished any good at all. ❧

No-To-Bac, 1890–1900

MAXFIELD PARRISH
(American, 1870–1966)
Color relief print; 42⅛ x 29⅛ in.
[106.8 x 74 cm]
Philadelphia Museum of Art.
The William H. Helfand
Collection. 1981-114-36

The knight in Maxfield Parrish's poster is a Roman warrior with long, flowing hair and an elaborate cape. No-To-Bac contained licorice, gentian, guaiac, and a salt, possibly ammonium chloride, prepared as a chewing gum. The pleasant, demulcent action provided a substitute for smoking, but was obviously not effective in curing the smoking habit.

One of the major products of the Sterling Remedy Company, No-To-Bac was usually advertised with an image of a muscular warrior slaying his deadly foe, Nicotine. Defensively, the copy in the advertisement deflects criticism by noting that No-To-Bac does not cure everyone and that "the claim 'never fails to cure' is a quack lie, and fraud's talk."

No. 134

Uncle Sam's Tobacco Cure, 1895

Advertisement; 15¼ x 10¾ in.
[38.7 x 27.3 cm]

From *Campbell's Illustrated Monthly*,
Chicago, vol. 4, no. 10 (March 1895)

One of the testimonials praising Uncle Sam's Tobacco Cure claims that a single tablet ended the desire for either smoking or chewing, but other "Truthful Testimonials" in the advertisement are slightly more believable. Oddly, the patriotic graphics in the advertisement do not seem relevant to curing addiction in any way.

The Hindoo Tobacco Habit Cure is composed entirely of Roots and Herbs.

THIS IS FOR YOU!

READ IT CAREFULLY.

IF YOU DO NOT NEED THE HELP WE OFFER,

Please hand it to your neighbor. He will thank you for it.

200 DOSES 50¢

MAKES WEAK MEN STRONG.

Restores the Debilitated to Manly Vigor.

MAKES STRONG MEN STRONGER.

HINDOO TOBACCO HABIT CURE

The Oldest and Most Reliable Remedy on the market for Destroying the Appetite for Tobacco IN ALL ITS FORMS.

CHEWING, SMOKING AND CIGARETTE HABIT CURED IN TWO DAYS.

PHYSICIANS TELL YOU THERE IS NO CURE FOR THE CIGARETTE SMOKER That the entire system is so impregnated with the opium and poisons inhaled from the cigarette, and has such a firm hold on the victim that his case is hopeless. We have a positive cure in our HINDOO REMEDY.

A FEW DOSES DESTROYS THE APPETITE.

In two days we drive the Poison entirely out of the system.

PERFECTLY HARMLESS, COMPOSED ENTIRELY OF ROOTS AND HERBS ▲ ▲ ▲

MILFORD DRUG CO.,
SOLE MANUFACTURERS AND ORIGINATORS OF THE HINDOO TOBACCO HABIT CURE,
Milford, Indiana, U. S. A.

MILFORD-DRUG-CO.
HINDOO-REMEDY
TOBACCO-HABIT-CURE

It is pleasant to take. It has cured others. It will cure you. Try it.

$500.00 to anyone who can show that we use opium, morphine, or any other harmful drugs in this remedy.

No failures when directions are followed. We have thousands of testimonials of marvelous cures. Let us have yours.

No. 135

Hindoo Tobacco Habit Cure, 1892

Four-page brochure; 12 x 8⅛ in.
[30.5 x 20.6 cm]
Printed by Milford Drug Co.,
Milford, Indiana

The basic approach of this product was that "the use of tobacco is a constant drain on the nervous system and makes men impotent." The brochure also notes that "Many thousands of dollars are spent annually to charlatan doctors" to treat this condition, but that the Hindoo Remedy could end the tobacco habit in a very short time.

No. 136

Dr. S. B. Collins' Painless Opium Antidote, 1874

Advertisement; 10¼ x 7⅛ in. [26 x 18.1 cm]

From *The Oread of Mount Carroll Seminary*, Carroll County, Illinois, vol. 6, no. 5 (July 1874)

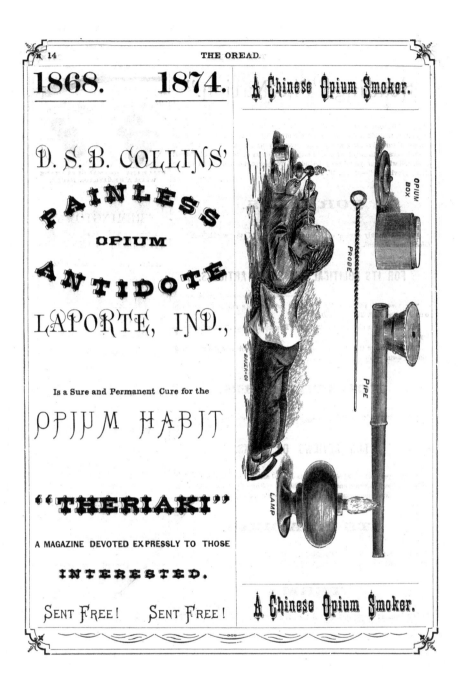

Religious journals were a favorite advertising medium for the manufacturers of proprietary medicines, and without the advertisements many such publications could not exist. The image of a Chinese opium smoker serves to reinforce the association of a growing immigrant group with opium smoking, even though few Chinese could have been expected to read the journal in which the wood engraving appears.

THERIAKI

AND

THEIR LAST DOSE.

• • •

Letters of Fitz Hugh Ludlow

AND OTHERS, TO

DR. SAMUEL B. COLLINS,

RELATING TO

THE MOST WONDERFUL MEDICAL
DISCOVERY OF THE AGE.

——— • • • ———

CHICAGO:
EVENING JOURNAL PRINT, NO. 46 DEARBORN STREET
1870.

No. 137
Samuel B. Collins, Theriaki and Their Last Dose, 1870
Published by Evening Journal Print, Chicago

No. 138
**Samuel B. Collins, Theriaki: A Treatise on the Habitual
Use of Narcotic Poison,** 1887
Printed in LaPorte, Indiana

No. 139
Dr. S. B. Collins' Painless Opium Antidote, c. 1875
Advertisement; 10⅛ x 6⅛ in. [25.7 x 15.6 cm]
Printed by Dr. Samuel B. Collins, LaPorte, Indiana

A practicing physician in La Porte, Indiana, Dr. Collins styled himself "The Great Narcologist of the Age," and first marketed his Opium Antidote in 1868 in Chicago newspapers. His was one of the more insidious addiction cures in that it substituted a slightly higher dose of morphine than whatever the patient had been previously taking. One contemporary analysis of a dose showed the morphine content to be 3.2%. One of his many advertisements illustrates his office above a bank building in LaPorte.

No. 140

Dr. Meeker's Antidote, 1890

Advertisement; 9 3/8 x 7 3/8 in. [23.8 x 18.7 cm]
Printed by the Meeker Medicine Co., Chicago

No. 141

Drunkenness, Dr. Cook's Specific "The Helping Hand," c. 1890

Advertisement; 6 3/4 x 5 1/4 in. [17.1 x 13.3 cm]
Printed by the Standard Drug Co., New York

The advertisements claimed to cure tobacco, narcotic and alcohol addiction, usually with varying dosage regimens. The prose in the Keeley booklet (opposite left) is inspiring, "Out from the shadows of clouded memory, out from the storm of battle against debasing appetite, out from a night of unending despair, out from the land of horrors and myths, gnomes and devils," and claimed a 96% success rate from the Keeley methods.

No. 142

William Rosser Cobbe, Restored at Dwight, 1894

Published by the Leslie E. Keeley Company, Dwight, Illinois

No. 143

H. H. Kane, The Living Death, 1884

Published by Presley Blakiston, Philadelphia
Printed in New York

32958

RESTORED AT DWIGHT.

VICTIM OF THE OPIUM DISEASE TELLS THE STORY OF HIS CURE.

For Years the Slave of the Drug, He Finds Freedom
Only in the Double Chloride of Gold Treatment—
His State of Mind and Body Compared with That in
Which He Sought the Little Illinois Village—Life
of the Patients—Their Magical Recoveries.

—BY—

WILLIAM ROSSER COBBE,

AUTHOR OF

"Slave of the Drug,"—"Drugs that Curse."
(Copyright by the Author, 1894.)

O-95-E-6-94. SPECIAL.

2571

The Living Death.

OPIUM,

MORPHINE, CHLORAL,

HASHISCH. ALCOHOL.

LAOCOÖN.

"Ille simul manibus tendit divellere nodos,
Clamores simul horrendos ad sidera tollit."
Virgil, Æneid, Lib. II.

By H. H. KANE, A. M., M. D.

174 FULTON STREET,
New York City.

IRISH COMIC SONG.

THE KEELEY CURE.

WORDS AND MUSIC BY

JAMES THORNTON.

4

NEW YORK.

FRANK HARDING'S MUSIC HOUSE,

229 BOWERY.

FOR SALE AT ALL MUSIC STORES.

In the late nineteenth century, the Keeley Cure became so popular that parodies appeared in music halls. This one tells the story of an alcoholic pumped so full of Bichloride of Gold that he became more valuable dead than alive:

My life became a burden soon no matter where I ran
Dime Museum managers chased me saying there's money in that man
And a hundred undertakers followed closely so 'tis said
Saying they'd bury me for nothing if I only would drop dead.

The Banner of Gold.

Song and Mixed or Male Chorus.

WORDS BY
CHAS. E. BANKS.

MUSIC BY
ALONZO HATCH.

Published by
THE S. BRAINARD'S SONS CO.
CHICAGO.

Copyrighted MDCCCXCI by ALONZO HATCH.

No. 145

The Banner of Gold, 1891

Song sheet cover; 13¾ x 10⅜ in.
[34.9 x 26.4 cm]
Words by Chas. E. Banks
Music by Alonzo Hatch
Published by the S. Brainard's
Sons Co., Chicago

Dr. Keeley's portrait is on the cover of this song dedicated to the Bichloride of Gold Club, a reference to a product which cannot be demonstrated chemically. The second verse reflects the addict's hope:

> The follies of youth and the habits of age,
> Alike are cast into the sea;
> Unfetter'd and hopeful we follow our sage,
> Once bo[u]nd, but now happily free.

No. 146

**Somebody, Somewhere,
is Praying for You!**, 1893

Song sheet cover;
13⅞ x 10¾ in. [35.2 x 27.3 cm]
Words by George Cooper
Music by Henry J. Sayers,
New York
Published by the Lyra
Publishing Co., New York

This song is dedicated to the Keeley Institute "for the good they are doing for humanity in restoring the drunkard to home and happiness by curing him of the disease of intemperance." The back page carries an advertisement for the Keeley Double Chloride of Gold Cure for nervous diseases, liquor and opium habits and emphasizes that it has been "adopted by the United States Government for use in National and State Soldiers' and Sailors' Homes."

No. 147

The Political Bichloride of Gold, 1892

FREDERICK VICTOR GILLAM (American, c. 1858–1920)
Color lithograph; 13⅜ x 20 in. [34 x 50.8 cm]
From *Judge* (January 2, 1892)
Printed in New York

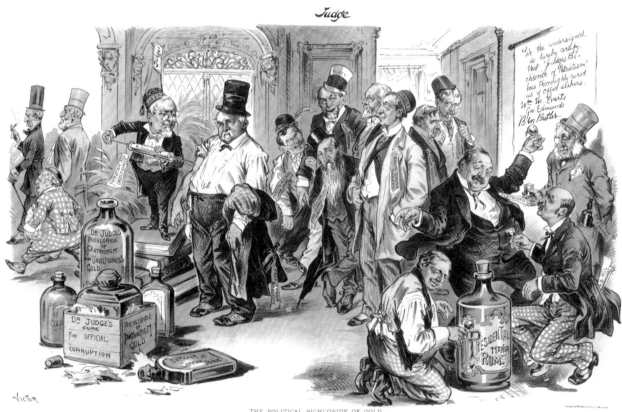

THE POLITICAL BICHLORIDE OF GOLD.

Dr. Judge proposes an injection that would positively cure the different forms of political dissipation that so sorely afflict our prominent politicians.

In place of Dr. Keeley's Bichloride of Gold, Gillam substitutes another fictional injectable, Dr. Judge's Bichloride of Patriotism and Unselfishness Gold. *Judge's* politics were consistently conservative, and thus those to be immunized are men whose politics it opposed. The leader of this group is Grover Cleveland, the Democratic candidate for president in 1892, and others in the print include several of his major political supporters.

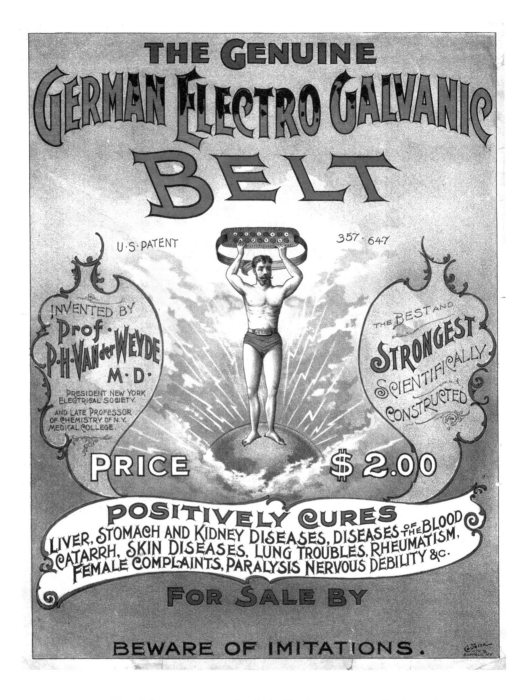

Electric belts were a popular device for the treatment of various ailments, but so were electric insoles, electric combs and other types of electric wearing apparel that offered similar relief. The belts usually contained copper and zinc disks connected to strips of flannel by wires, an arrangement suggestive of a wet battery. A blistering agent such as capsicum might also be present. The apparatus, thus, produced a mild burning sensation, indicating to the wearer that something was happening.

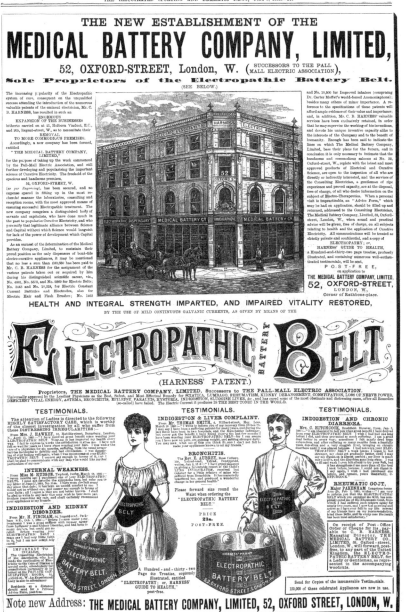

No. 149

The New Establishment of the Medical Battery Company, Limited, 1885

Advertisement; 16 x 9½ in. [40.6 x 24.1 cm]

From *The Illustrated Sporting and Dramatic News* (June 6, 1885)

The Medical Battery Company was the leading English supplier of electric belts, personifying, as their advertisement acknowledged "that legitimate alliance between Science and Capital without which Science would languish for lack of the power of development which Capital provides." The illustrations show the proper method of wearing the belts by both sexes.

No. 150
No. 150

**The Health Jolting Chair
Gavotte**, 1885

Song sheet cover;
13¾ x 10⅞ in. [34.9 x 27.6 cm]
Published by the Health Jolting
Chair Company, New York

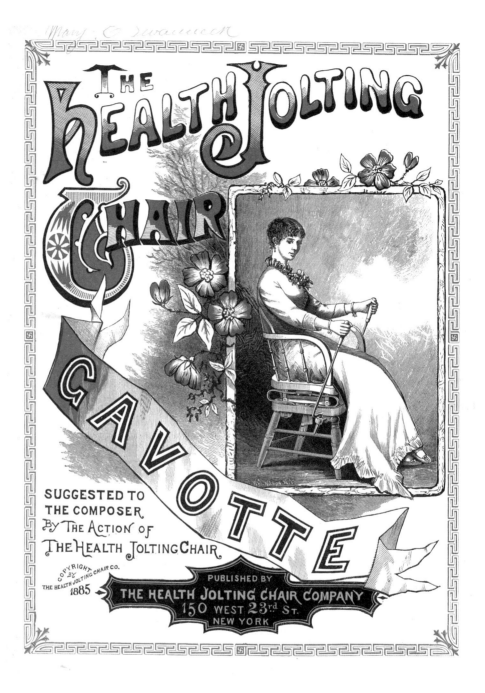

By using the wonders of electricity, the chair "affords an exercise similar to that given by a saddle-horse. It can be regulated to give it in any degree of severity desired." Such exercise provides "the Most highly prized Feminine Attractions," which are spelled out on the back page of the sheet music (right), along with additional useful information to ward off disease and to stimulate important organs of the body.

THE MOST HIGHLY PRIZED
Feminine Attractions

Are: A Beautiful, Rich Complexion; Bright, Sparkling Eyes; A Sweet, Pure Breath; A Graceful, Well-Developed Figure; Vigorous Mental Action; and a Vivacious Manner.

These attractions are all characteristic of healthy young womanhood—natural to her normal estate. If a young lady does not possess them, it is safe to say, with absolute certainty, that she has some disordered condition of health—that she is trespassing upon, or neglecting, some hygienic law, whose strict observance is necessary to her maintenance in health and beauty. In the upper ranks of society, and especially of fashionable society, the fairer sex are particularly prone to neglect the taking of proper exercise. The neglect of this hygienic requirement is sure to result in ill health. It is a requisition that cannot be dispensed with. It is a part of the constituted condition of existence, emphasized in *holy writ*, and whose verity is a continual matter of experienced observation. Nature has no use for the incorrigibly slothful. Many persons are too lazy to live; and they do not live. Their lives are shortened—disease fastening upon their ill-nourished bodies, sweeping them from mundane existence. The exercise of the most important parts of the body— the internal nutritive organs, comprising the heart, lungs, stomach, liver, etc.—naturally should receive the first consideration in hygienic living; yet these are the parts that are usually most neglected by the class of fair beings mentioned, as well as by most persons of sedentary habits and occupations. The consequence of such neglect is an inactive condition of these parts, which causes a poor circulation of the blood, poor digestion and assimilation of the food eaten, and a deficient amount of excretion of the worn-out nutritive elements, which collect in the general system, contaminating it, producing headache, nausea, sick, creepy sensations, pain in the bones, bad breath, a thick, muddy complexion, dull, yellow eyes, and a general depressed condition, that represses mental activity and all healthy cheerful life. All these undesirable results would not occur if these important parts of the body were properly exercised. There are many serious impediments to the taking of this exercise, among which may be mentioned the discomforts incidental to too hot or too cold temperatures; or to very stormy, wet, or dusty conditions; and also the restrictions of modern fashionable dress and customs. A profound and prolonged consideration of these facts has led to the invention of a very ingenious, yet comparatively simple mechanism, the moderate use of which affords the amount of exercise necessary for the preservation of vigorous general health, and the cure of many disordered conditions that may have arisen from its neglect. Furthermore, this exercise can be taken in the most convenient, comfortable, effective, and expeditious manner—more so than by any other method hitherto known. This mechanism is known as **THE HEALTH JOLTING CHAIR**, an illustration of which is here given. The chair affords an exercise similar to that given by a saddle-horse. It can be regulated so as to give it in any degree of severity desired; strengthening and increasing the activity of all the organs named, and beautifully developing the arms, shoulders, and chest. We would be pleased to send free to any address an interesting pamphlet entitled "Exercise of the Internal Organs of the Body Necessary to Health." It contains a full exposition of the subject, including a description of The Health Jolting Chair and the remarkable benefits that are derived from its use.

The Health Jolting Chair Company, 150 West 23d St., New York.

Putnams Print, 27 & 29 W. 23d St., N. Y.

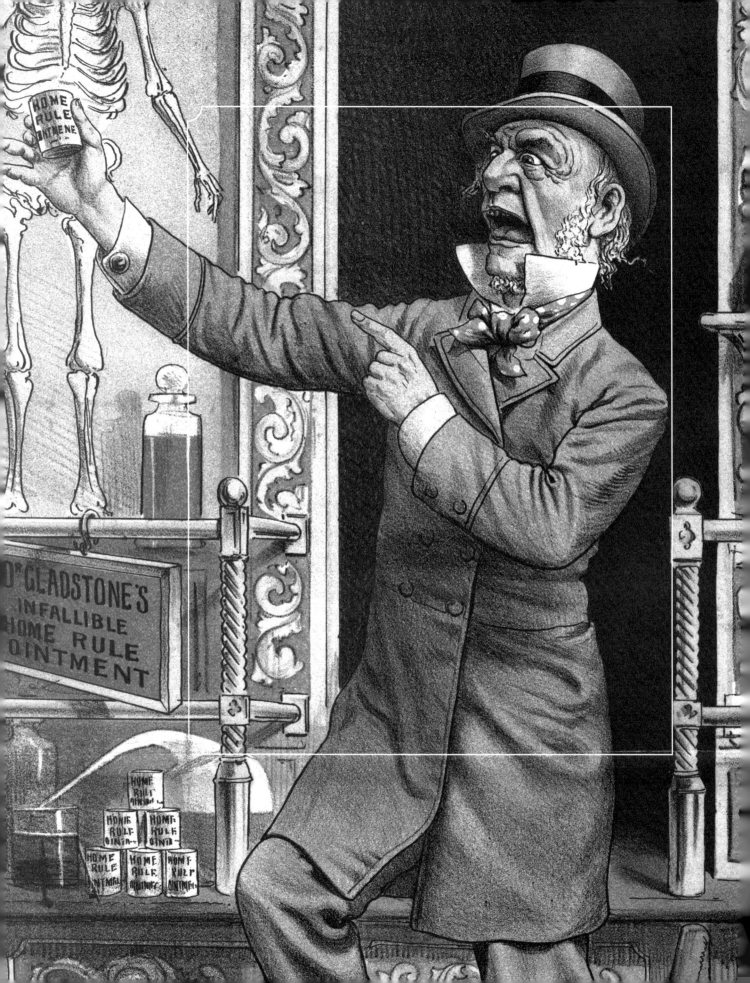

Quacks in the Arts.

The quack's visit to the village square was a common theme for artists, and there are, as a result, a large group of paintings and prints showing the charlatan at work both in the fine and the popular arts. Hogarth included several well-known quacks in his moral pictures, Joshua Ward, Dr. Misaubin, Chevalier John Taylor, and Sarah Mapp among them, and they have also appeared in *imagerie populaire* and other books and pictures for children. The image of Dr. Dulcamara, the seller of a love potion in Donizetti's opera *L'Elisir D'Amore* (*The Elixir of Love*) is but one example of the quack in music, and there are other popular songs, usually comic in nature, in which medicine sellers are pictured. Quacks have also been characters in fiction, exemplified by such works as *Tono-Bungay* by H. G. Wells, *The Clarion* by the muckraking journalist Samuel Hopkins Adams, and *The Autobiography of a Quack* by the famous Philadelphia neurologist, S. Weir Mitchell. Finally the field of political caricature has made abundant use of quack doctors. They are usually seen prescribing for the ills of a nation, and despite their use of a variety of heroic measures, their patients never improve. Every Western nation has its quacks playing such roles, and for the United States the list of such political figures portrayed as quacks includes Andrew Jackson, Abraham Lincoln, Theodore Roosevelt and almost every president in office over the last sixty years. 🍂

No. 151

**A Harlot's Progress, Expires
While the Doctors are Quarrelling,** 1734

WILLIAM HOGARTH (English, 1697–1764)
Engraving; 12⅞ x 15⅝ in. [32.7 x 39.7 cm]

In a series of six prints, Hogarth illustrated incidents in the life of a prostitute
from her arrival in London until her death. The engravings reproduce paintings,
the fifth of which shows the harlot, just released from prison, attended by two
quack doctors, probably Dr. Ward (pp. 81, 87) and Dr. Misaubin, a licentiate of the
College of Physicians. Papers on the floor refer to Dr. Rock, another eighteenth-
century English quack who sold the "Famous, Anti-Venereal, Grand, Specifick Pill,"
and the Anodyne Necklace, a long-lived product for teething children (p. 104).

No. 152

Marriage à-la-Mode, the Scene with the Quack, 1745

B. BARON (English, eighteenth century)
After William Hogarth (English, 1697–1764)
Engraving; 15⅛ x 18¼ in. [38.4 x 46.4 cm]

Marriage-A-la-Mode, (Plate III)

Hogarth's popular series traced the unhappy events following the marriage
of an ill-matched pair. In this plate, the third in a series of six, after earlier
paintings, the husband and his mistress, each holding a box of pills, visit
the office of a quack doctor modeled after the well-known Dr. Misaubin
(p. 204). But a large woman holding a knife suggests that there is another
solution for the young woman's venereal disease (which she has also given
to her lover) in addition to Dr. Misaubin's famous pills.

No. 153

"Room for the Doctor, gentlemen! Room for the Doctor! ...," 1886

A. FORESTIER
(English, nineteenth century)
Engraving; image 12 x 9¼ in.
[30.5 x 23.5 cm]
From *The Illustrated London News* (September 4, 1886)

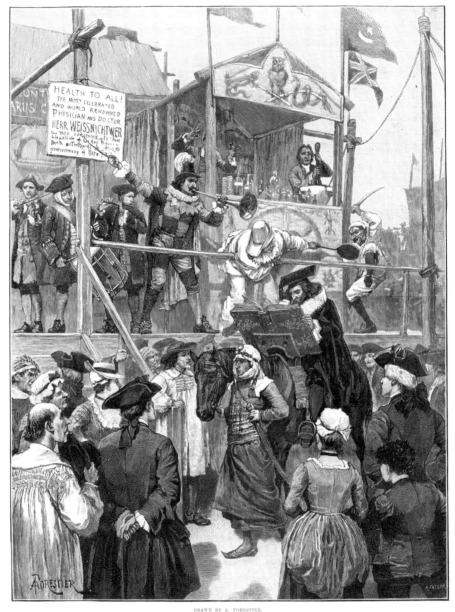

DRAWN BY A. FORESTIER.

" Room for the Doctor, gentlemen ! Room for the Doctor ! " and the people parted right and left, while, mounted on a black steed, that learned person rode very slowly towards the stage.

"THE WORLD WENT VERY WELL THEN." By WALTER BESANT.

This is an illustration from the novel by Walter Besant, *The World Went Very Well Then,* serialized in both *The Illustrated London News* and *Harper's Weekly* prior to its first book publication by *Harper's* in 1886. The first English publication (London: Chatto and Windus, 1887) also included illustrations by Forestier. In this print, the doctor appears to be deeply immersed in his studies as he arrives, preceded by musicians, clowns and even a pharmacist who mixes a fresh batch of his secret nostrum.

H. G. WELLS

TONO-BUNGAY

No. 154
H. G. Wells, Tono-Bungay, 1960
Illustrated by Lynton Lamb
Published by the Heritage Press, New York

With an Introduction by

Norman H. Strouse

&

Illustrated by

LYNTON LAMB

—— ——

THE HERITAGE PRESS
New York

This is a novel about a young man who joins his uncle in the marketing of a patent medicine, largely through ingenious advertising campaigns. In a chapter on "How We Made Tono-Bungay Hum" he boasts, "Tono-Bungay carried me to freedoms and powers that no life of scientific research, no passionate service of humanity could ever have given me," a feeling that might have been echoed by other successful nostrum promoters.

No. 155

S. Weir Mitchell, The Autobiography of a Quack, 1900

Illustrated by A. J. Keller

Published by the Century Co., New York

"'AND DO YOU MEAN TO SAY HE WAS N'T POISONED?' SAID SHE."

THE AUTOBIOGRAPHY OF
A QUACK

AND

THE CASE OF
GEORGE DEDLOW

BY

S. WEIR MITCHELL, M. D.,
LL. D. HARVARD AND EDINBURGH

ILLUSTRATED BY
A. J. KELLER

NEW YORK
THE CENTURY CO.
1900

Mitchell (1830–1914) was the leading American neurologist around the turn of the century, and a poet and novelist as well. This is the story of Dr. E. Sandcraft, more a rogue than a quack but who, among other acts at various times, practiced homeopathy, treated all diseases by vegetable remedies alone, advertised a cancer cure and dishonestly used spiritualism to diagnose illnesses and prescribe cures.

LUCKY LUKE

VII

No. 156
**Morris, L'Elixir
du Docteur Doxey**, 1967

Published by Dupuis,
Marcinelle-Charleroi, Belgium

L'Elixir du Docteur DOXEY

Texte et illustrations de MORRIS

DUPUIS

MARCINELLE-CHARLEROI ★ PARIS ★ MONTREAL ★ BRUXELLES ★ LA HAYE

The French comic book presents the adventures of cowboy Lucky Luke in bringing charlatan Doctor Doxey to justice because of his excessive promotion of several nostrums. The idea of the American medicine show did reach Europe to some extent through Sequah, an American medicine show worker who succeeded in England, Holland and a few other countries early in the twentieth century, but in general its influence was limited.

Dr. Comicus Selling His Pills, 1815

THOMAS ROWLANDSON (English, 1756–1827)
Hand-colored aquatint; image 4¼ x 7⅛ in. [10.8 x 18.1 cm]

Dᴿ COMICUS SELLING HIS PILLS.

One of fifteen plates in William Combe's *The Adventures of Doctor Comicus or the Frolicks of Fortune, a Comic Satirical Poem for the Squeamish & the Queer...*, this print depicts one of many adventures of Dr. Comicus, here shown as a medicine seller. Dr. Comicus was the first of many imitations of the successful series of Dr. Syntax books for which William Combe also wrote the text and Rowlandson did the illustrations.

THE QUACK'S SONG

WRITTEN BY
F. C. BURNAND.

MUSIC BY
W. MEYER LUTZ.

SUNG WITH THE GREATEST SUCCESS BY
EDWARD TERRY,
IN F. C. BURNAND'S EXTRAVAGANZA "CAMARALZAMAN" AT THE GAIETY THEATRE.
LONDON: HOPWOOD & CREW, 42, NEW BOND ST W. Pr. 4/-

No. 158

The Quack's Song, 1887

Song sheet cover; 14 x 9¾ in.
[35.6 x 24.8 cm]
Words by F. C. Burnand
Music by W. Meyer Lutz
Published by Hopwood
& Crew, London

Camaralzaman, the quack in this forgotten musical comedy, is dressed appropriately in a costume displaying the chief ingredient of his nostrum. His song begins:

> *Now, then, all who've got the rheumatism,*
> *Groaning, moaning, owning they've no heroism,*
> *I can cure you all by mesmerism,*
> *If you're aching, shaking, taking, quickly come to me.*

No. 159

**Le Docteur mirifique
(The Wonderful Doctor)**, 1877

ANONYMOUS (French)
Lithograph; 10½ x 10¼ in. [26.7 x 26 cm]
From *Almanach des Chansons Populaires*
(Paris, 1877)

In addition to appearances in opera (opposite), the bravado of itinerant quacks was also used as a popular music theme. In this issue of an eight-page songster reprinting words of leading fashionable tunes of the day, the doctor discusses the exemplary virtues of his leading products.

No. 160

L'Elisir d'Amore (The Elixir of Love), 1839

CÉLESTIN NANTEUIL (French, 1813–1873)

Lithograph; 10⅝ x 6½ in. [27 x 16.5 cm] Printed by Caboche et Cie

No. 161

Signor Frezzolini als Dulcamara in der Oper L'Elisir d'Amore (Signor Frezzolini as Dulcamara in the Opera The Elixir of Love), c. 1800

AND. GEIGER (Austrian, nineteenth century)
AFTER SCHOELLER (Austrian, nineteenth century)
Hand-colored engraving; plate 9 x 5½ in. [22.9 x 14 cm]
Printed by Bureau der Theaterzeitung, Vienna

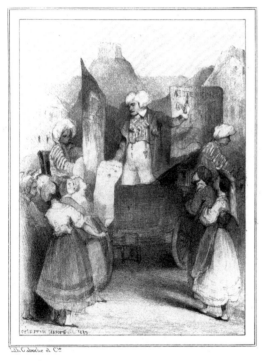

L'ELISIR D'AMORE
(1er Acte 2e Tableau) Théâtre Royal Italien.

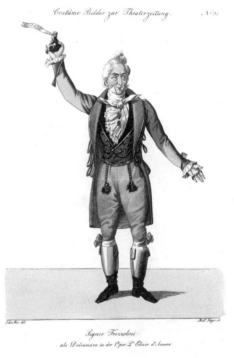

Gaetano Donizetti's comic opera *The Elixir of Love* was first performed in Milan in 1832. It tells the story of Nomorino who, sensing a rival's effort to woo the fair and wealthy Adina, chooses to purchase a love potion from Dr. Dulcamara, an itinerant medicine seller. The elixir makes him more drunk than lovable, but he does win the affections of Adina in the end.

No. 162

Le Charlatan, c. 1890

ANONYMOUS (French)

Color lithograph; 15⅞ x 10½ in.
[40.3 x 26.7 cm]

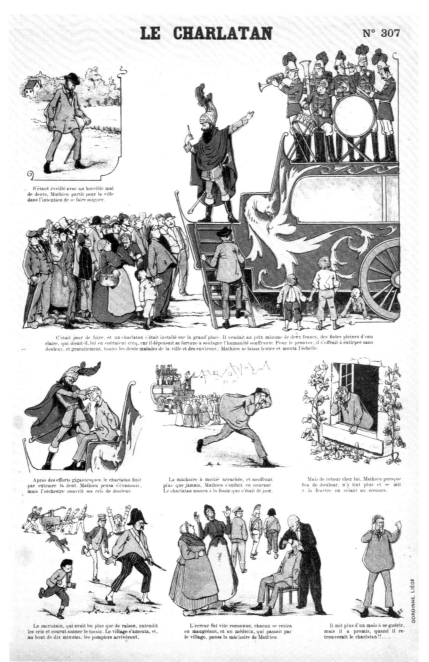

In this example of *imagerie populaire* (popular prints) a quack's errors result in a patient's agony. The charlatan sells vials of plain water for two francs even though, he stresses, they cost him five francs. To prove the product's value, he has offered to pull all diseased teeth in town without pain. But the bargain proves to be a poor one because the wrong tooth has been removed.

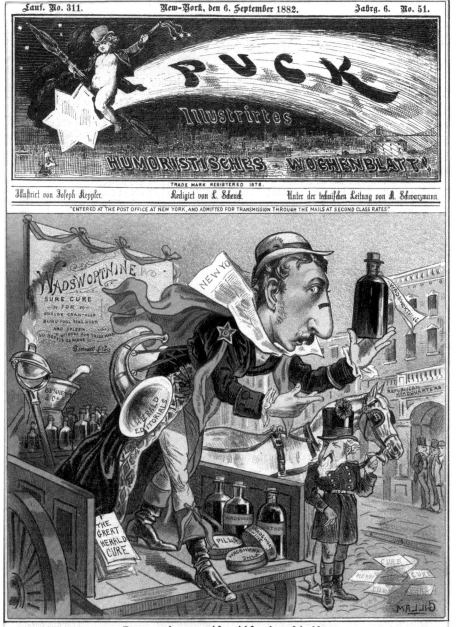

Der grosse amerikanische Quacksalber.
Ein gutes Heilmittel in ungeschickten Händen.

No. 163

Der Grosse Amerikanische Quacksalber (The Great American Quack), 1882

BERNHARD GILLAM
(American, 1856–1896)
Color lithograph;
image 7¾ x 8½ in. [19.7 x 21.6 cm]
From *Puck*, vol. 6, no. 51
(September 6, 1882)

During the summer of 1882, the editor of *The New York Herald*, James Gordon Bennett, actively promoted the candidacy of James W. Wadsworth to be the Republican candidate for governor of New York in the forth-coming election. Gillam's metaphor translates his advocacy into a push for Wadsworthine, a "sure cure." Wadsworth, not an overly popular figure, had been state comptroller, and did not win the nomination.

The Great Quackery "Combine" on its Travels, 1887

CHARLES J. TAYLOR (American, 1855–1929)
Color lithograph; 13⅝ x 20 in. [34.6 x 50.8 cm]
From *Puck* (1887)

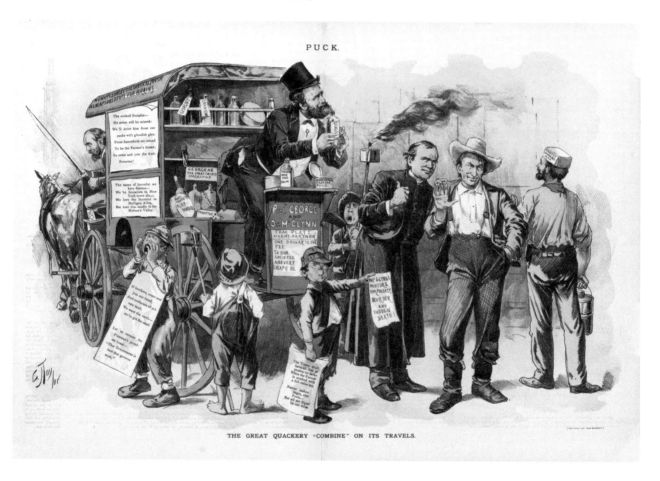

THE GREAT QUACKERY "COMBINE" ON ITS TRAVELS.

In this attack on the single tax theories of the social reformer Henry
George (1839–1897), his colleague Father Edward McGlynn, pastor
of Saint Stephen's Catholic Church in New York City, is an itinerant
quack using his wagon as a lecture platform. *Puck's* comments suggest
that George's ideas will hurt the "Honest Working Man," always in
need of defense from quack ideas.

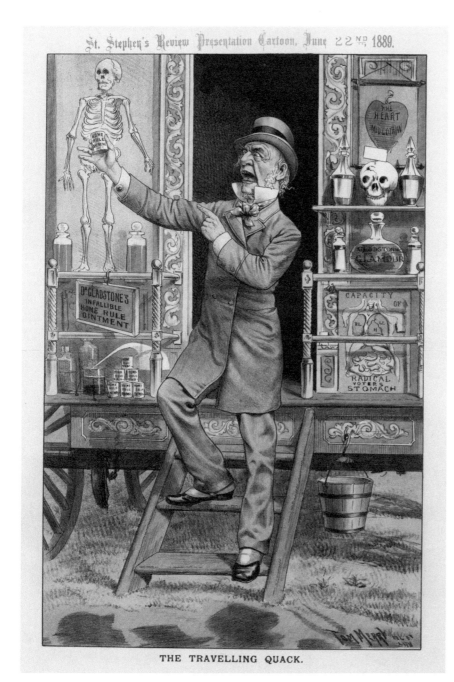

St. Stephen's Review Presentation Cartoon, June 22ND 1889.

THE TRAVELLING QUACK.

No. 165

The Travelling Quack, 1889

TOM MERRY (English, nineteenth century)
Color lithograph; image 18¼ x 12 in.
[46.4 x 30.5 cm]
From *St. Stephen's Review* (June 22, 1889)

William Ewart Gladstone (1809–1898), four times prime minister of Great Britain, was in opposition in 1889 when this print was published. The Infallible Home Rule Ointment that he sells is a remedy to end England's misrule in Ireland, a project to which Gladstone dedicated his major energies during the latter part of his political career. Both of his Home Rule Bills of 1886 and 1893 were defeated, and Ireland's problems endured long after his failure.

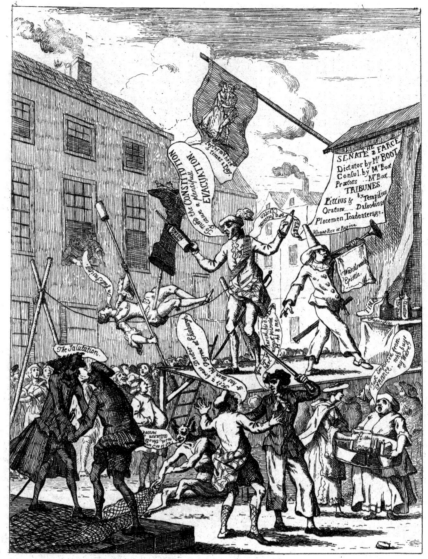

The St—te QUACK.

Publish'd according to Act of Parliament. Price .

This is one of the more vicious of many political caricatures attacking
Lord Bute, leader of the government in 1762. He is the quack doctor on
the platform. The Princess of Wales, with whom Bute was rumored to
have had an affair, is the tightrope dancer sliding on a rope with a large
boot (Bute's name was so pronounced) atop her body. Other references
in the print allude to events of the day and recent articles in newspapers.

No. 167

The Rival Quacks, or Black Draught Versus Universal Pills, 1837

JOHN DOYLE (Irish, 1797–1868)
Color lithograph; 9¾ x 13½ in. [24.8 x 34.3 cm]
Published by T. McLean, London

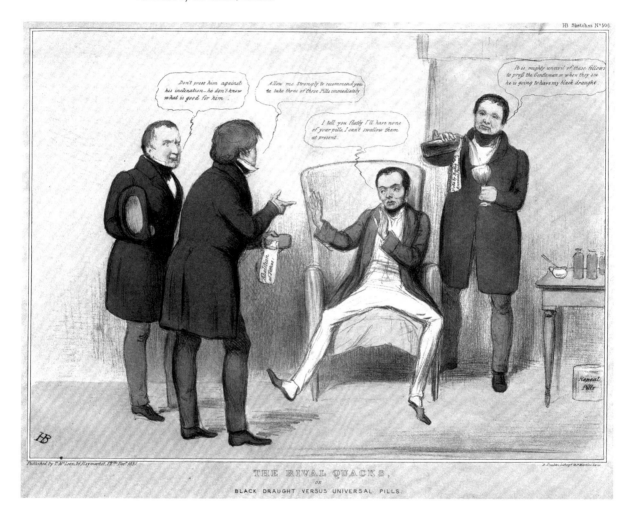

Doyle's caricature deals with the efforts of three Radical members of Parliament to convince Lord John Russell to adopt their views on various reforms needed in voting, the duration of Parliament, church rates, the law of primogeniture and several other matters. These members are Thomas Wakely, the influential editor of *The Lancet;* Joseph Hume; and Daniel O'Connell, the Irish political leader, who has his own proposal in hand.

The Evils of Quackery.

At periodic intervals throughout their long history quacks have been the subject of attacks by physicians, journalists, politicians, cartoonists and even their fellow charlatans. But by the middle of the nineteenth century, when medicine and technology began to make significant advances, when the audacity of product claims began to exceed common sense, and when the ubiquitous advertisements of thousands of newly hatched proprietary medicines began to spoil the environment, more serious efforts were mounted to bring about restrictions and controls. In England, the Medical Registration Act came into force in 1858, restricting medical activities to those properly licensed. Somewhat later in the United States, editorials, cartoons and detailed criticisms of some of the more flagrant abuses were chronicled in pamphlets, newspapers and magazines. Despite the influence of proprietary medicine advertisers who had specific clauses included in contracts with magazines forbidding critical statements, a series of articles in the *Ladies' Home Journal, Collier's Weekly* and other publications sensitized the public to the excesses of the nostrum evil. The Pure Food and Drugs Act, passed by Congress in 1906, curtailed the main abuses, but subsequent regulations were needed throughout the twentieth century to keep pace with the creative efforts of the developers of quack foods, medicines and gadgets. Even so, the quack survives, promising cures for incurable diseases as well as drugs, foods and appliances to make us thinner, handsomer and healthier forever. 🍃

No. 168

The Advertising Craze, 1893

ANONYMOUS (American)
Color lithograph; 8¼ x 11¼ in. [21 x 28.6 cm]
From *Judge* (December 23, 1893)

THE ADVERTISING CRAZE.
It is enough to make a nervous man think he has them all.

This caricature is a response to the excessive outdoor advertising by proprietary medicines. Companies posted broadsides and posters on walls, and in the late nineteenth century their advertisements also began to proliferate on rocks and in open fields. Among the products attacked are many of the best known: Bromo Seltzer, Brandreth's Pills, Fletcher's Castoria, Carter's Little Liver Pills, Hood's Sarsaparilla, Frog in Your Throat, Saint Jacob's Oil and Duffy's Malt Whiskey are easily recognized.

Quackery—Medical Minstrels Performing for the Benefit of Their Former Patients—No Other Dead-Heads Admitted, 1879

JOSEPH KEPPLER (American, born Austria, 1838–1894)
Color lithograph; 11⅞ x 18½ in. [30.2 x 47 cm]
From *Puck* (November 19, 1879)

QUACKERY—MEDICAL MINSTRELS PERFORMING FOR THE BENEFIT OF THEIR FORMER PATIENTS—NO OTHER DEAD-HEADS ADMITTED.

In his biting satire on the excessive promotion and irresponsible formulations of many proprietary medicines, Keppler leaves no group untouched, attacking allopaths (the regular physicians), homeopaths, eclectics, vegetarians, phlebotomists, hydropaths and even spirit mediums and Turkish bathers. He especially singles out arsenic, calomel, laudanum, quinine and morphine as being in the same league as quack medicines.

No. 170

Death's-Head Doctors — Many Paths to the Grave, 1881

JOSEPH KEPPLER (American, born Austria, 1838–1894)
Color lithograph; 11½ x 18⅝ in. [29.2 x 47.3 cm]
From *Puck* (1881)

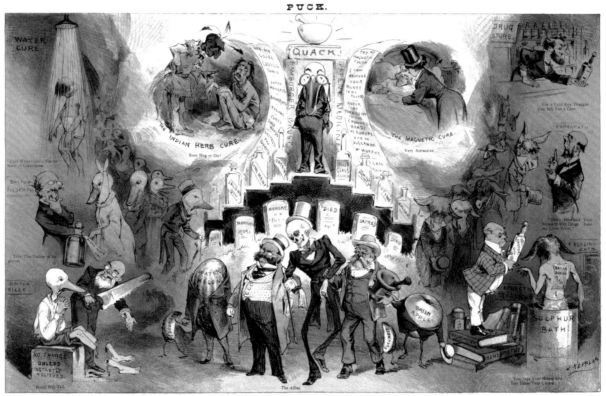

DEATH'S-HEAD DOCTORS.—MANY PATHS TO THE GRAVE.

The panoply of those responsible for the horrors of quackery continued to
expand in the early years of the twentieth century. Keppler's print includes
pharmacists, the water cure, the Indian herb cure and the Magnetic cure
in addition to those he had previously criticized (p. 223). The well-known
proprietary Saint Jacob's Oil, Colonel Pleasonton's Blue Glass treatment,
(p. 97), and certain foods are condemned as well.

No. 171

Death in the Pestle, c. 1885

HENRY NAPPENBACH (American, 1862–1931)
Color lithograph; 11⅝ x 18¼ in. [29.5 x 46.4 cm]
From *The Wasp* (c. 1885)
Printed by Schmidt Label & Co., San Francisco

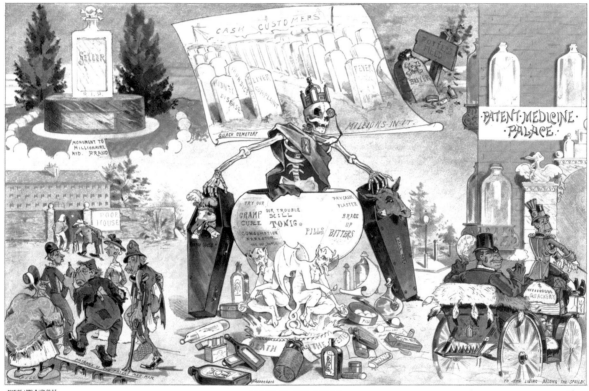

DEATH IN THE PESTLE.

This caricature condemns the fortunes made from patent medicine quackery while the patrons of the patent medicine man march to the poor house. But death claims still more of the victims, and the quack cemetery has millions in it.

No. 172

The "Cure" Craze, 1889

GRANT HAMILTON (American, 1862–?)
Color lithograph; 13¼ x 19⅞ in. [33.7 x 50.5 cm]
From *Judge* (September 21, 1889)

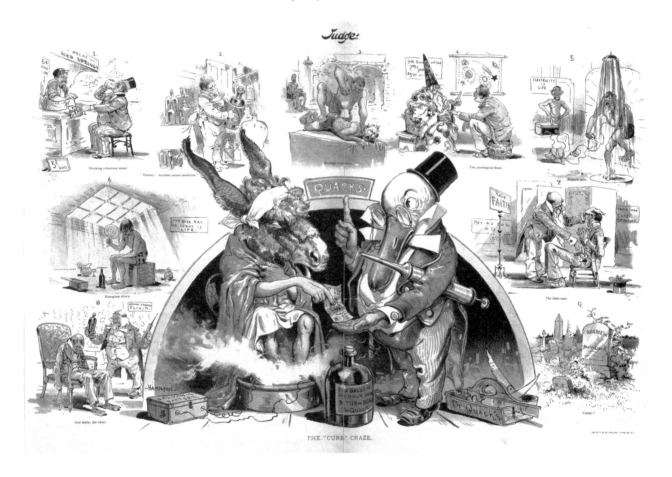

THE "CURE" CRAZE.

This is a critique of several systems employed by nineteenth-century fringe groups: hydropathy, electricity, faith healing, massage, astrology, curing illness by filtering light from blue glass and, of course, patent medicines. Hamilton's satire shows the ultimate users of these remedies as asses, and the merchant receiving the money from the treatments as Dr. Quack.

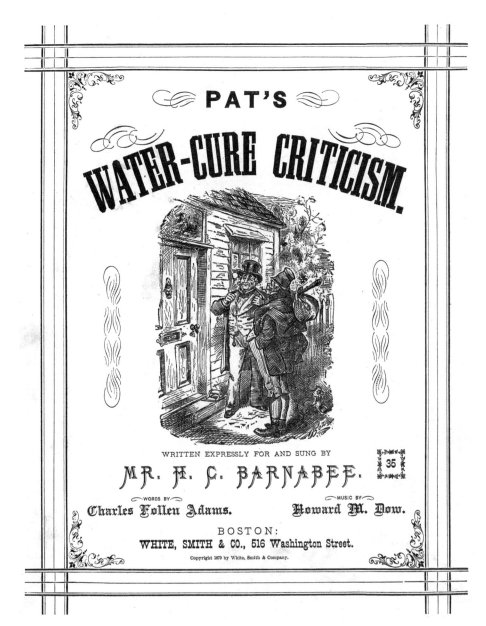

No. 173
Pat's Water-Cure Criticism,
1879

Song sheet cover; 12½ x 10 in.
[31.8 x 25.4 cm]
Words by Charles Follen Adams
Music by Howard M. Dow
Published by White, Smith &
Company, Boston

Many people considered systems such as homeopathy and hydropathy to be
little more than quackery. The physician discourses on his methods in the verse:
From the lake and the murmuring rill
This Elixir of Life, With healing so rife,
I apply to the cure of each ill.
But Pat, the man to whom he addresses these words, suggests that there
should be a duck in the lake singing a song entitled "Quack! Quack!"

No. 174

Joseph Clutton, A True and Candid
Relation of the Good and Bad Effects
of Dr. Joshua Ward's Pill and Drop, 1736

Printed in London

A TRUE and CANDID

RELATION

OF THE

Good and Bad Effects

O F

JOSHUA WARD's

PILL and DROP.

Exhibited in SIXTY-EIGHT CASES; QUO-
TATIONS from the Writings of Learned
Phyſicians concerning ARSENICK;
Some CASES of Perſons who have taken
it; and EXPERIMENTS to ſhew what are
the component Principles of *theſe Pills.*

Introduced with Occurrences ſhewing the Riſe
and Progreſs of this Controverſy.

The Whole being an *ESSAY* to diſcover how far this *Ran-
dom Practice* of PHYSICK is really uſeful.

By *JOS. CLUTTON.*

LONDON,

Printed for the Author; and ſold by *J. Wilford,* behind the
Chapter-houſe, in St. *Paul's* Church-yard. MDCCXXXVI.

(**Price One Shilling.**)

Until the nineteenth century, physicians and medicine sellers vied for market
share, with the public often treated as well by one group as the other. Joshua
Ward's Pill and Drop were among the better-known proprietary products in the
early 1700s (p. 87). In this study, the London physician Joseph Clutton promises
to show the good and ill effects of Ward's specialties. Not surprisingly, the bad
prevails. Clutton boldly states that Ward's products contained antimony and
arsenic, but Ward denied the allegation.

No. 175

John Corry, Quack Doctors Dissected..., c. 1805

Printed in London

Along with the success of nostrum proprietors in selling heavily advertised specialties at the end of the eighteenth century came continual attacks by critics. One, John Corry, went after the chief offenders, and this pamphlet offers an abridgment of his diatribes against Samuel Solomon (p. 172), William Brodum (p. 173) and the tractors of Elisha Perkins (p. 111). Its frontispiece illustrates the moment when one outraged citizen, offended by his wife's overdosage of Cordial Balm of Gilead, got his friends to toss Solomon in a blanket as revenge.

SHORT EXPOSE ON QUACKERY,

BY

DR. EUEN;

OR,

INTRODUCTION OF HIS SON

TO

PHYSICIANS AND COUNTRY MERCHANTS.

———

PHILADELPHIA:
———
February—1840.

———

N. B.—Please read this pamphlet as soon as convenient, and hand it back to the bearer, my son.—W. E.

Euen's pamphlet was an attack directed against two of the largest selling proprietary products, Brandreth's Pills, which he felt to be worthwhile but too expensive, and Swaim's Panacea (p. 75), which had problems because it contained mercury. The pamphlet was given to prospective purchasers of Euen's product line personally by his son, a traveling salesman.

QUACKERY UNMASKED:

OR

A CONSIDERATION OF THE MOST PROMINENT

EMPIRICAL SCHEMES

OF THE PRESENT TIME,

WITH AN ENUMERATION OF SOME OF THE CAUSES WHICH CONTRIBUTE TO THEIR SUPPORT.

No. 177
Dan King, Quackery Unmasked, 1858
Published by S.S. & W. Wood, New York

———

BY DAN KING, M. D.,

FELLOW OF THE MASS. MED. SOCIETY, LATE COMMISSIONER ON TRIALS, MEMBER OF THE AMERICAN MED. ASSOCIATION ; ALSO, AUTHOR OF THE LIFE AND TIMES OF T. W. DORR, ETC., ETC.

———

"IF quackery, individual or gregarious, is ever to be eradicated, or even abated, in civilized society, it must be done by enligtening the publie mind in regard to the true powers of medicine."—JACOB BIGELOW.

———

NEW EDITION.

———

NEW-YORK:
S. S. & W. WOOD, PUBLISHERS.

A practicing New England physician, King was better known as a pamphleteer and writer. This text, his major work, contains chapters on those mid-nineteenth-century practices of which he disapproved, among them homeopathy, hydropathy, Thomsonianism, Eclecticism and bonesetting. He also published attacks on tobacco, alcohol and spiritualism. King even condemned female physicians, suggesting that "the idea of their engaging in the general practice of medicine and surgery, is preposterous."

No. 178

Jean-Jacques Paulet, L'Antimagnétisme or origine, progès, décadence,
renouvellement et réfutation du magnétisme animal

Printed in London, 1784

L'ANTIMAGNÉTISME
ou
ORIGINE, PROGRÈS, DÉCADENCE,
RENOUVELLEMENT ET RÉFUTATION
DU MAGNÉTISME ANIMAL.

Sed quantô ille magis formas se vertet in omnes,
Tantò , nate, magis contende tenacia vincla,
Donec talis erit, mutato corpore, qualem
Videris, incæpto.
VIRGIL. Georgic. lib. IV.

À LONDRES.

1784.

Mesmer's advocacy of animal magnetism as a remedy for various ailments
began to have detractors almost from the day it began to be promoted. Paulet
(1740–1826), a physician at the University of Montpellier, traced the history of
various theories of animal magnetism prior to Mesmer in his text, saving his
most serious critique for the doctrines espoused by Mesmer himself.

16

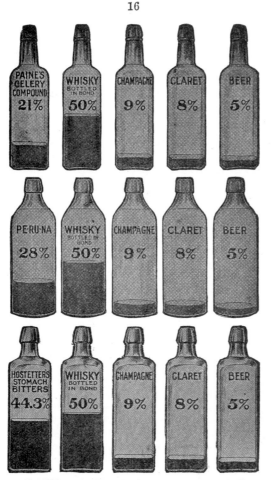

ALCOHOL IN "MEDICINES" AND IN LIQUORS.

These diagrams show what would be left in a bottle of patent medicine if everything was poured out except the alcohol; they also show the quantity of alcohol that would be present if the same bottle had contained whisky, champagne, claret or beer. It is apparent that a bottle of Peruna contains as much alcohol as five bottles of beer, or three bottles of claret or champage—that is, bottles of the same size. It would take nearly nine bottles of beer to put as much alcohol into a thirsty man's system as a temperance advocate can get by drinking one bottle of Hostetter's Stomach Bitters. While the "doses" prescribed by the patent medicine manufacturers are only one to two teaspoonfuls several times a day, the opportunity to take more exists, and even small doses of alcohol, taken regularly, cause that craving which is the first step in the making of a drunkard or drug fiend.

No. 179
Samuel Hopkins Adams,
The Great American Fraud, 1907

Published by P. F. Collier & Son, Chicago

In a series of ten articles in *Collier's Weekly*, in 1905, the journalist Samuel Hopkins Adams laid bare the deceptions and frauds of the American patent medicine trade. Adams, Lincoln Steffens, Ida Tarbell and Ray Stannard Baker, were among the leading muckraking journalists whose work exposed certain side effects in the continuing growth of large corporations. The articles in *Collier's Weekly*, collected in this publication, proved to be extremely effective in opening the eyes of concerned readers.

Medical Letters

AS we have millions of medical letters we can fill orders for any quantity from 1,000 up. Following is a list of some of the different classes of these letters that we can furnish promptly:

Asthma.	General Medical.
Blood Poison.	Hair Preparations.
Bust Developer.	Heart.
Cancer.	Kidney.
Catarrh.	Morphine.
Constipation.	Nervous Debility.
Consumption.	Obesity.
Deafness.	Paralysis.
Drunkenness.	Piles.
Dyspepsia.	Rheumatism.
Eczema.	Rupture.
Eye Troubles.	Syphilis.
Epilepsy.	Stomach.
Female Complaints.	Skin Disease.

Etc., Etc., Etc.

These letters were all written to well known and successful medical advertisers, and are a very profitable class of letters for anyone with a legitimate medical proposition to use.

If you have a medical proposition to get before the people it is most important that you should use original letters. By this plan you can avoid all waste of time and money, addressing only people who are interested in what you have to offer.

Write us for particulars and prices regarding the class of letters you are interested in.

No. 180
Council on Pharmacy and Chemistry of the American Medical Association, The Propaganda for Reform in Proprietary Medicines, 1908

5th edition
Printed in Chicago

Even after passage of the Pure Food and Drugs Act in 1906 the American Medical Association kept up its continual investigations of proprietary medicines. Published articles were later collected in several editions of *The Propaganda for Reform,* and included product analyses, critiques of advertisements, how testimonials are obtained, marketing of testimonial letters and related issues.

HILL GROWS WARY

So much for the testimonials. Dr. Hill, within the past few months has grown wary. Like every other consumption

"*Consumption Is Curable.*"

J. Laurence Hill, A. M. M. D.

Graduate Edinburgh University, Scotland; Chicago Homeopathic Medical College; Post Graduate Course, Northwestern College of Ophthalmology and Otology; Chicago Eye, Ear, Nose and Throat College; and Special Courses Instruction under Prof. Ludwig Hektoen, M. D., Professor of Pathology in Rush Medical College and formerly in the College of Physicians and Surgeons, Chicago; also under the late Prof. J. S. Mitchell, A. M., M. D., Specialist in Diseases of the Respiratory Organs; and **Special Post Graduate Course in the Post Graduate Medical College of Chicago, Specializing in Tuberculosis of the lungs, June-July, 1909**

Photographic reproduction of a card sent out by Hill to his prospective victims. Note that he states that he is a graduate of the University of Edinburgh, Scotland; the registrar of that institution states that Hill's name does not appear on their books as a graduate! Since this article was written Hill sends out a card similar to this one in every detail EXCEPT THAT ALL REFERENCE TO ELINBURGH UNIVERSITY IS OMITTED!

No. 181

American Medical Association, Nostrums and Quackery, 1912

2nd edition
Published by the American Medical Association Press, Chicago

The physician Arthur J. Cramp joined the American Medical Association in 1906 and shortly thereafter began publishing a steady barrage of exposés on proprietary medicines. These were subsequently collected into a series of volumes containing "Articles on the Nostrum Evil and Quackery." The first edition, 1911, contained more than 500 pages detailing fraudulent statements and listing secret formulas of more than 750 individual products.

No. 182

"Men's Specialists":
Some Quacks and Their Methods,
1914

Published by the American Medical
Association, Chicago

"MEN'S SPECIALISTS"

SOME QUACKS AND THEIR METHODS

Reprinted with Modifications from

The Chicago Daily Tribune.

RACES AND CREEDS CURE FAKERS
 FIND DISEASE
 IN WELL MEN
BY PERMISSION

"THE BEST CHECK TO ANY GIVEN
EVIL IS ALWAYS THAT PROVIDED BY
AN EDUCATED PUBLIC OPINION . . .
THE QUACK WHO IS UNABLE TO FIND
A PUBLIC ON WHICH TO PREY GOES
BANKRUPT. "
 —EVAN YELLON.

ISSUED BY THE
PROPAGANDA DEPARTMENT
OF THE JOURNAL OF THE AMERICAN MEDICAL ASSOCIATION
535 NORTH DEARBORN STREET, CHICAGO

Chicago seems to have been rife with physicians and others claiming to treat men's diseases in the first decades of the twentieth century. This stimulated *The Chicago Daily Tribune* to conduct an investigation of their methods. "Giving a detailed exposé of practically all the advertising quacks" in the city, these were published in the fall of 1913; subsequently the American Medical Association published them separately. A sorry list it is indeed, pointing out that more than the Food and Drugs Act was needed to curtail abuses. It still is.

TRUTH ABOUT QUACKS

AND

SELF MEDICATION

Prepared by

S. DANA HUBBARD, M.D.

NEW YORK

Attending Dermatologist to the
New York City Children's Hospital
Dermatologist Letchworth Village
Director
Bureau Public Health Education, New York City
Department of Health

Published by

THE CLAREMONT PRINTING CO., Inc.

100-102 Grand Street :: New York City

No. 183
S. Dana Hubbard, Truth About Quacks and Self Medication, 1922

Published by the Claremont Printing Co., Inc., New York

Even after the passage of the Pure Food and Drugs Act the excesses of fraudulent promotions did not go away. Articles, books, pamphlets and films were still necessary to caution the public. This pamphlet not only provided warnings but also advertised two films produced by its author, *Some Wild Oats*, which promised "to throw light where shadows fall" and *The Naked Truth*, "the story of a fellow who sowed his wild oats."

Footnotes.

1. Irvine Loudon, "The Vile Race of Quacks with which this Country is Infested," in Bynum and Porter, eds., *Medical Fringe and Medical Orthodoxy 1750–1850.* (London: Croom Helm, 1987), p. 106.

2. Roger Hambridge, "Empiricomany, or an Infatuation in Favour of Empiricism or Quackery," in Soupel and Hambridge, eds., *Literature and Science and Medicine.* (Los Angeles: Clark Memorial Library, 1982), p. 72.

3. William G. Rothstein, "When Did a Random Patient Benefit from a Random Physician: Introduction and Historical Background." *Caduceus* 12:3 (1996), p. 2.

4. For the French, see Matthew Ramsey, *Professional and Popular Medicine in France, 1770–1830.* (Cambridge: Cambridge University Press, 1988), pp. 226–227. For Boswell, see William B. Ober, *Boswell's Clap and Other Essays.* (Carbondale: Southern Illinois University Press, 1979), p. 16.

5. William Schupbach, "Sequah: An English American Medicine-man in 1890." *Medical History* 29 (1985), pp. 272–317.

6. William H. Helfand, "Samuel Solomon and the Cordial Balm of Gilead." *Pharmacy in History* 31:4 (1989), p. 155.

7. William H. Helfand, *Crowning Achievements: Dentistry in the Ars Medica Collection of the Philadelphia Museum of Art.* (Philadelphia: Philadelphia Museum of Art, 1999), p. 15.

8. Eric Jameson, *The Natural History of Quackery.* (London: Michael Joseph, 1961), p. 81.

9. Roy Porter, *Health For Sale.* (Manchester: Manchester University Press, 1989), p. 3.

10. Ibid., p. 5.

11. David Gentilcore, *Healers and Healing in Early Modern Italy.* (Manchester: Manchester University Press, 1998), p. 98.

12. Jonathan Barry, "Publicity and the Public Good: Presenting Medicine in Eighteenth Century Bristol," in Bynum and Porter, eds., *Medical Fringe and Medical Orthodoxy 1750–1850,* p. 31.

13. Madge E. Pickard and R. Carlyle Buley, *The Midwest Pioneer, His Ills, Cures and Doctors.* (New York: Henry Schuman, 1946), p. 107.

14. Harold J. Cook, *The Decline of the Old Medical Regime in Stuart London.* (Ithaca: Cornell University Press, 1986), p. 48. The titles were *The Ladies Companion or the English Midwife,* and *A Friend to the Sick, or the Honest English Man's Preservation.*

15. P. S. Brown, *Medical History* 20 (1976), p. 164.

16. William Buchan, *Observations Concerning the Prevention and Cure of the Venereal Disease.* 2nd edition. (London: T. Chapman, 1797), p. 57.

17. Roy Porter, "Before the Fringe: Quackery and the Eighteenth Century Medical Market," in Roger Cooter, ed., *Studies in the History of Alternative Medicine.* (New York: St. Martin's Press, 1988), p. 7.

18. Charles E. Rosenberg, William H. Helfand and James N. Green, *'Every Man His Own Doctor': Popular Medicine in Early America*. (Philadelphia: The Library Company of Philadelphia, 1998), introduction.

19. For Walpole, see C. Welsh, *A Bookseller of the Last Century, Being Some Account of the Life of John Newbery, and of the Books Published, with a Notice of the Later Newberys*. (London: Griffith, Farran, Okeden and Welsh, 1885), p. 26. For Boswell, see William B. Ober, *Boswell's Clap and Other Essays*, p. 16. For Byron, see Leslie A. Marchand, ed., *Byron's Letters and Journals*. (London: John Murray, 1973–1981), p. 216. For the United States, see Pickard and Buley, *The Midwest Pioneer, His Ills, Cures and Doctors*, p. 266.

20. Lori Loeb, "George Fulford and Victorian Patent Medicine Men: Quack Mercenaries or Smilesian Entrepreneurs." *Canadian Bulletin of Medical History/Bulletin Canadien D'histoire de la Médecine* 16 (1999), p. 126.

21. David Gentilcore, "Counting Charlatans in Early Modern Italy." Paper at the meeting of the American Association of the History of Medicine. Bethesda, Maryland (May 2000).

22. Ramsey, *Professional and Popular Medicine in France, 1770–1830*, p. 34.

23. Brooks McNamara, *Step Right Up*. (Garden City: Doubleday & Co. Inc., 1976), p. 20.

24. Dorothy Porter and Roy Porter, *Patient's Progress*. (Palo Alto: Stanford University Press, 1989), p. 18.

25. Porter, *Health for Sale*, p. 2.

26. Roy Porter, "Before the Fringe: Quackery and the Eighteenth Century Medical Market," in Cooter, ed., *Studies in the History of Alternative Medicine*, p. 6.

27. Roger Cooter, "Bones of Contention? Orthodox Medicine and the Mystery of the Bone-Setter's Craft," in Bynum and Porter, eds., *Medical Fringe and Medical Orthodoxy 1750–1850*, p. 165.

28. Porter, *Health for Sale*, p. 238.

29. Ramsey, *Professional and Popular Medicine in France, 1770–1830*, p. 48.

30. Pickard and Buley, *The Midwest Pioneer, His Ills, Cures and Doctors*, p. 286.

31. American Medical Association, *Nostrums and Quackery*. (Chicago, 1911). p. 447. The analysis notes water content at 99.381%.

32. P. S. Brown, *Medical History*, p. 159.

33. William H. Helfand, "James Morison and His Pills." *Transactions of the British Society for the History of Pharmacy* 1:3 (1974), p. 117.

34. George B. Griffenhagen and James Harvey Young, "Old English Patent Medicines in America." *Contributions from the Museum of History and Technology, Washington* 218:10 (1959), p. 167.

35. James Harvey Young, *The Toadstool Millionaires*. (Princeton: Princeton University Press, 1961), p. 175.

36. Porter, *Health For Sale*, p. 46.

37. Warnings against counterfeits should not be taken at their face value. As Francis Doherty notes in *A Study in Eighteenth Century Advertising Methods: The Anodyne Necklace*. (Lewiston, N.Y. and Lampter, Dyfed, U.K.: Edward Mellen Press, 1992), p. 115: "Counterfeiting was both a lucrative occupation for quacks and others to pursue, but it was also a way of boasting in public that your product was so successful that unscrupulous

people were willing to copy and promote it as their own, so some caution needs to be used when handling claims about counterfeit medicines."

38. C. J. S. Thompson, *The Quacks of Old London.* (London: Brentano's Ltd., 1928), p. 51.

39. Daniel Defoe, *Journal of the Plague Year.* (London: Printed for E. Nutt at The Royal Exchange; J. Roberts in Warwick Lane; A. Dodd without Temple-Bar; and J. Graves in St. James's Street, 1722), p. 36

40. Pickard and Buley, *The Midwest Pioneer, His Ills, Cures and Doctors,* p. 180.

41. William H. Helfand, "Advertising Health to the People," in Rosenberg, et al., *'Every Man His Own Doctor': Popular Medicine in Early America,* p. 34. Also see Pickard and Buley, *The Midwest Pioneer, His Ills, Cures and Doctors,* pp. 266, 269.

42. Dan King, *Quackery Unmasked.* (Taunton: S. S. & W. Wild, 1858), pp. 251–252.

43. Alfred Franklin, *La Vie Privé d'Autrefois — Les Médecins.* (Paris: 1892), pp. 3, 16. Also see Pickard and Buley, *The Midwest Pioneer, His Ills, Cures and Doctors,* p. 169; and David L. Cowen, *Medicine and Health in New Jersey: A History.* (Princeton: D. Van Nostrand Company Inc., 1964), p. 71.

44. David Gentilcore, "Charlatans, Mountebanks and Other Similar People: The Regulation and Role of Itinerant Practitioners in Early Modern Italy." *Social History* 20:3 (1995), p. 301.

45. For France, see Ramsey, *Professional and Popular Medicine in France, 1770–1830,* p. 78. For the United States, see David L. Cowen, "Pharmacy and Freedom." *American Journal of Hospital Pharmacy* 41 (1984), p. 462.

46. Pickard and Buley, *The Midwest Pioneer, His Ills, Cures and Doctors,* p. 169.

47. Young, *The Toadstool Millionaires,* p. 42.

48. Porter, Roy, *Bodies Politic.* (London: Reaktion Books, 2001), p. 22.

49. Porter, *Health For Sale,* p. 16.

50. Newbery was the publisher of *Goody Two-Shoes,* a popular children's story possibly written by Oliver Goldsmith. Chapter One begins: "How and about Little Margery and her Brother. CARE and Discontent shortened the Days of Little Margery's Father…, he was forced from his Family, and seized with a violent Fever in a Place where Dr. James's Powder was not to be had, and where he died miserably."

51. Sheila O'Connell, *The Popular Print in England.* (London: British Museum Press, 1999), pp. 55, 227. The firm owned a one-third interest in Bateman's Drops, and was also responsible for shipping a considerable amount of British proprietary medicines to America in the years before the War of Independence.

52. Young, *The Toadstool Millionaires,* p. 157.

53. There is an extensive literature on why people resort to quacks. See Viola W. Bernard, "Why People Become the victims of Medical Quackery." *Proc. Second National Congress on Medical Quackery, Washington* (1963), pp. 53–56; and James Harvey Young, *The Medical Messiahs.* (Princeton: Princeton University Press, 1967), pp. 423–433.

Bibliography.

Adams, Samuel Hopkins. *The Great American Fraud*. Chicago: The American Medical Association, 1907.

American Medical Association. *Nostrums and Quackery*. Chicago: Press of the American Medical Association, 1911.

Bynum, William F., and Roy Porter, eds. *Medical Fringe and Medical Orthodoxy 1750–1850*. London: Croom Helm, 1987.

Cooter, Roger, ed. *Studies in the History of Alternative Medicine*. New York: Saint Martin's Press, 1988.

Covey, A. Dale. *The Secrets of Specialists*. Detroit: Physicians Supply Co., 1905.

Crellin, John, *"Lionel Lockyer and His Pills." Proceedings of the XXIII International Congress of the History of Medicine*. London: Wellcome Institute for the History of Medicine, 1972.

de Francesco, Grete. *The Power of the Charlatan*. Translated from the German by Miriam Beard. New Haven: Yale University Press, 1939.

Doherty, Francis. *A Study in Eighteenth Century Advertising Methods: The Anodyne Necklace*. Lewiston, N.Y. and Lampter, Dyfed, U.K.: Edward Mellen Press, 1992.

Gentilcore, David. "Charlatans, Mountebanks and Other Similar People: The Regulation and Role of Itinerant Practitioners in Early Modern Italy." *Social History* 20:3 (1995), 297–314.

——. *Healers and Healing in Early Modern Italy*. Manchester: Manchester University Press, 1998.

Griffenhagen, George B., and James Harvey Young. "Old English Patent Medicines in America." *Contributions from the Museum of History and Technology, Washington* 218:10 (1959), 156–183.

Helfand, William H. "James Morison and His Pills." *Transactions of the British Society for the History of Pharmacy* 1:3 (1974), 103–135.

——. "Mariani et le Vin de Coca." *Revue d'Histoire de la Pharmacie* 27:247 (1980), 227–235.

——. "Samuel Solomon and the Cordial Balm of Gilead." *Pharmacy in History* 31:4 (1989), 151–159.

McNamara, Brooks. *Step Right Up*. Garden City: Doubleday & Co. Inc., 1976.

Pickard, Madge E., and R. Carlyle Buley. *The Midwest Pioneer, His Ills, Cures and Doctors*. New York: Henry Schuman, 1946.

Porter, Dorothy, and Roy Porter. *Patient's Progress*. Palo Alto: Stanford University Press, 1989.

Porter, Roy. "The Language of Quackery in England 1660–1800." In Burke, Peter and Roy Porter, eds., *The Social History of Language*. Cambridge: Cambridge University Press, 1986.

——. *Health For Sale*. Manchester: Manchester University Press, 1989.

——. *Bodies Politic*. London: Reaktion Books, 2001.

Presbrey, Frank. *The History and Development of Advertising.* Garden City: Doubleday, Doran & Co., Inc., 1929.

Ramsey, Matthew. "Medical Power and Popular Medicine: Illegal Healers in Nineteenth-Century France." *Journal of Social History* 10 (1976–77), 560–587.

——. *Professional and Popular Medicine in France, 1770– 1830.* Cambridge: Cambridge University Press, 1988.

Rosenberg, Charles E., William H. Helfand and James N. Green. *'Every Man His Own Doctor': Popular Medicine in Early America.* Philadelphia: The Library Company of Philadelphia, 1998.

Schupbach, William. "Sequah: An English American Medicine-Man in 1890." *Medical History* 29 (1985), 272–317.

Siena, Kevin P., "The 'Foul Disease' and Privacy: The Effects of Venereal Disease and Patient Demand on the Medical Marketplace in Early Modern London." *Bulletin of the History of Medicine* 75 (2001), 199–224.

Soupel, S., and Roger Hambridge, eds. *Literature and Science and Medicine.* Los Angeles: Clark Memorial Library, 1982.

Thompson, C. J. S. *The Quacks of Old London.* London: Brentano's Ltd., 1928.

Young, James Harvey. *The Toadstool Millionaires.* Princeton: Princeton University Press, 1961.

——. *The Medical Messiahs.* Princeton: Princeton University Press, 1967.

——. *American Health Quackery: Selected Essays.* Princeton: Princeton University Press, 1992.

Index.

Colophon.

Quack, Quack, Quack.

BENJAMIN FRANKLIN, marginalia
Arms of the Paris Faculty of Medicine, c. 1760

*Quack, Quack, Quack: The Sellers of Nostrums
in Prints, Posters, Ephemera and Books* is
published on the occasion of an exhibition
at The Grolier Club from September 18 to
November 23, 2002.

The design and typography are by William
Drenttel, Jessica Helfand, Rob Giampietro
and Kevin Smith of Winterhouse Studio,
Falls Village, Connecticut. The printing is by
Suzanne Salinetti and the staff of The Studley
Press, Dalton, Massachusetts. The binding is
by Acme Bindery, Boston, Massachusetts.

The text is composed in *Vendetta,* a Venetian-
style font designed by John Downer for Emigre
in 1999. Headlines are composed in *Ziggurat,*
an Egyptian-style font designed by Jonathan
Hoefler for the Hoefler Type Foundry in 1993.
The paper is Mohawk Superfine. The book
was printed the Summer of 2002.

NYC THE GROLIER CLUB MMII